FF DOT.

– The Pixel Art of FINAL FANTASY –

Welcome to the

World of Pixel Art!

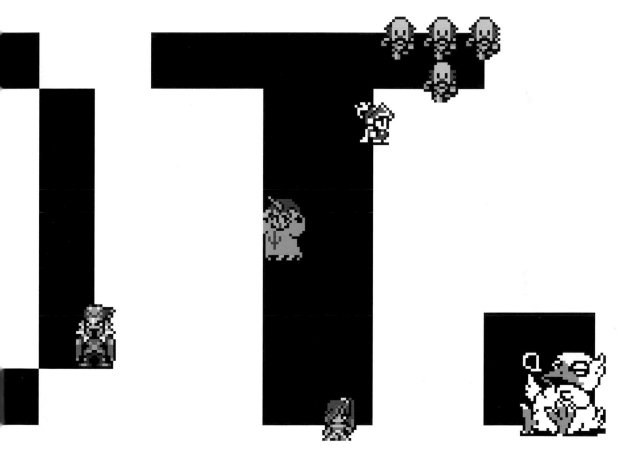

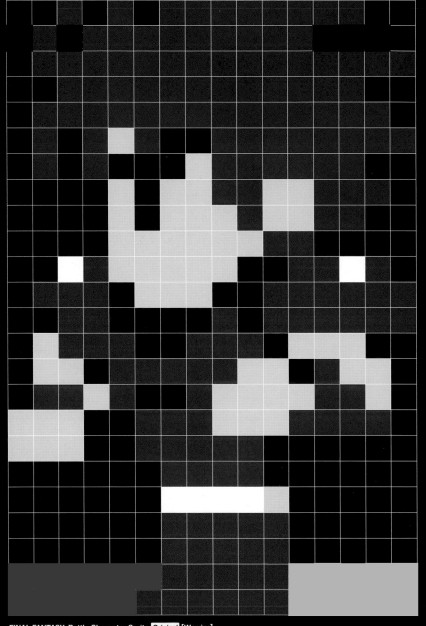

24 pixels

Color Palette

FINAL FANTASY: Battle Character Sprite Original [Warrior]
16 pixels × 24 pixels

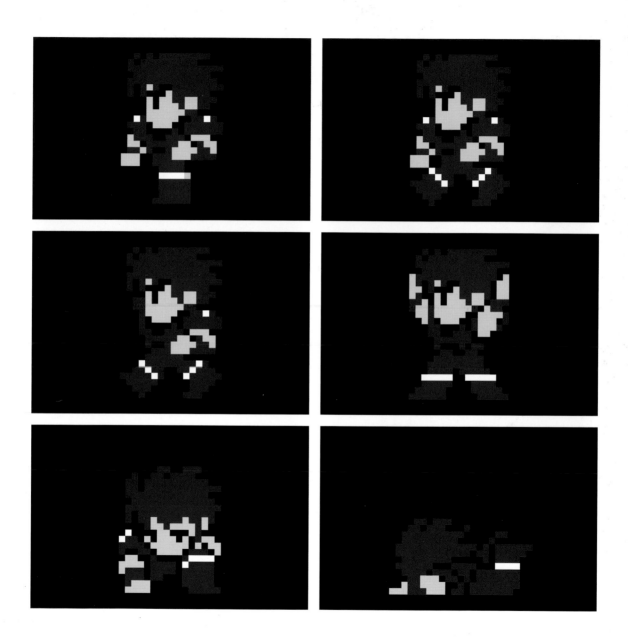

16 pixels

24 pixels

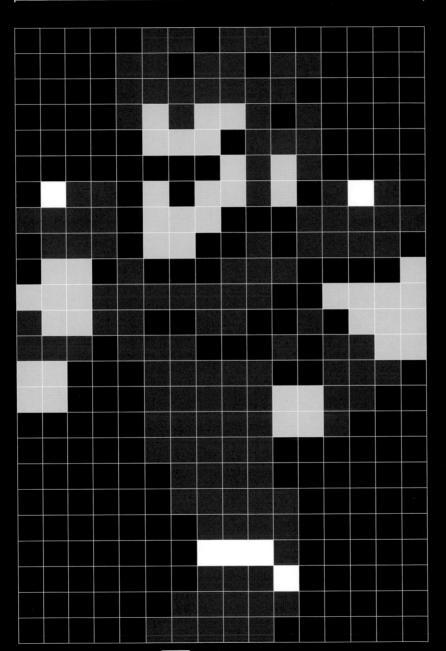

Color Palette

FINAL FANTASY: Battle Character Sprite Original [Knight]
16 pixels × 24 pixels

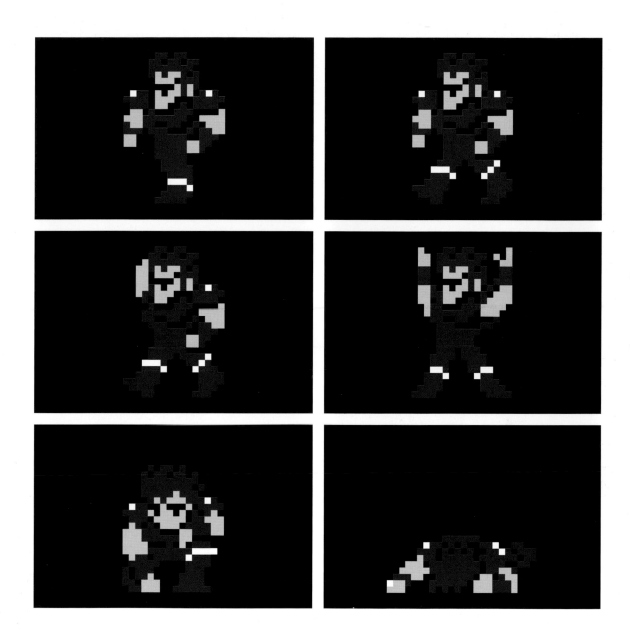

16 pixels

24 pixels

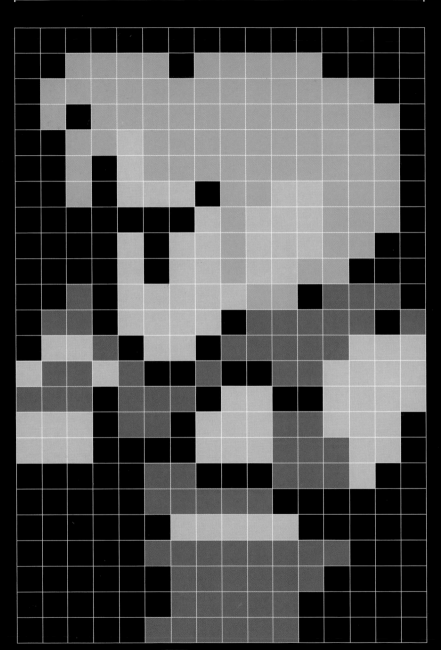

FINAL FANTASY: Battle Character Sprite `Original` [Thief]
16 pixels × 24 pixels

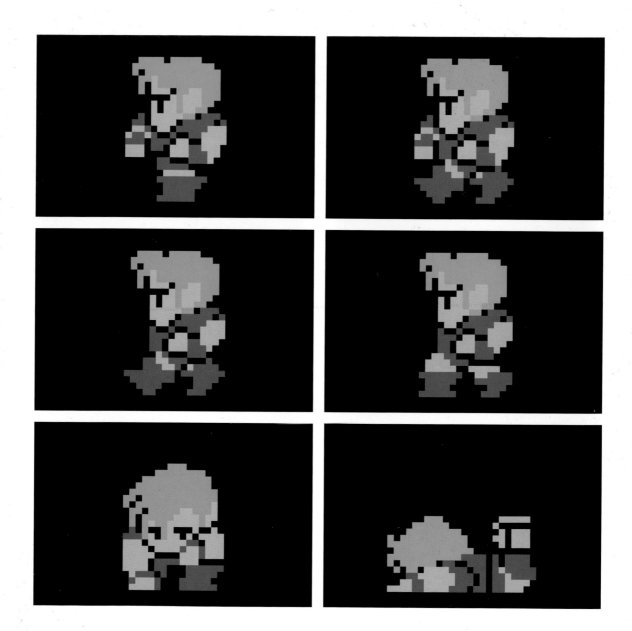

16 pixels

24 pixels

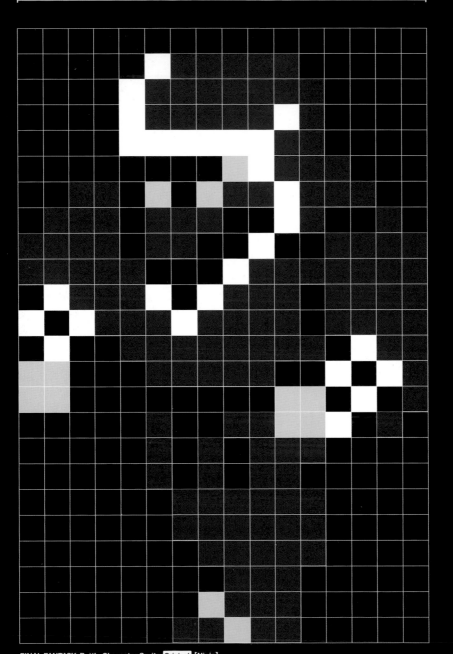

Color Palette

FINAL FANTASY: Battle Character Sprite Original [Ninja]
16 pixels × 24 pixels

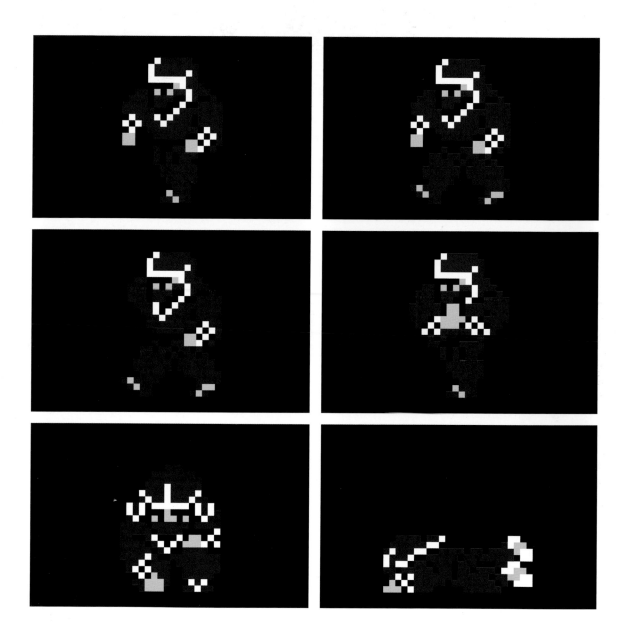

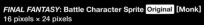

24 pixels

Color Palette

FINAL FANTASY: Battle Character Sprite Original [Monk]
16 pixels × 24 pixels

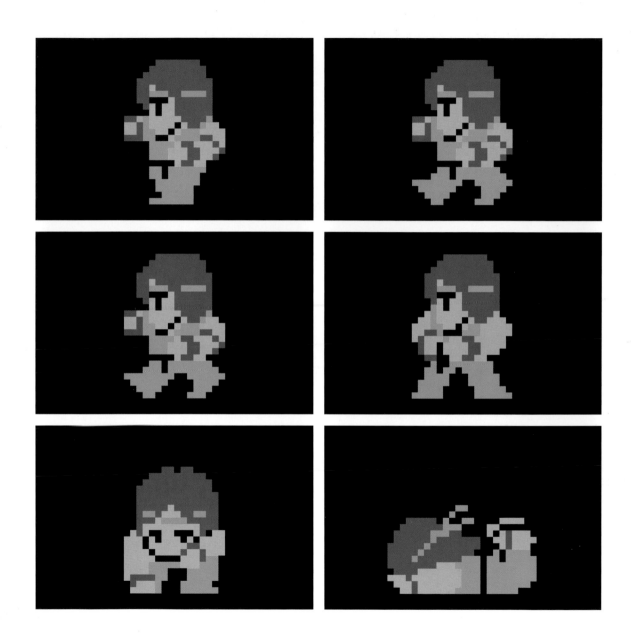

24 pixels

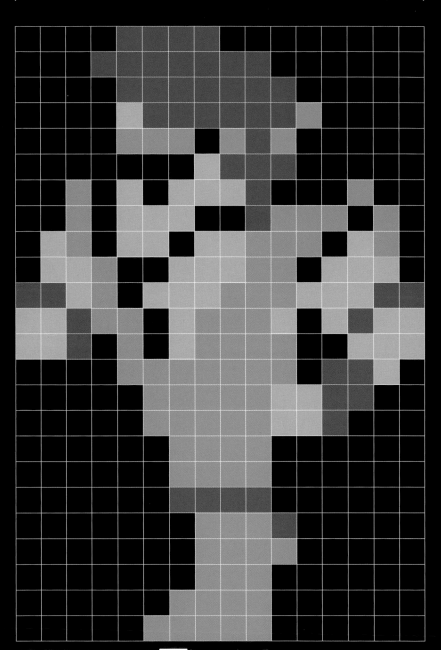

Color Palette

FINAL FANTASY: Battle Character Sprite Original [Super Monk (Master)]
16 pixels × 24 pixels

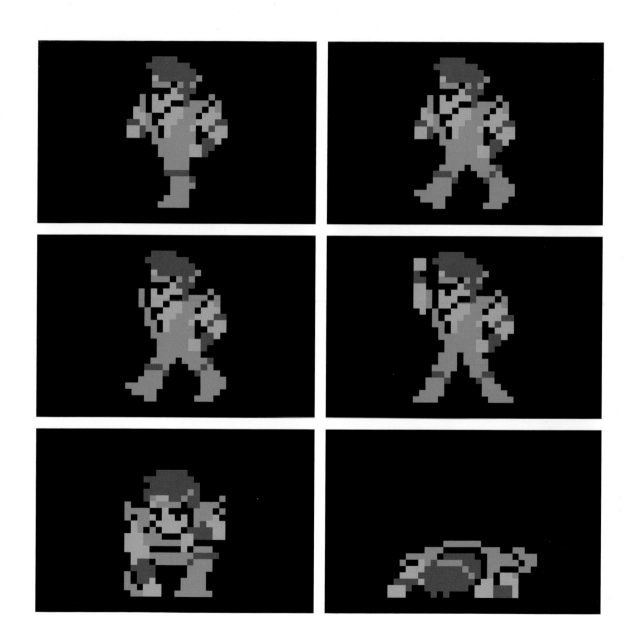

16 pixels

24 pixels

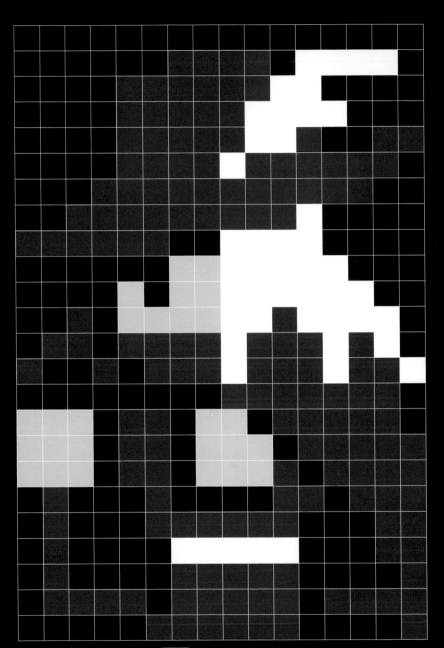

FINAL FANTASY: Battle Character Sprite Original [Red Mage]
16 pixels × 24 pixels

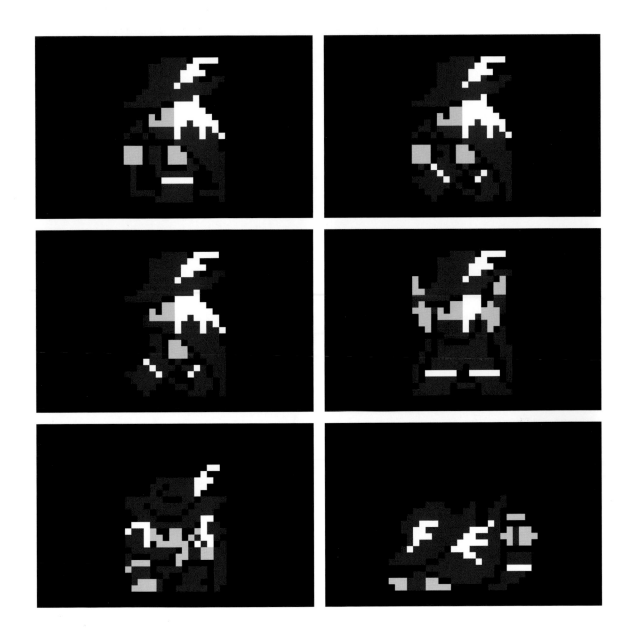

16 pixels

24 pixels

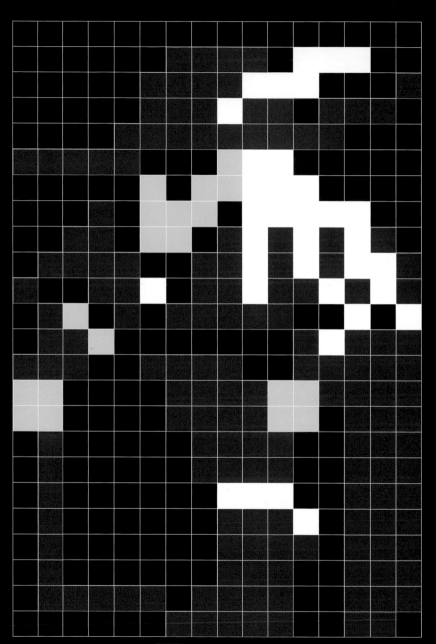

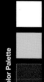

Color Palette

FINAL FANTASY: Battle Character Sprite `Original` [Red Wizard]
16 pixels × 24 pixels

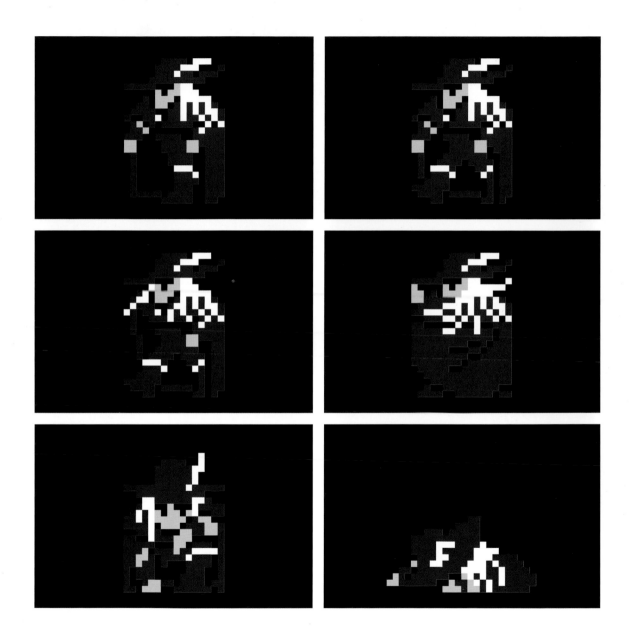

16 pixels

24 pixels

Color Palette

FINAL FANTASY: Battle Character Sprite Original [White Mage]
16 pixels × 24 pixels

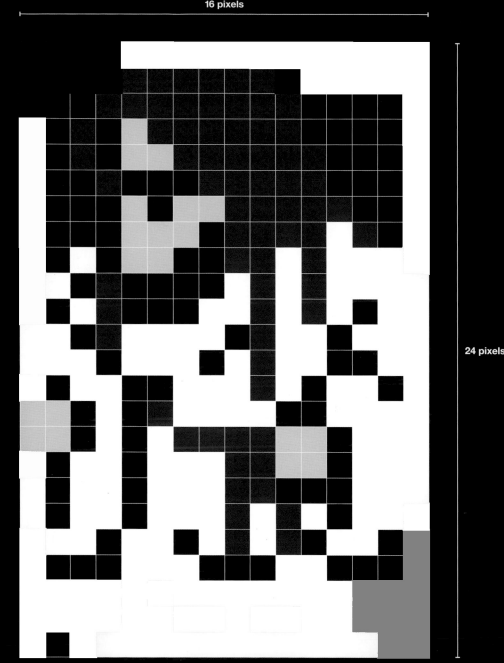

16 pixels

24 pixels

Color Palette

FINAL FANTASY: Battle Character Sprite Original [White Wizard]

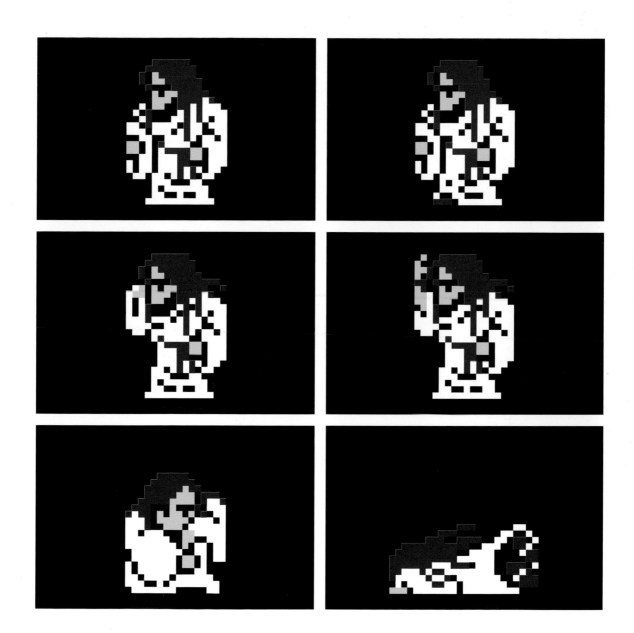

24 pixels

Color Palette

FINAL FANTASY: Battle Character Sprite Original [Black Mage]
16 pixels × 24 pixels

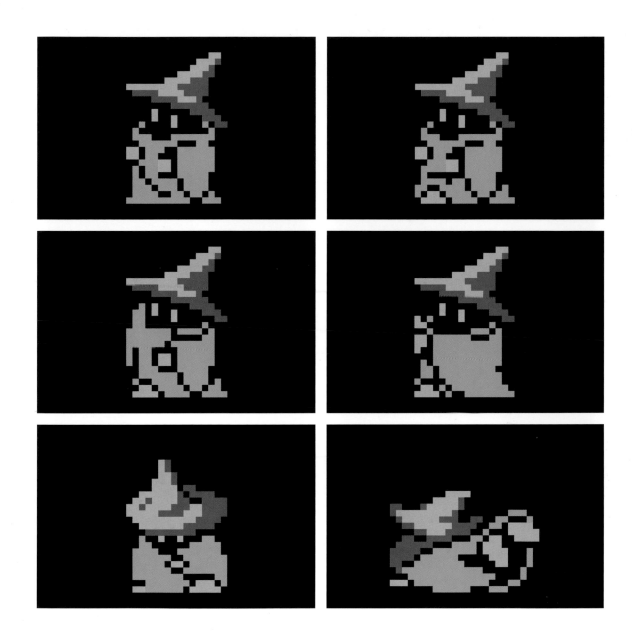

16 pixels

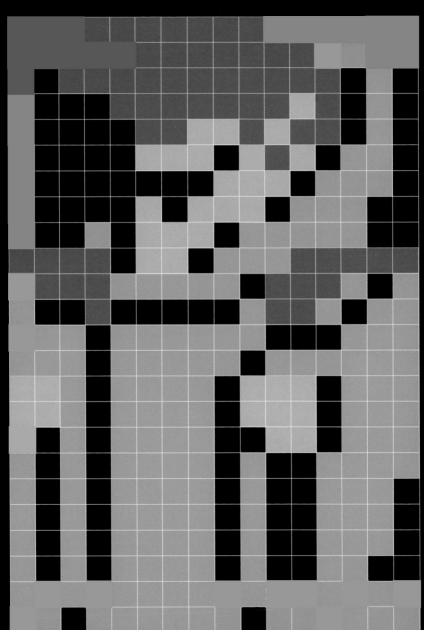

24 pixels

Color Palette

FINAL FANTASY: Battle Character Sprite Original [Black Wizard]
16 pixels × 24 pixels

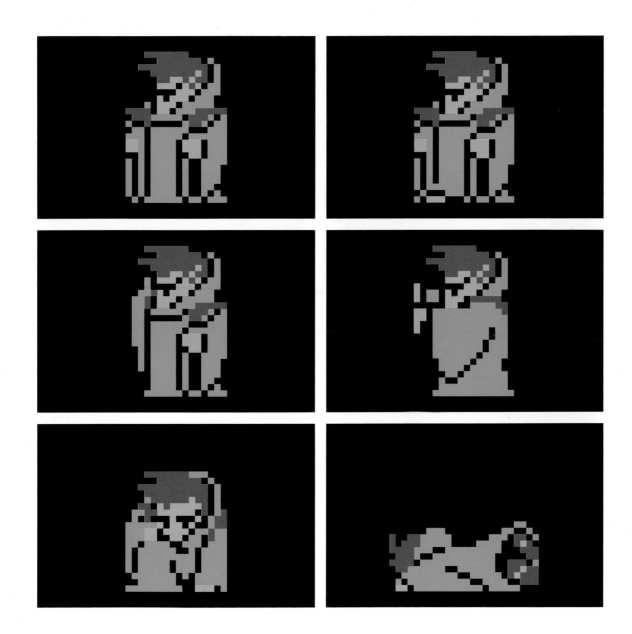

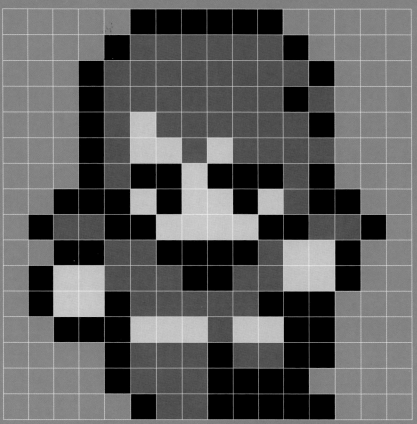

16 pixels

FINAL FANTASY: **World Character Sprite**
16 pixels × 16 pixels

Color Palette

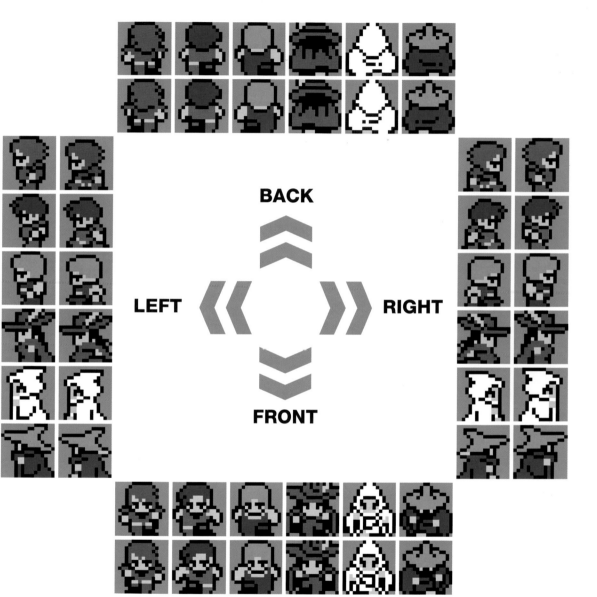

BACK

LEFT

RIGHT

FRONT

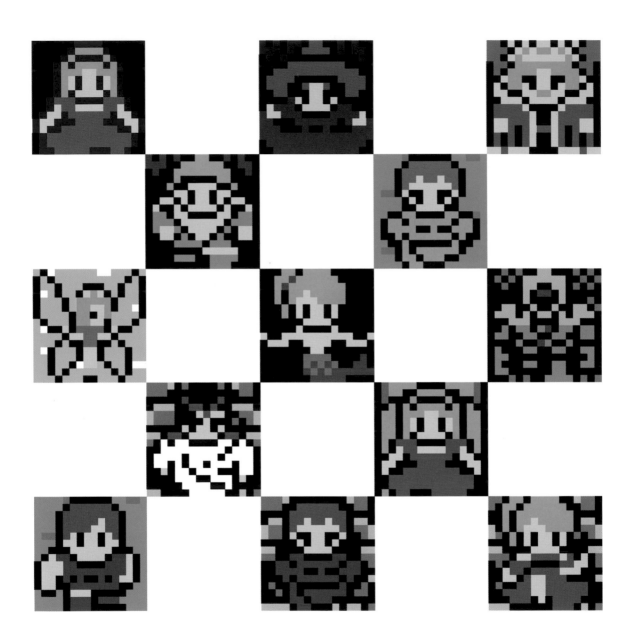

FINAL FANTASY: World Character Sprites

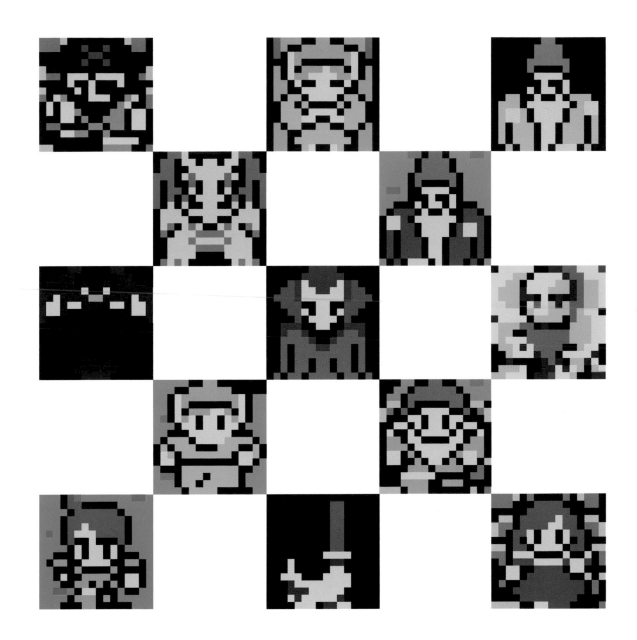

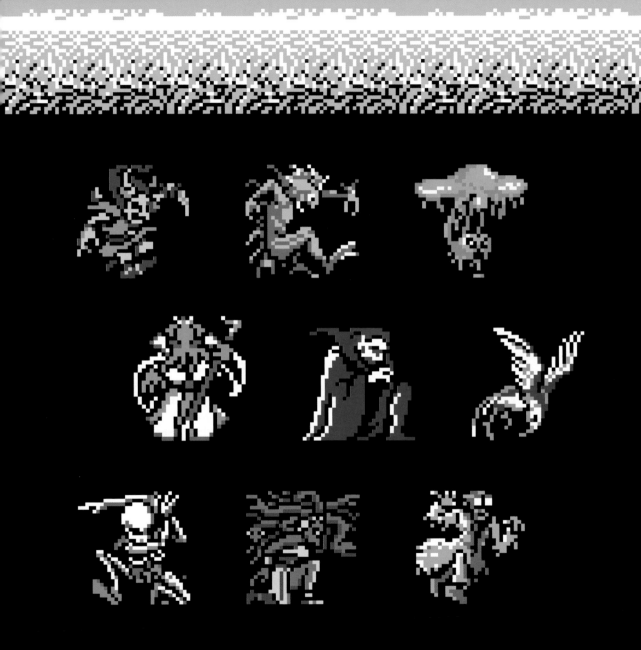

FINAL FANTASY: Enemies

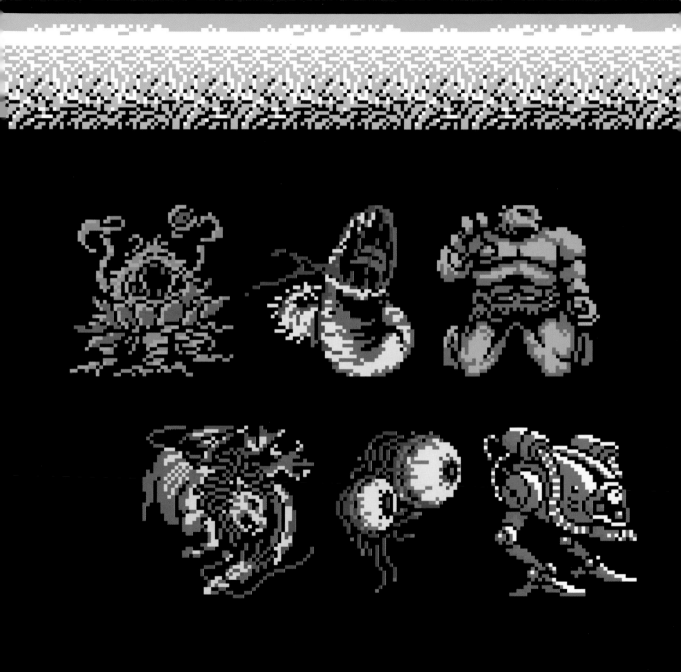

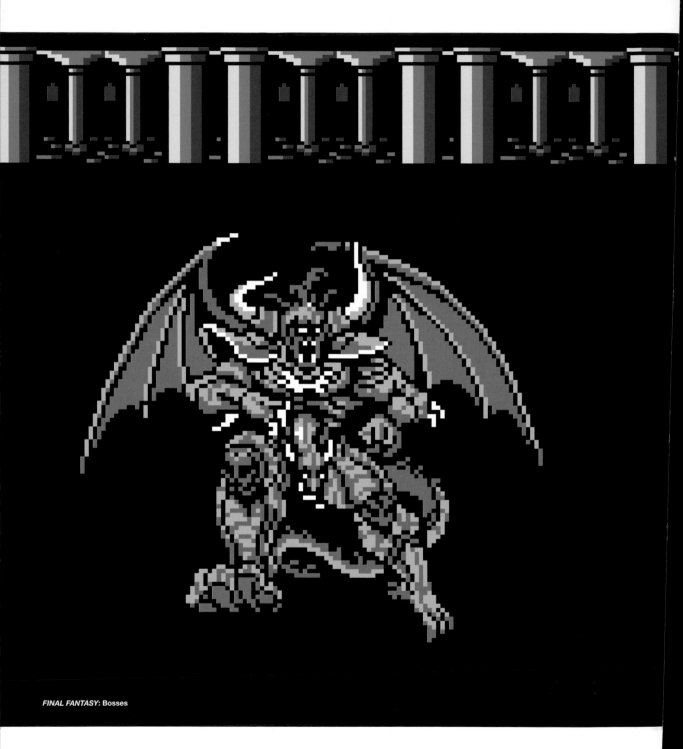

FINAL FANTASY: Bosses

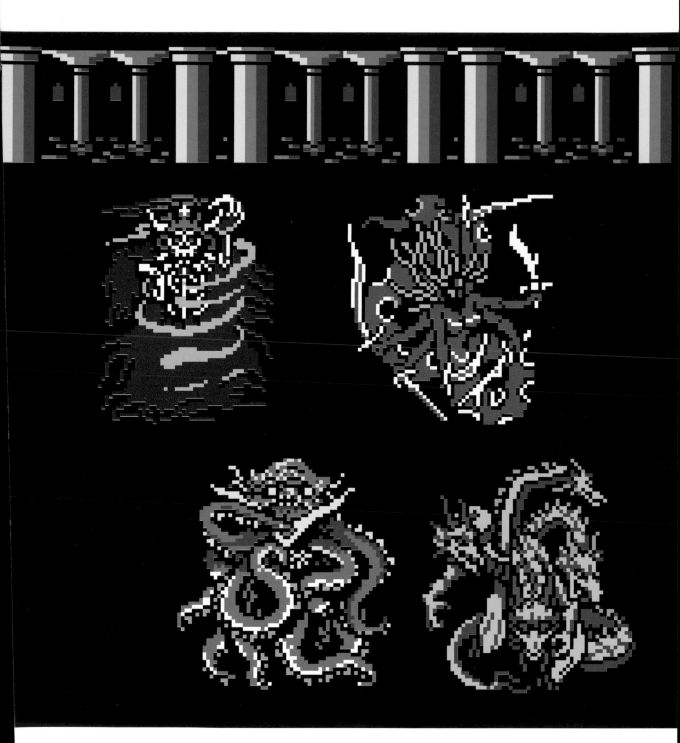

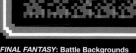

FINAL FANTASY: Battle Backgrounds

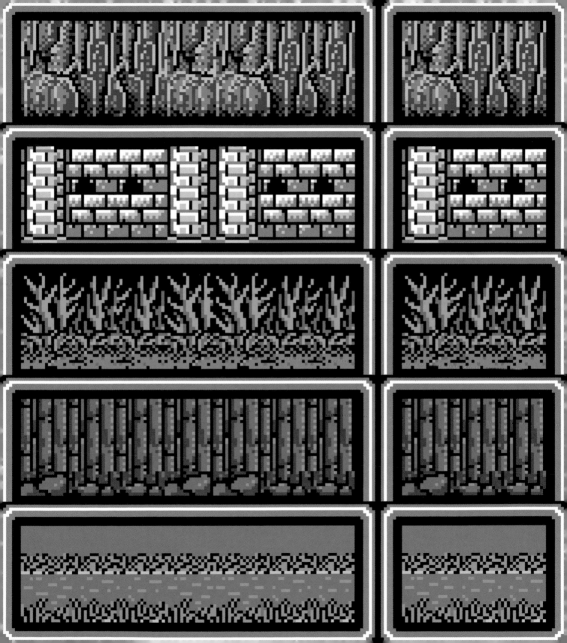

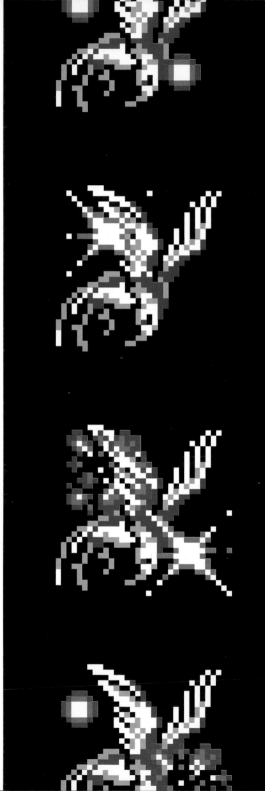
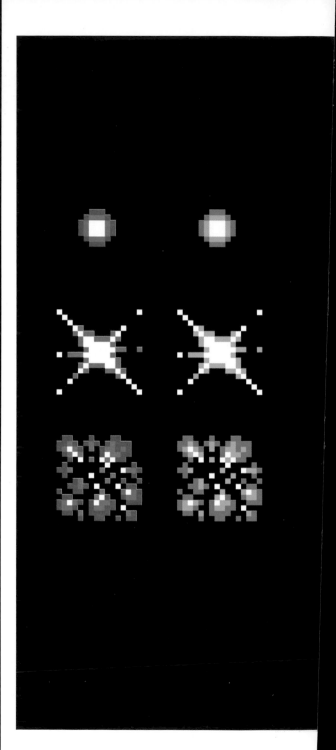

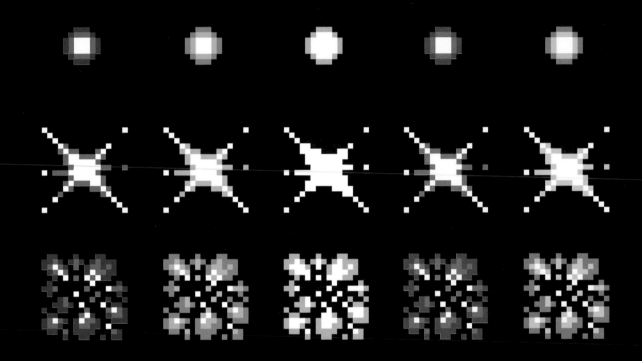

FINAL FANTASY: Battle Visual Effects

FINAL FANTASY

©1987
SQUARE

そして‥‥ たんきゅうのたびは
はじまった

4にんの わかものは ひかりの
せんしとして みずからに
あたえられた しめいのおおきさと
まちうける はらんのうんめいに
めまいさえ おぼえるのであった。

そのいみさえ しらず
4にんの わかものがもつ
4つのクリスタル‥‥
はるかむかし そのなかには
かがやきがやどっていたという。

さあ たびだつのだ
このせかいをおおう
あんこくを ふりはらい
へいわのひかりを ふたたび
このちに‥‥

And so their quest began.

As the four Warriors of Light,
they felt overwhelmed by
the great task destiny had
placed before them.

They did not even know the
true significance of the four
crystals they held in their hands . . .

The crystals that once,
long ago, held a light that
shone so brilliantly.

The time for their journey had come.

The time to cast off the veil of
darkness and bring the world
once more into light . . .

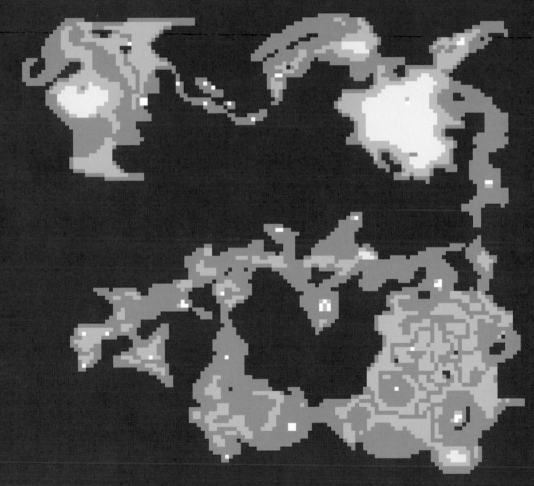

FINAL FANTASY: World Map & Emblem

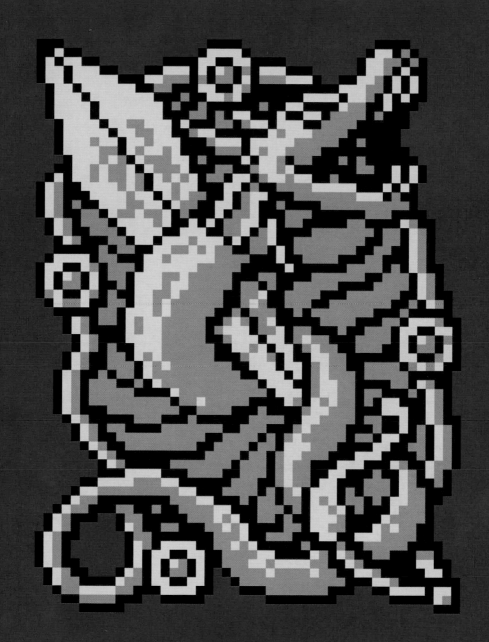

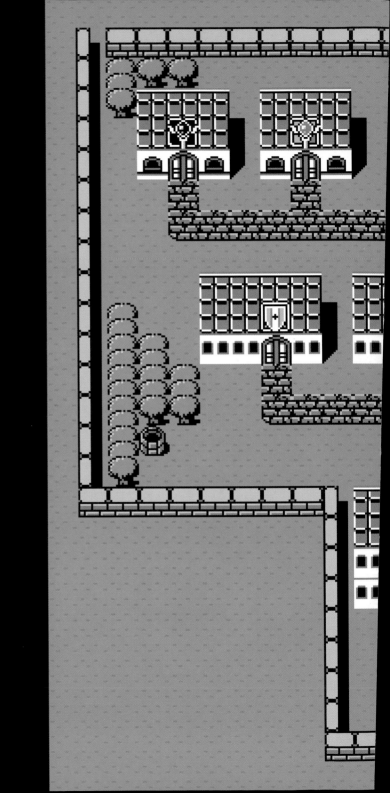

Map Tile Palette (16 pixels × 16 pixels)

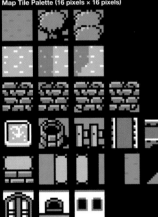

Color Palette

FINAL FANTASY: Town [Cornelia]
34 tiles × 26 tiles

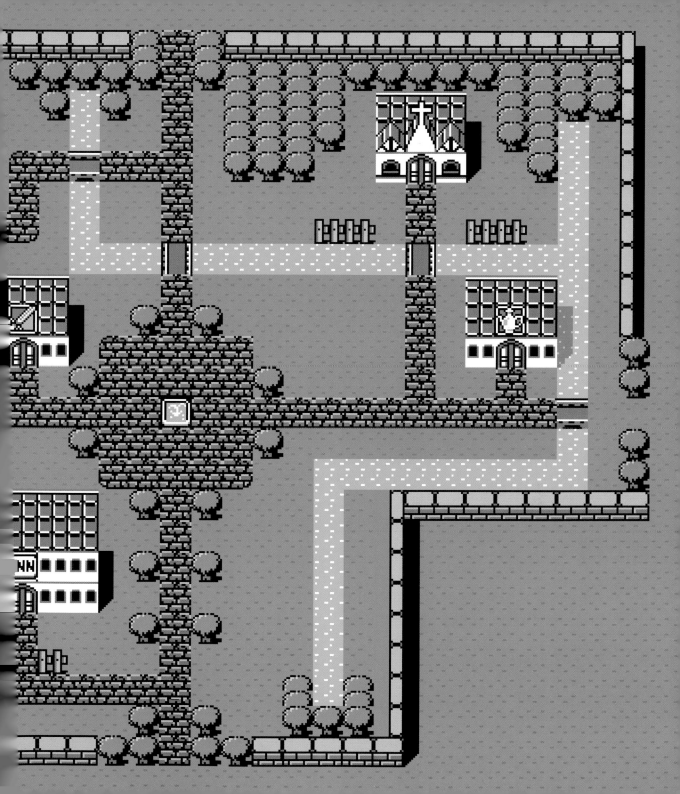

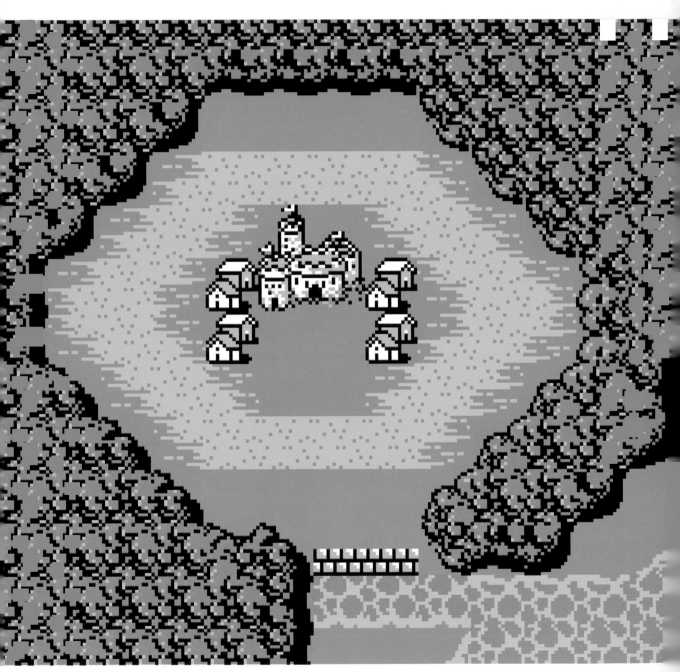

FINAL FANTASY: World Locations [Elven Castle & Town]

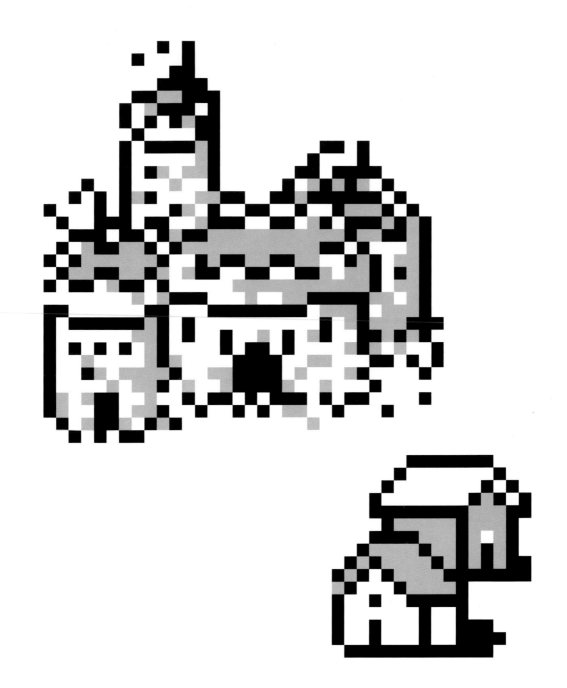

16 pixels

16 pixels

16 pixels

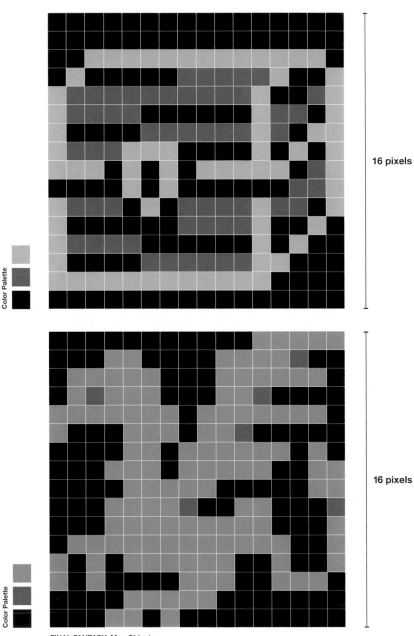

Color Palette

Color Palette

FINAL FANTASY: Map Objects
16 pixels × 16 pixels

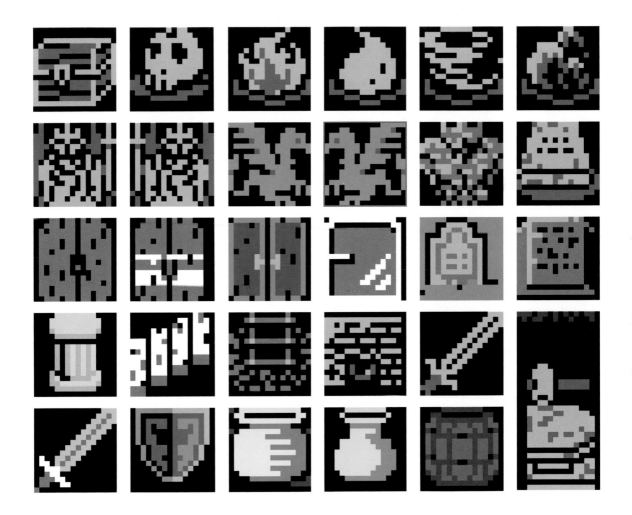

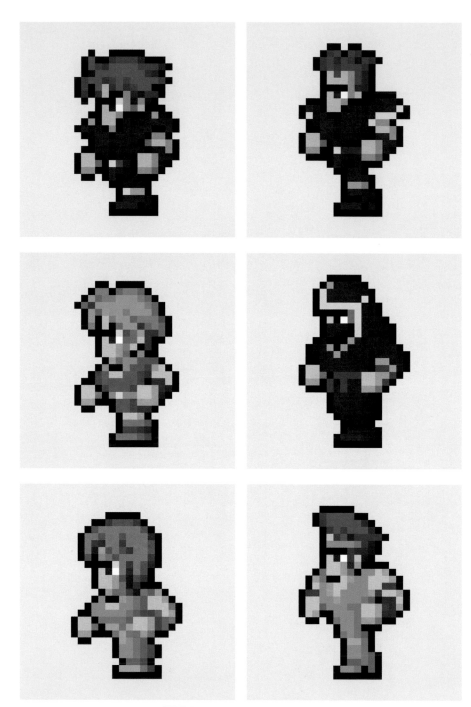

FINAL FANTASY: Battle Character Sprites 2018 Ver. [Warrior／Knight／Thief／Ninja／Monk／Super Monk (Master)]

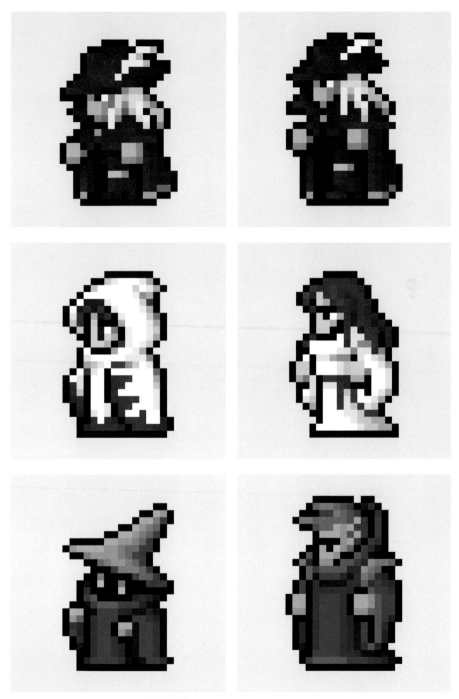

FINAL FANTASY: Battle Character Sprites `2018 Ver.` [Red Mage / Red Wizard / White Mage / White Wizard / Black Mage / Black Wizard]

I

II

Cursor

III

IV

V

VI

054

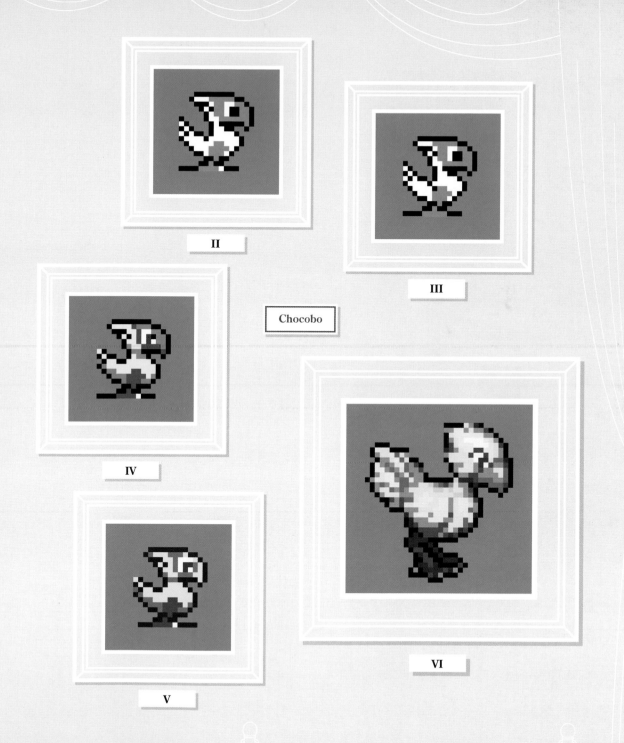

II

III

Chocobo

IV

V

VI

24 pixels

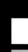

FINAL FANTASY II: Battle Character Sprite Original [Standing]

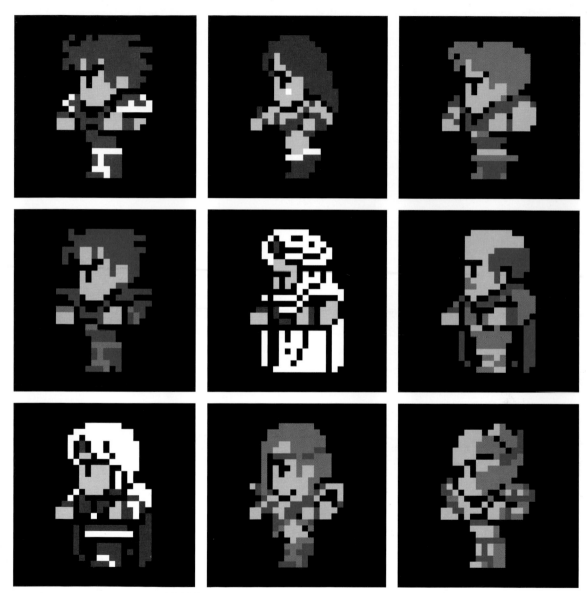

FINAL FANTASY II: Battle Character Sprites `Original` [Standing] Frioniel (Firion) / Maria / Guy / Leonhart (Leon) / Minwu / Josef / Gordon / Leila / Ricard

Color Palette

24 pixels

FINAL FANTASY II: Battle Character Sprite Original [Walking]
16 pixels × 24 pixels

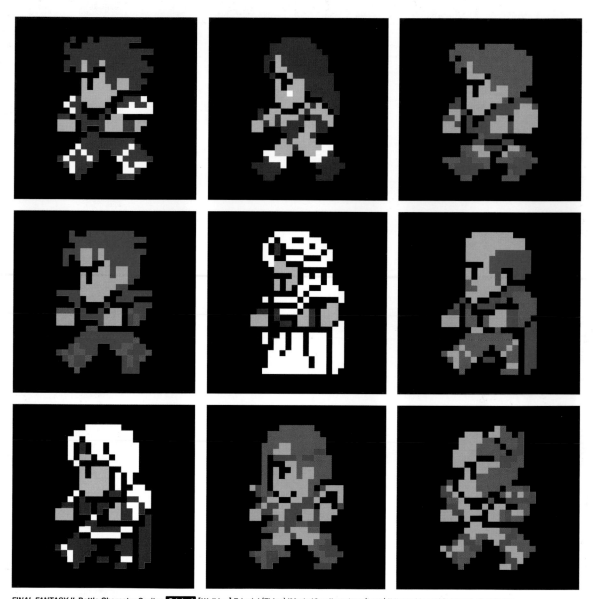

FINAL FANTASY II: Battle Character Sprites Original [Walking] Frioniel (Firion) / Maria / Guy / Leonhart (Leon) / Minwu / Josef / Gordon / Leila / Ricard

24 pixels

Color Palette

FINAL FANTASY II: Battle Character Sprite [Original] [Victory]

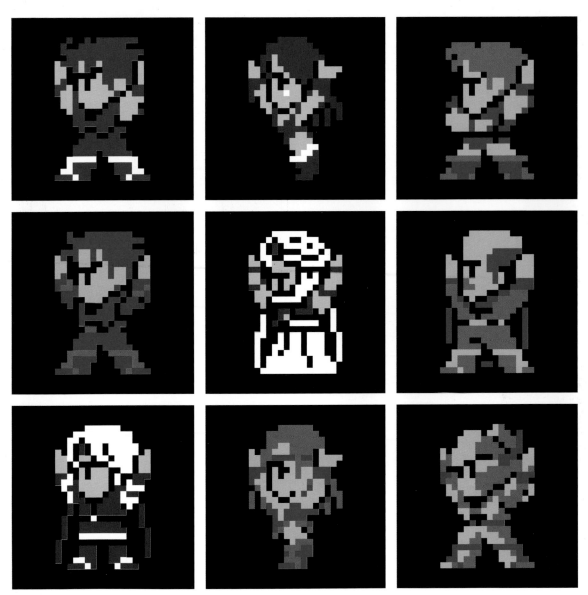

FINAL FANTASY II: Battle Character Sprites [Original] [Victory] Frioniel (Firion)/Maria/Guy/Leonhart (Leon)/Minwu/Josef/Gordon/Leila/Ricard

16 pixels

24 pixels

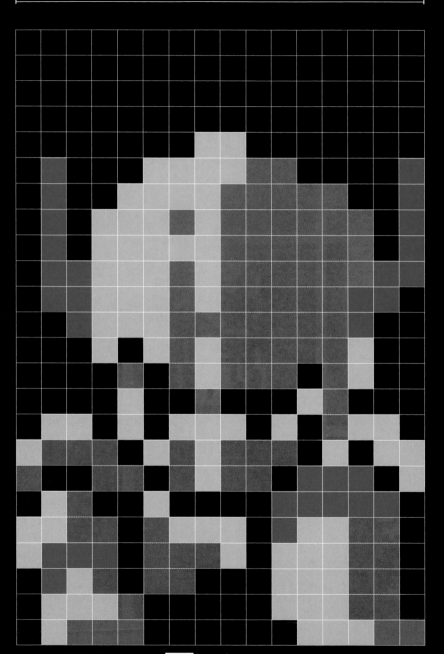

FINAL FANTASY II: Battle Character Sprite Original [Low HP]
16 pixels × 24 pixels

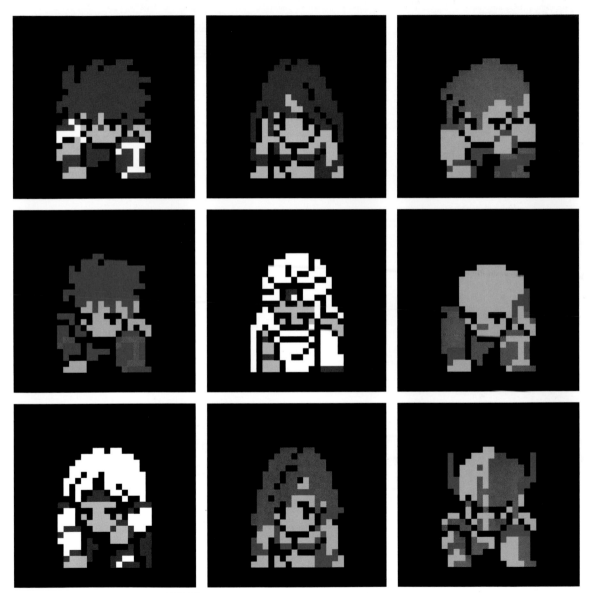

FINAL FANTASY II: Battle Character Sprites `Original` [Low HP] Frioniel (Firion)/Maria/Guy/Leonhart (Leon)/Minwu/Josef/Gordon/Leila/Ricard

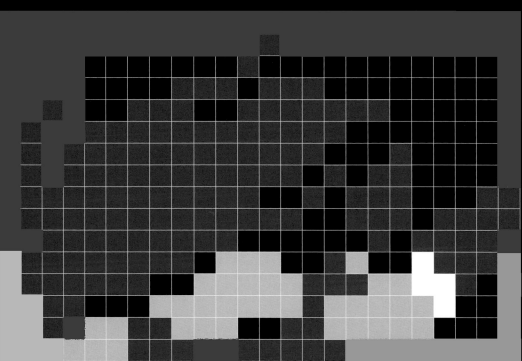

FINAL FANTASY II: Battle Character Sprite `Original` [Defeat]
24 pixels × 16 pixels

Color Palette

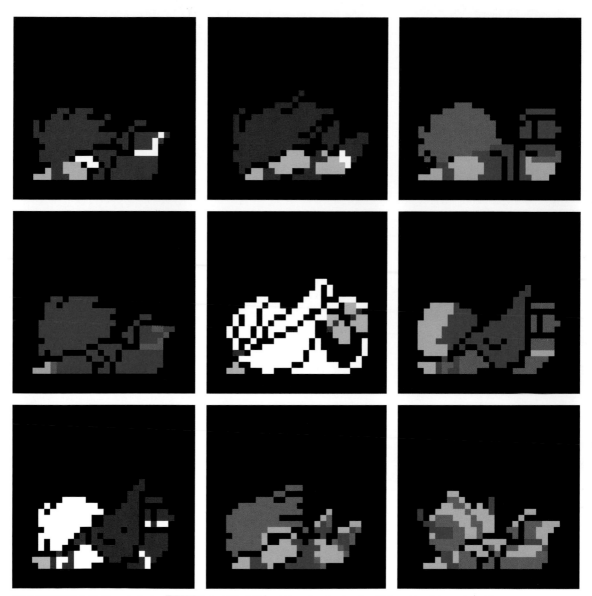

FINAL FANTASY II: Battle Character Sprites Original [Defeat] Frioniel (Firion)／Maria／Guy／Leonhart (Leon)／Minwu／Josef／Gordon／Leila／Ricard

16 pixels

24 pixels

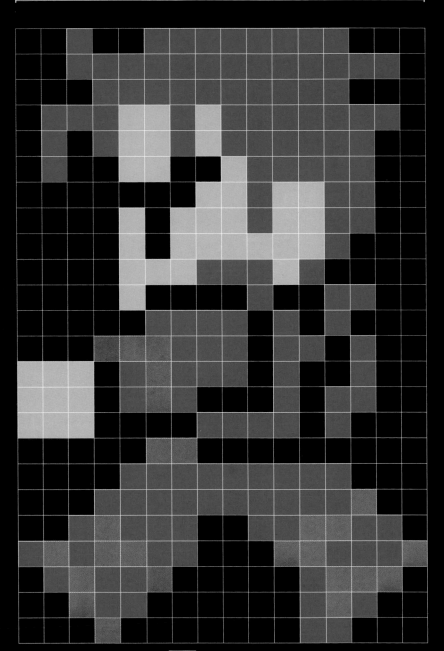

FINAL FANTASY II: Battle Character Sprite Original [Attack]
16 pixels × 24 pixels

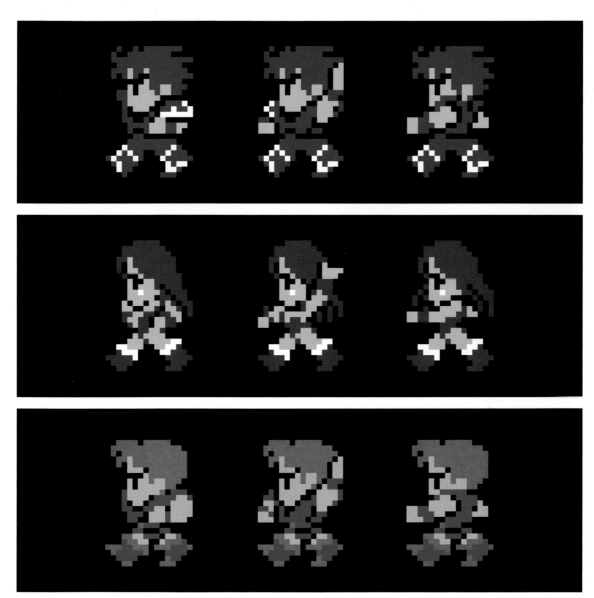

FINAL FANTASY II: Battle Character Sprites Original [Attack] Frioniel (Firion) / Maria / Guy

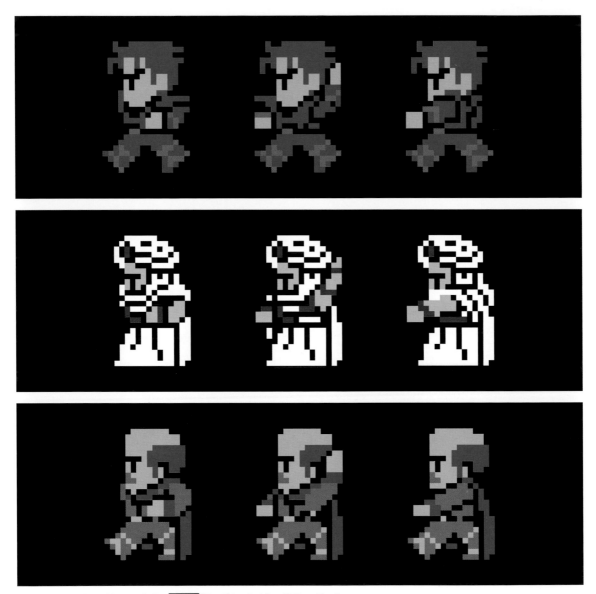

FINAL FANTASY II: Battle Character Sprites `Original` [Attack] Leonhart (Leon)/Minwu/Josef

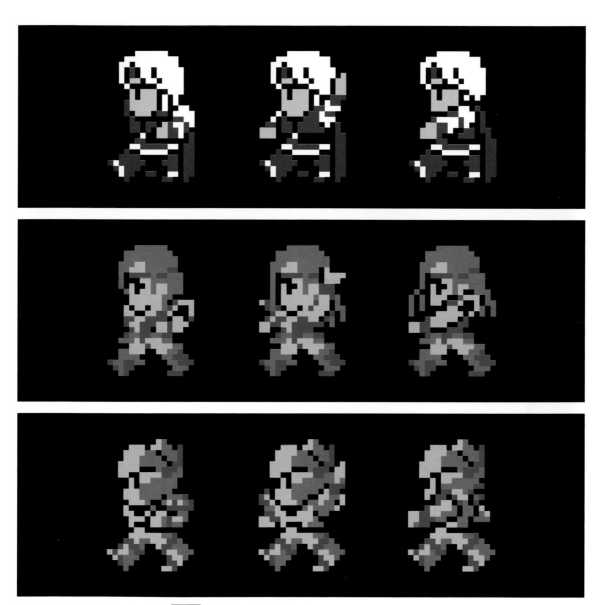

FINAL FANTASY II: Battle Character Sprites Original [Attack] Gordon / Leila / Ricard

16 pixels

16 pixels

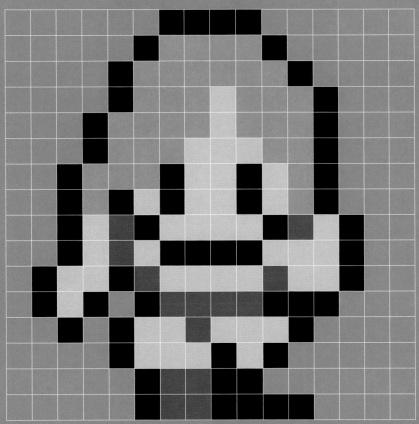

FINAL FANTASY II: World Character Sprite
16 pixels × 16 pixels

FINAL FANTASY II: World Character Sprites [Frioniel (Firion) / Maria / Guy / Leonhart (Leon) / Minwu / Josef / Gordon / Leila / Ricard]

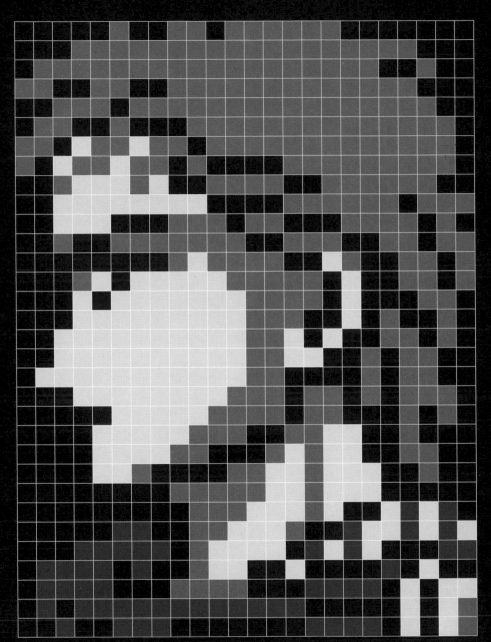

Color Palette

FINAL FANTASY II: Character Portrait
24 pixels × 32 pixels

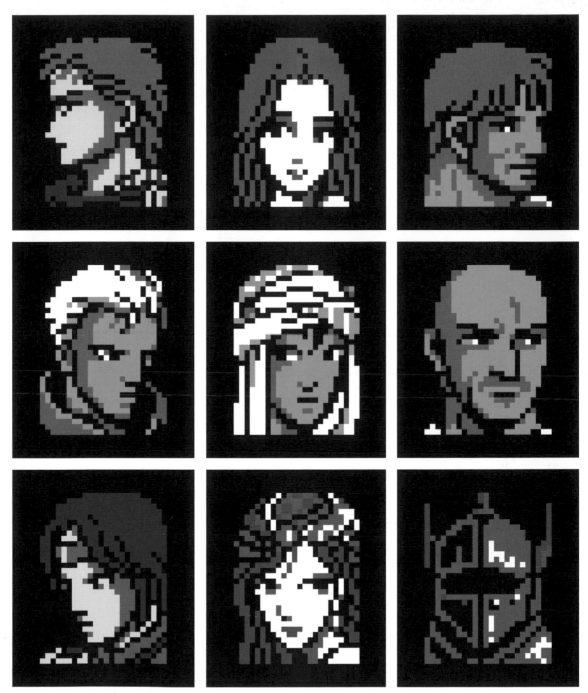

FINAL FANTASY II: Character Portraits [Frioniel (Firion) / Maria / Guy / Leonhart (Leon) / Minwu / Josef / Gordon / Leila / Ricard]

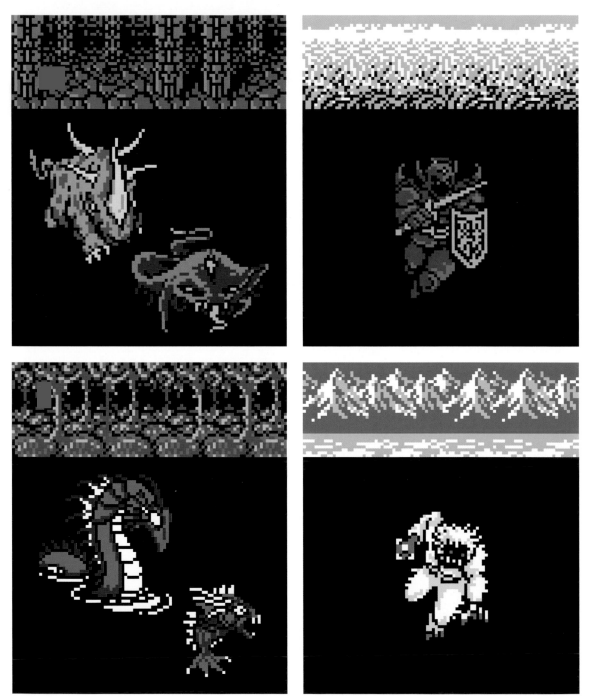

FINAL FANTASY II: Enemies #001

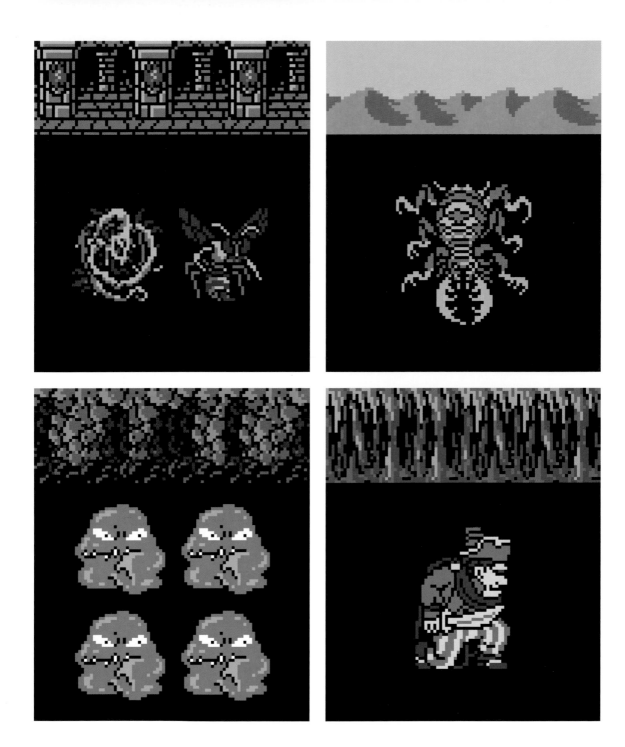

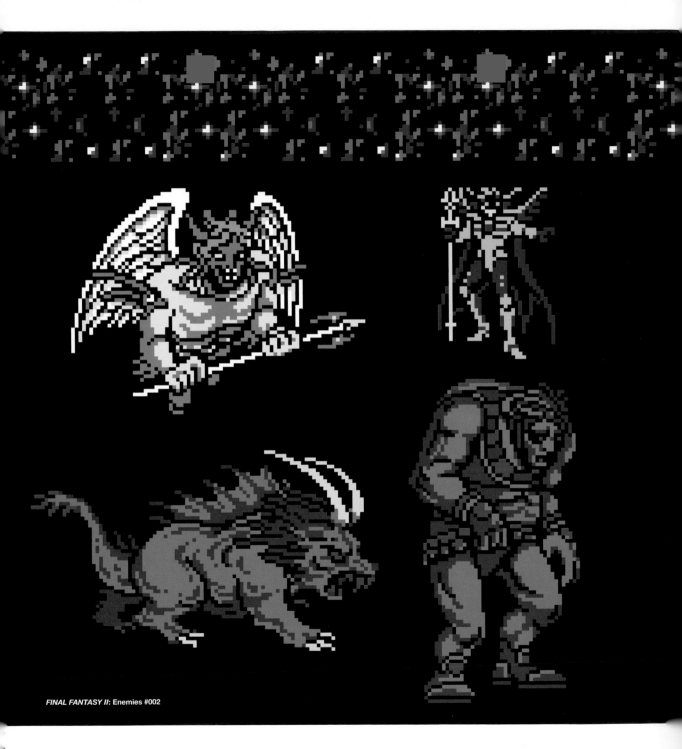

FINAL FANTASY II: Enemies #002

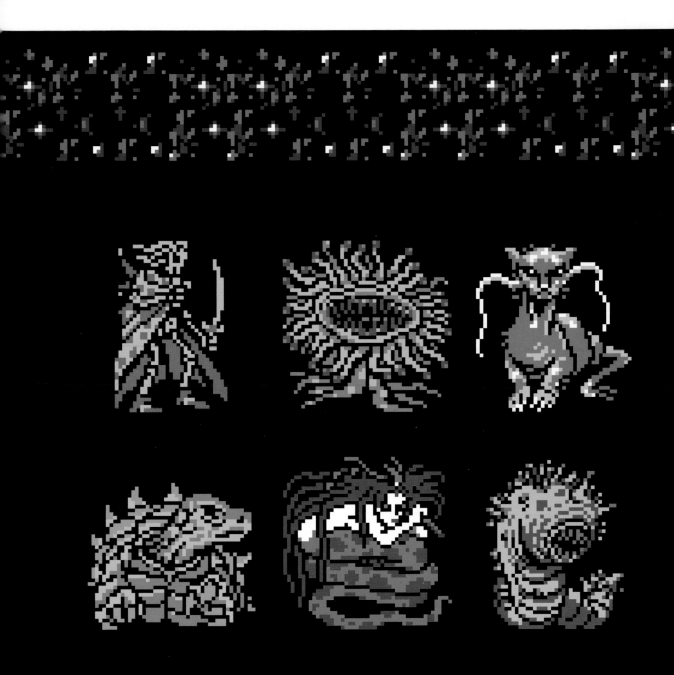

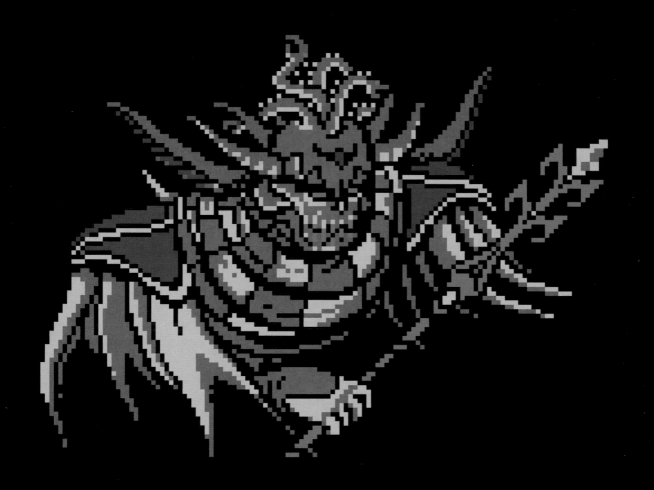

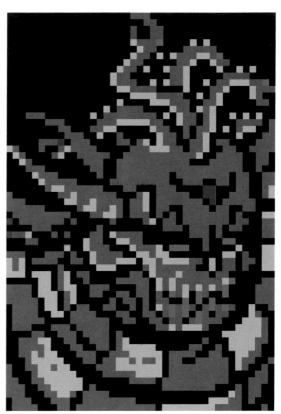

FINAL FANTASY II: The Emperor

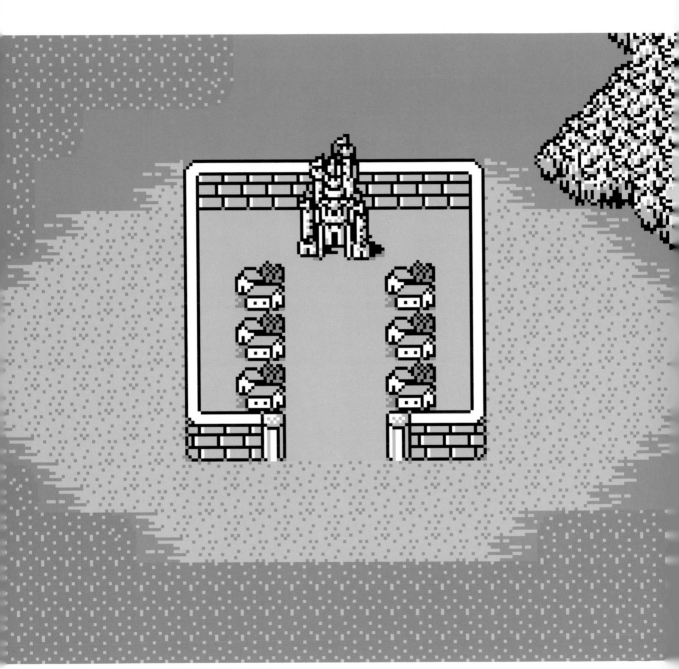

FINAL FANTASY II: World Locations [Castle Fynn & Town of Fynn]

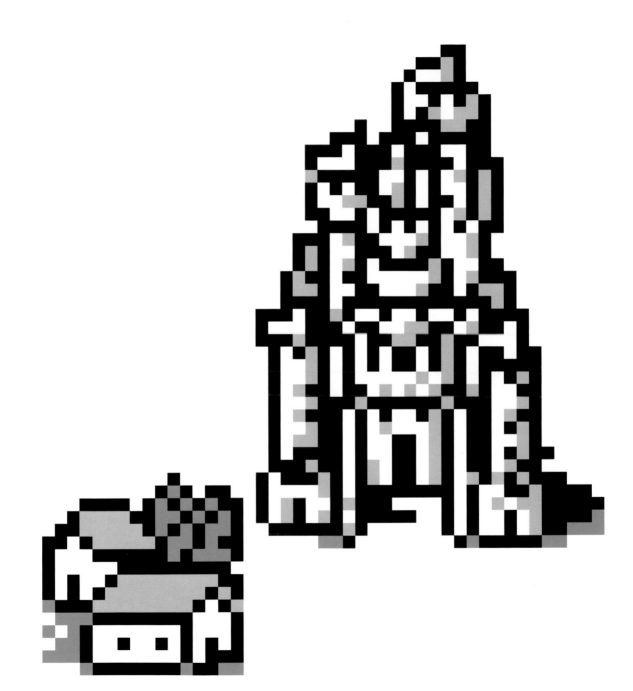

FINAL FANTASY II: World Locations [Mysidian Tower / Castle Palamecia]

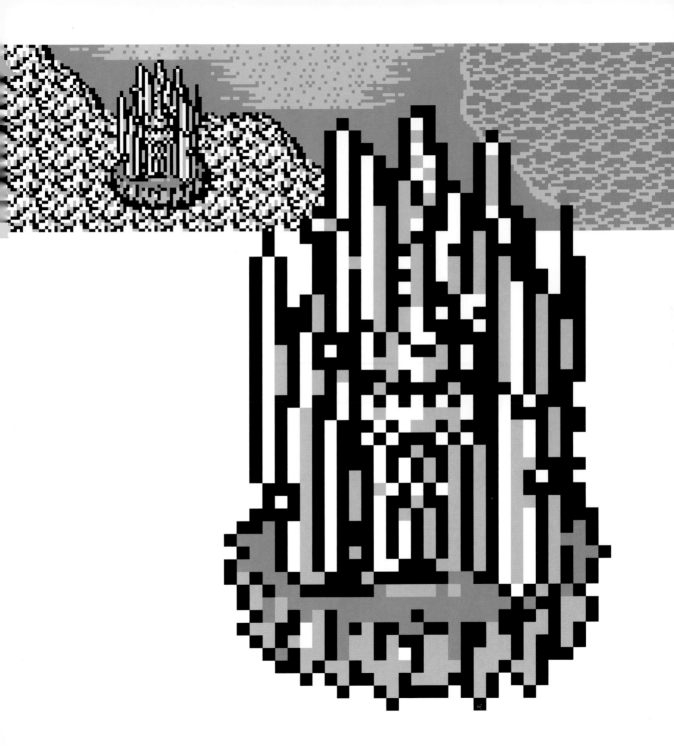

Map Tile Palette (16 pixels × 16 pixels)

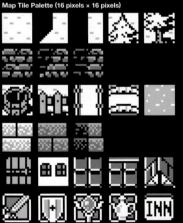

Color Palette

FINAL FANTASY II: Town [Salamand]
32 tiles × 30 tiles

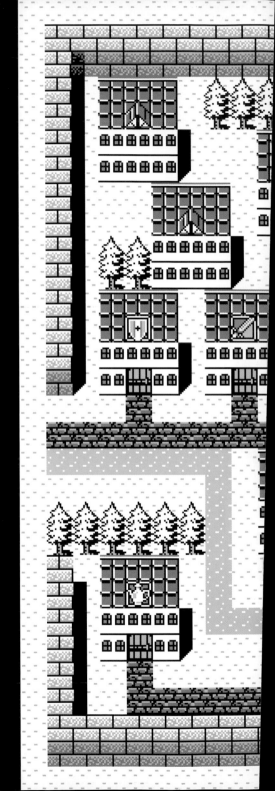

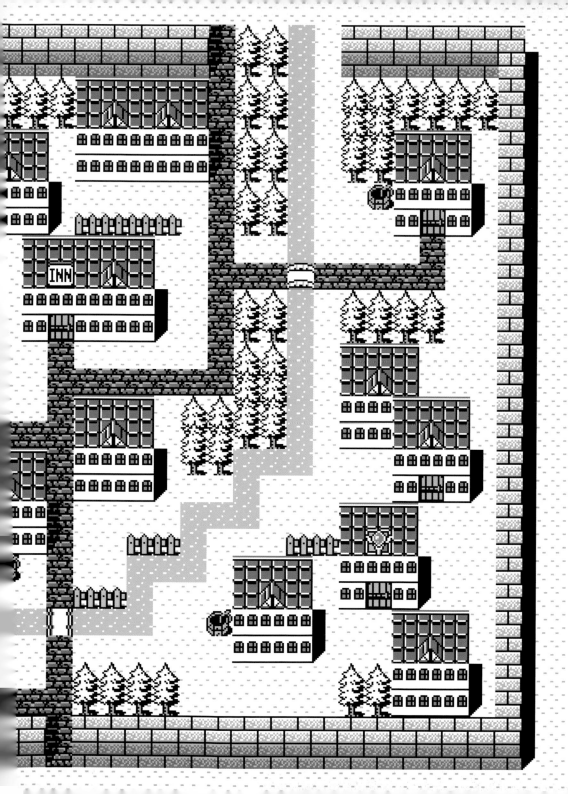

16 pixels

16 pixels

FINAL FANTASY II: Map Objects #001
16 pixels × 16 pixels

Color Palette

16 pixels

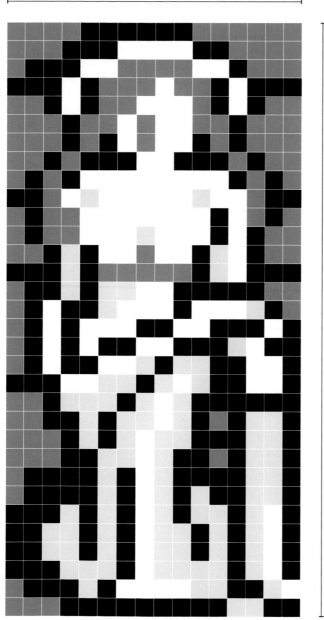

32 pixels

FINAL FANTASY II: Map Objects #002
16 pixels × 32 pixels

Color Palette

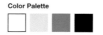

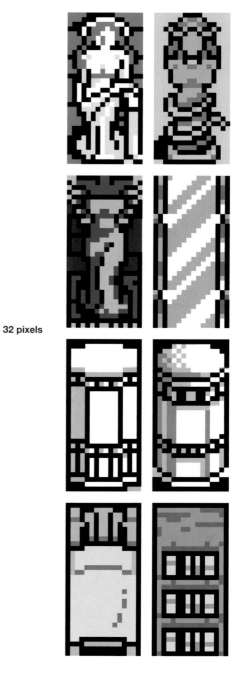

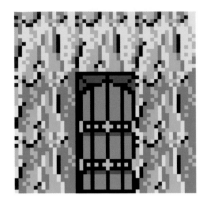

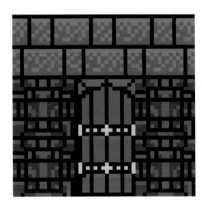
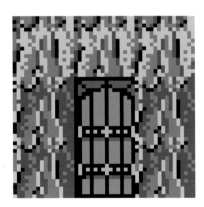

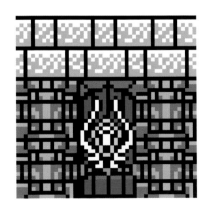
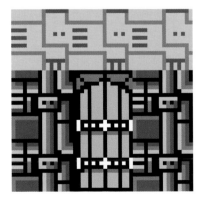

FINAL FANTASY II: Doors & Walls

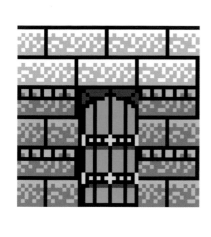

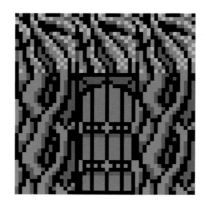

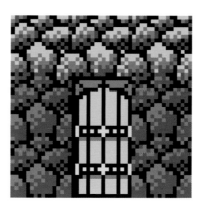

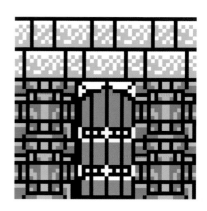

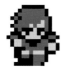

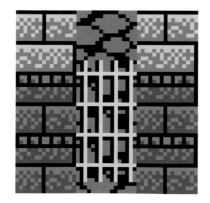

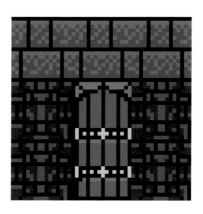

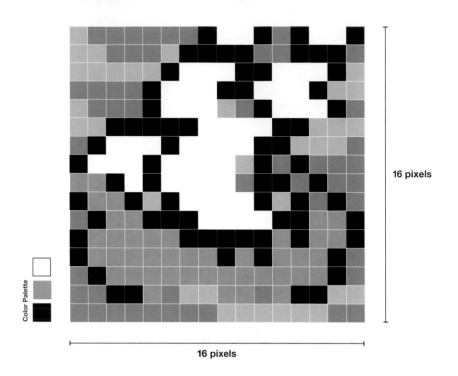

16 pixels

16 pixels

Color Palette

16 pixels

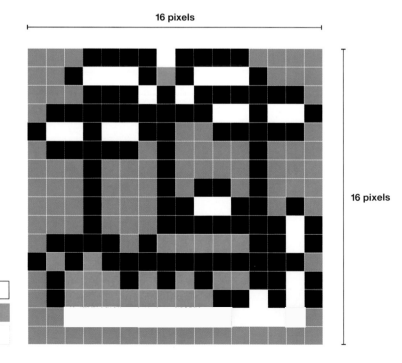

16 pixels

Color Palette

FINAL FANTASY II: Ship Sprites
16 pixels × 16 pixels

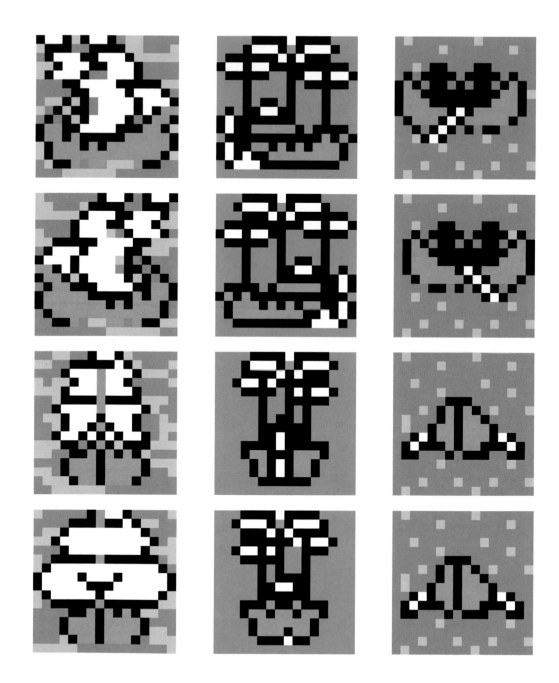

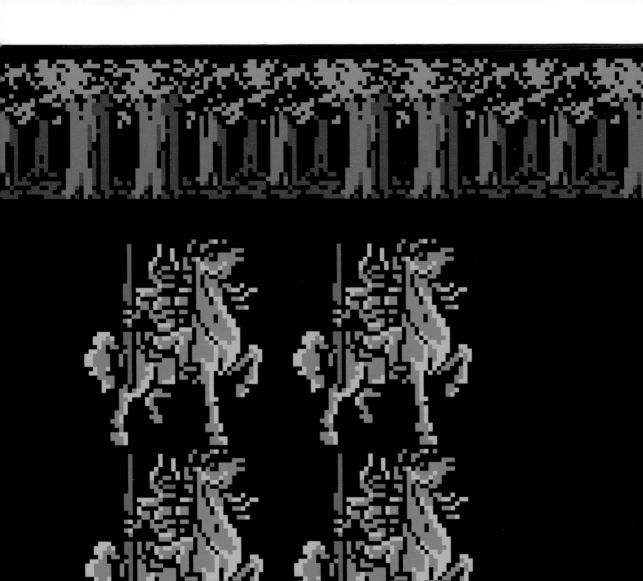

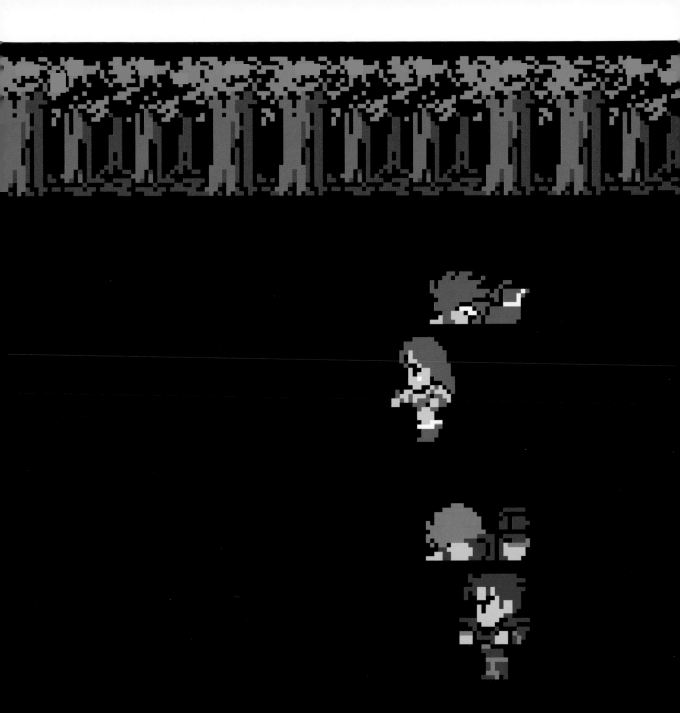

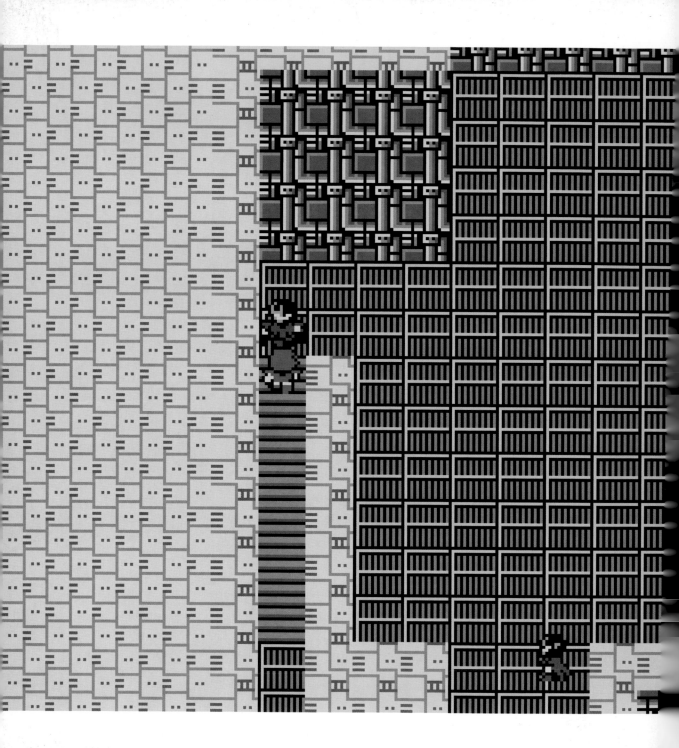

めがみのベル　　　たいようのほのお

ひくうせん　　　　だいせんかん

ミスリル　　　■のばら

Rebels! Meet your fates!

Goddess's Bell	Sunfire
Airship	Dreadnought
Mythril	▶ Wild Rose

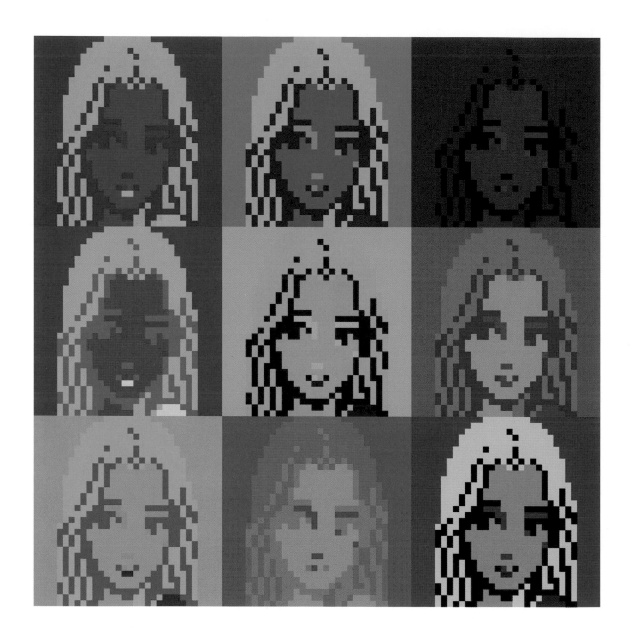

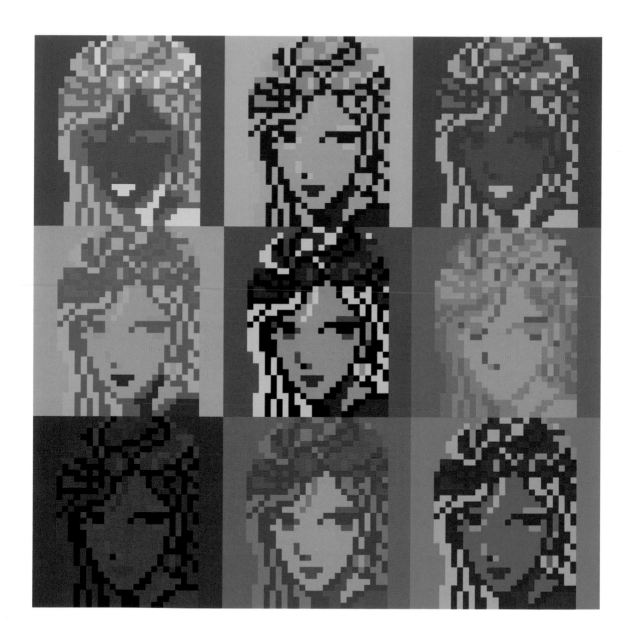

097

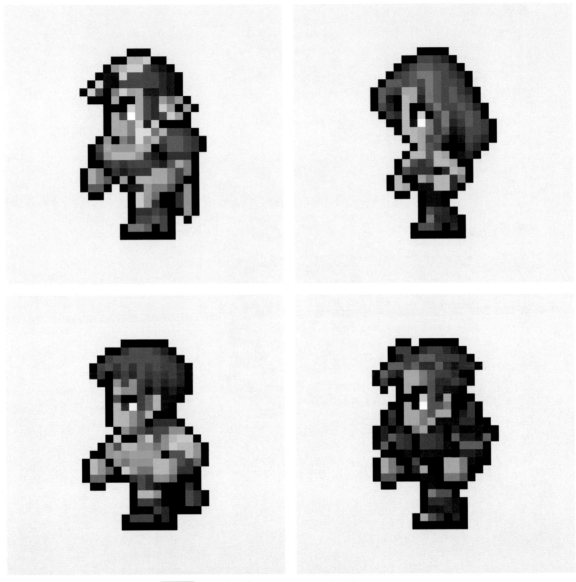

FINAL FANTASY II: Battle Character Sprites `2018 Ver.` [Frioniel (Firion)/Maria/Guy/Leonhart (Leon)]

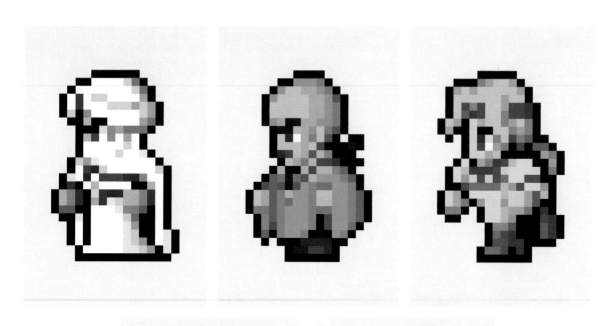

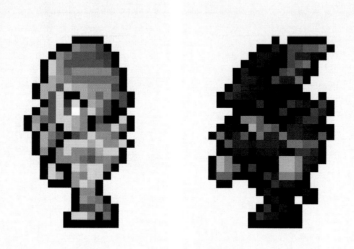

FINAL FANTASY II: Battle Character Sprites `2018 Ver.` [Minwu/Josef/Gordon/Leila/Ricard]

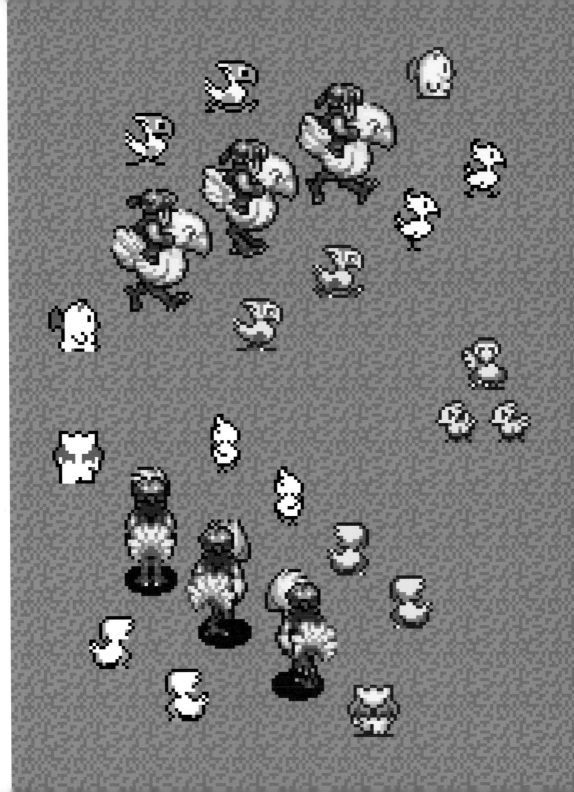

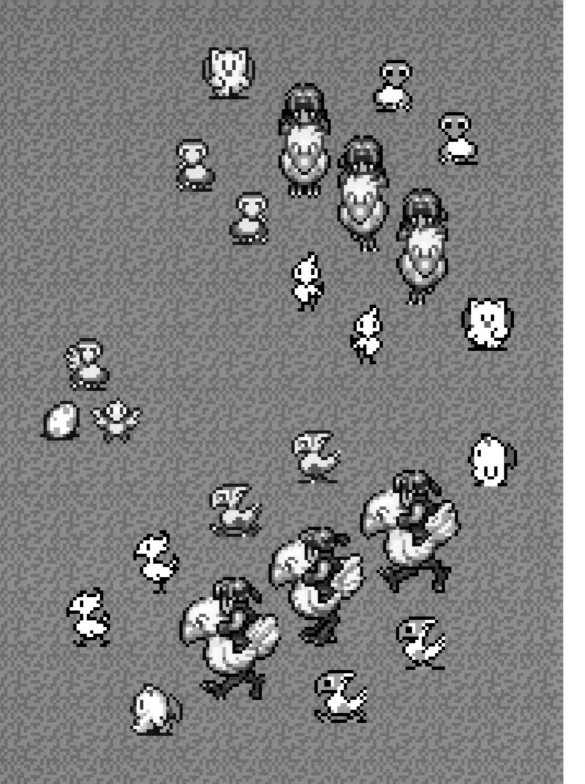

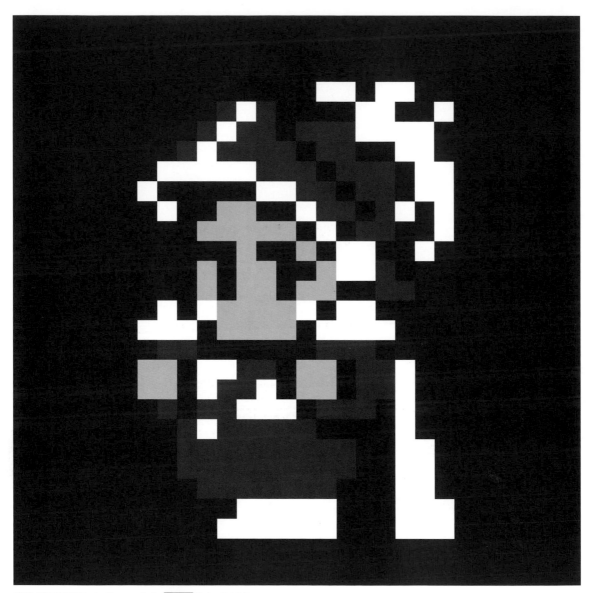

FINAL FANTASY III: Battle Character Sprite `Original` [Onion Knight]

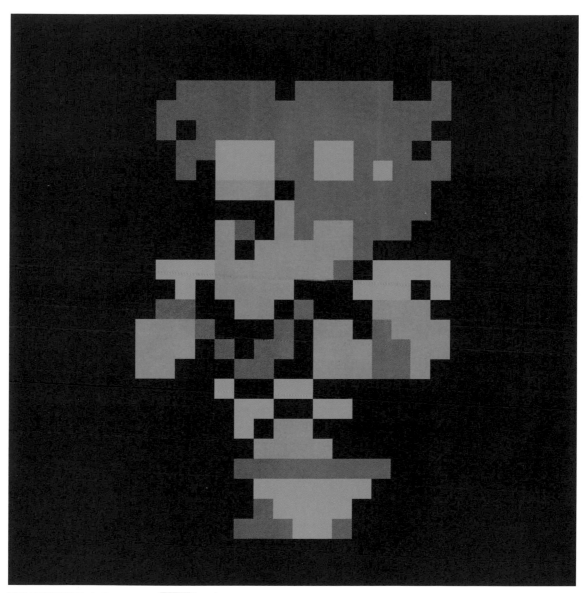

FINAL FANTASY III: Battle Character Sprite Original [Monk]

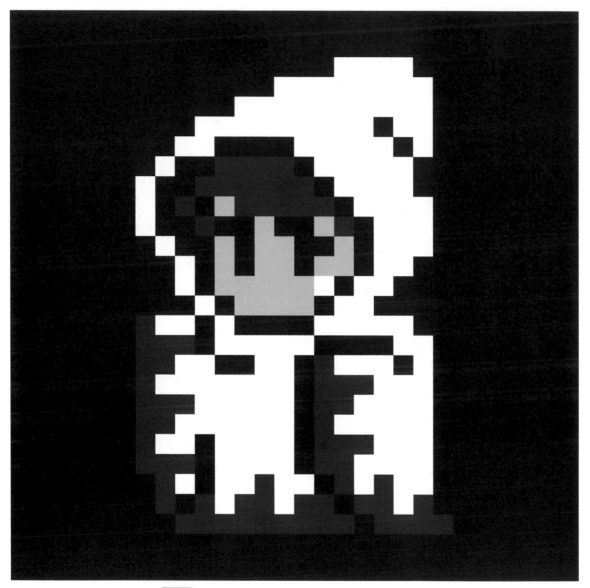

FINAL FANTASY III: Battle Character Sprite **Original** [White Mage]

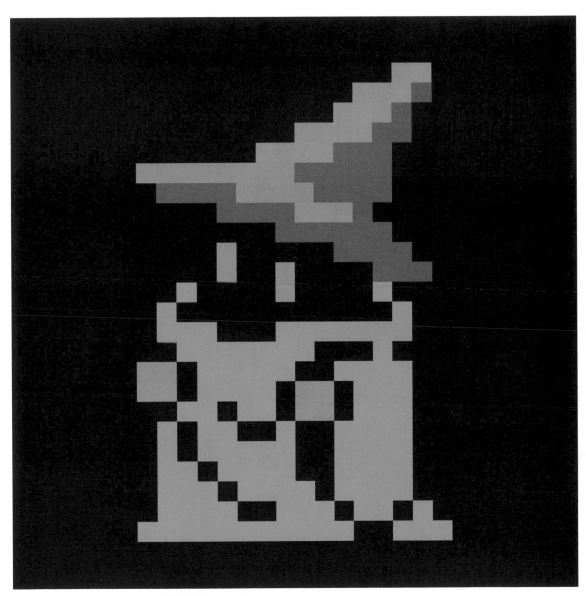

FINAL FANTASY III: Battle Character Sprite **Original** [Black Mage]

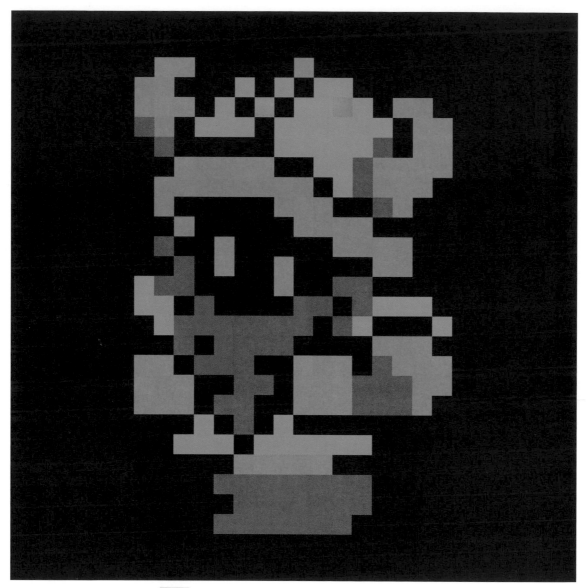

FINAL FANTASY III: Battle Character Sprite `Original` [Viking]

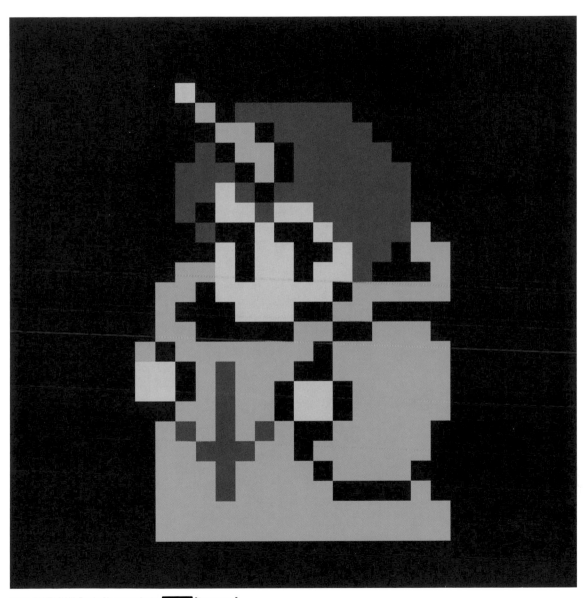

FINAL FANTASY III: Battle Character Sprite Original [Summoner]

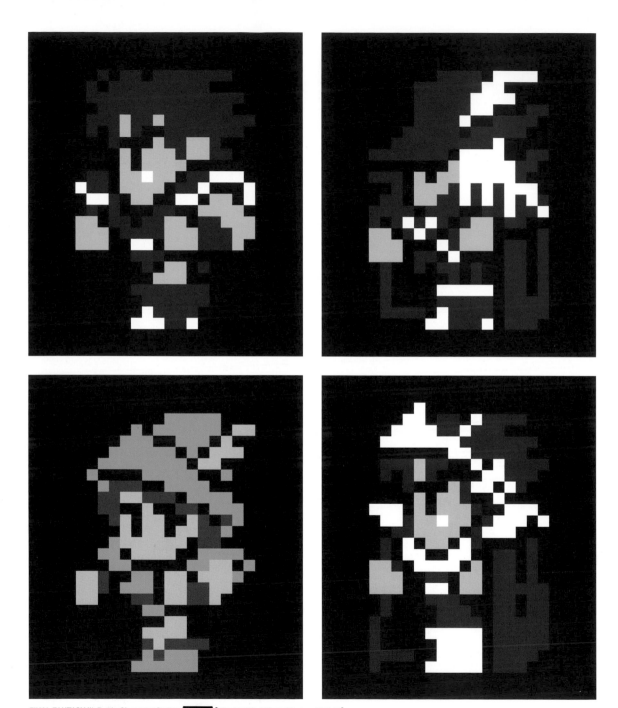

FINAL FANTASY III: Battle Character Sprites `Original` [Warrior／Red Mage／Ranger／Knight]

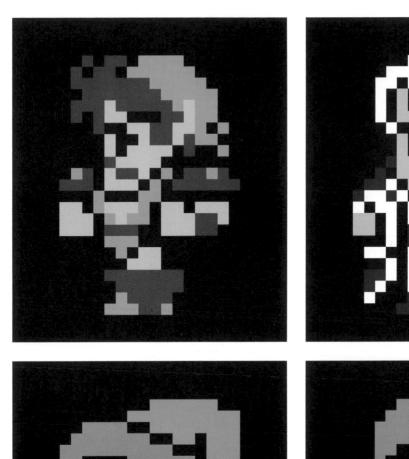

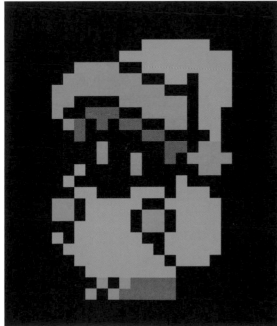

FINAL FANTASY III: Battle Character Sprites Original [Thief/Scholar/Geomancer/Dragoon]

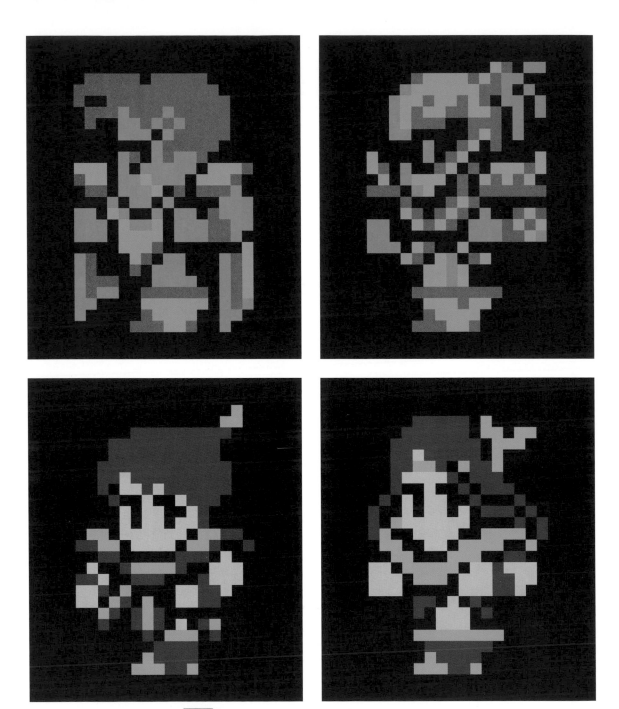

FINAL FANTASY III: Battle Character Sprites Original [Black Belt / Dark Knight / Evoker / Bard]

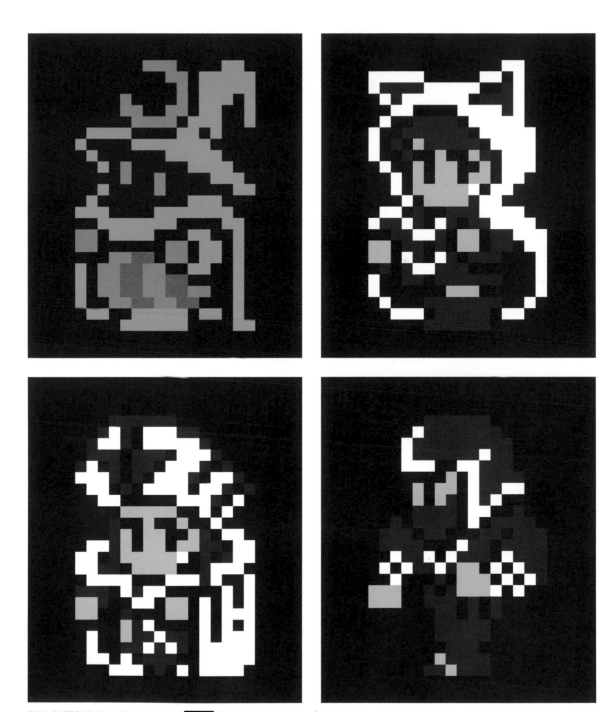

FINAL FANTASY III: Battle Character Sprites Original [Magus / Devout / Sage / Ninja]

16 pixels

24 pixels

Color Palette

FINAL FANTASY III: **Battle Character Sprite** Original **[Walking]**
16 pixels × 24 pixels

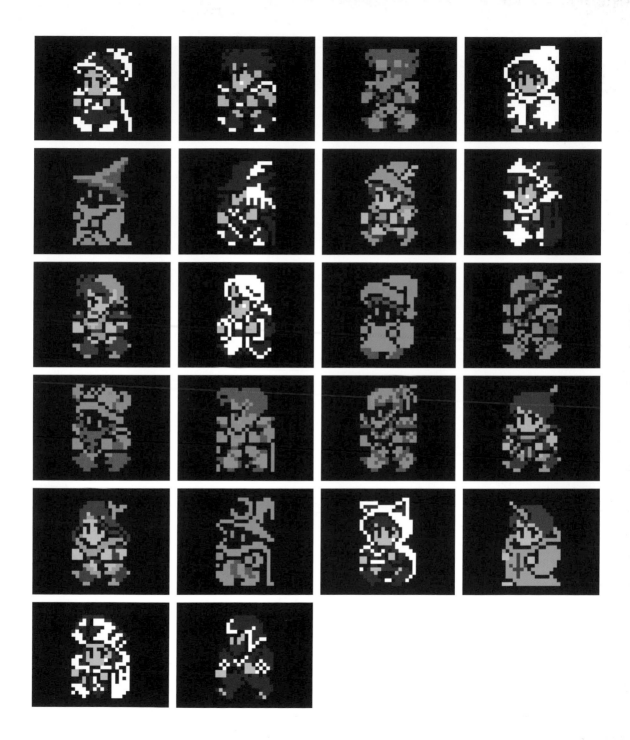

16 pixels

24 pixels

Color Palette

FINAL FANTASY III: Battle Character Sprite Original [Victory]
16 pixels × 24 pixels

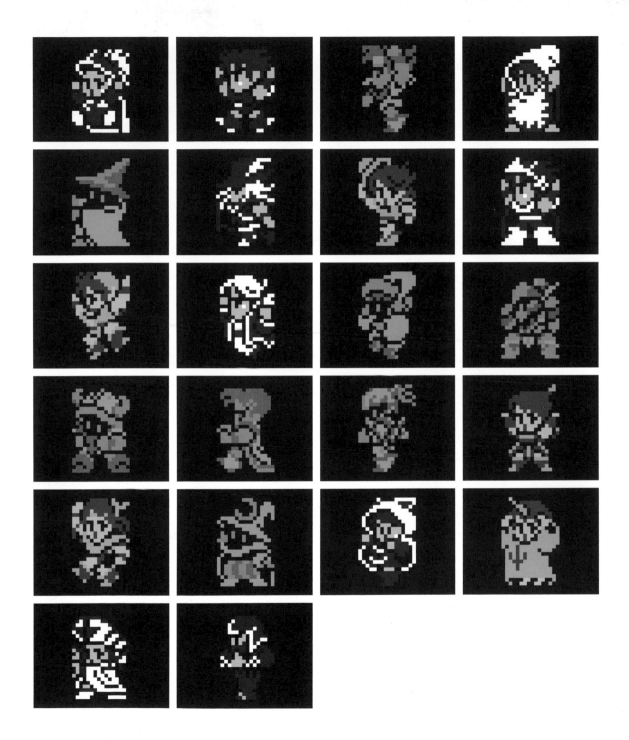

16 pixels

24 pixels

Color Palette

FINAL FANTASY III: Battle Character Sprite Original [Damaged]
16 pixels × 24 pixels

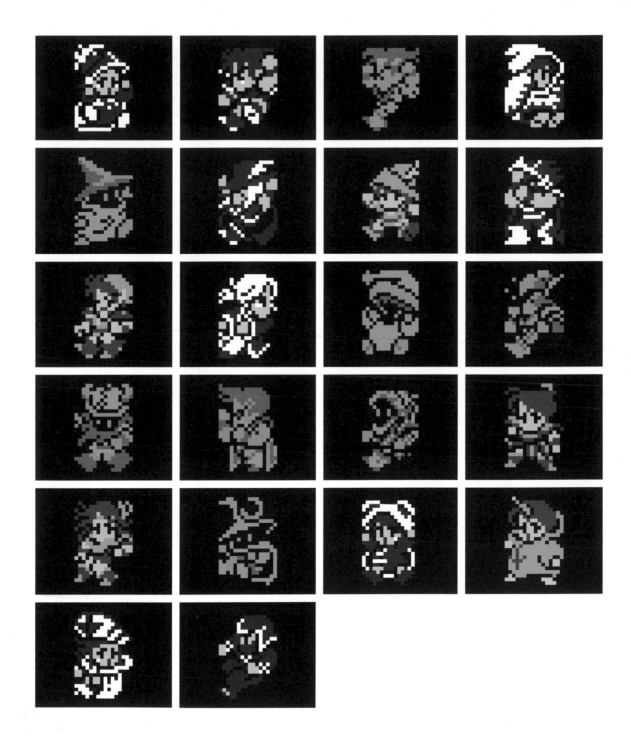

16 pixels

24 pixels

Color Palette

FINAL FANTASY III: Battle Character Sprite Original [Low HP]
16 pixels × 24 pixels

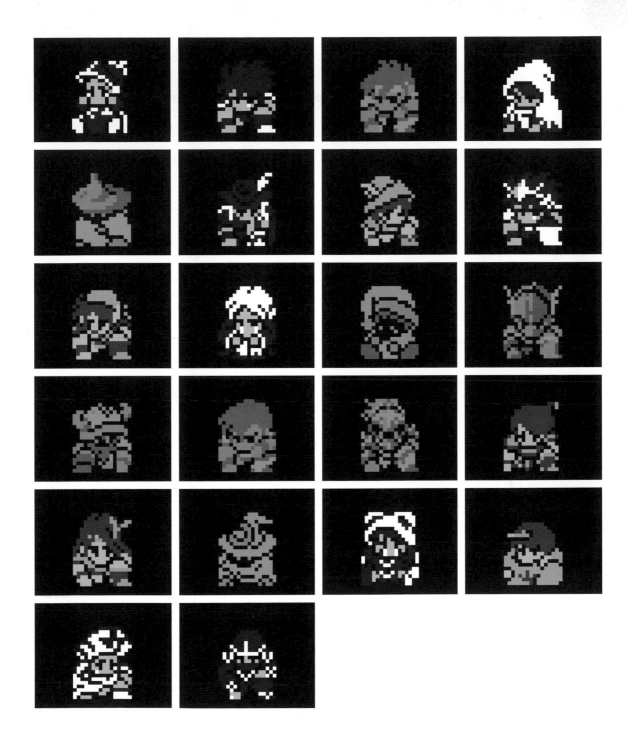

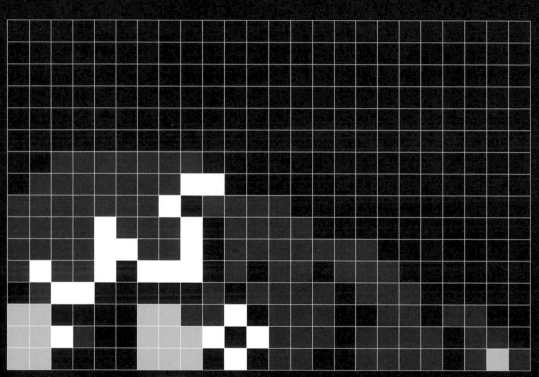

16 pixels

FINAL FANTASY III: Battle Character Sprite [Defeat]
24 pixels × 16 pixels

Color Palette

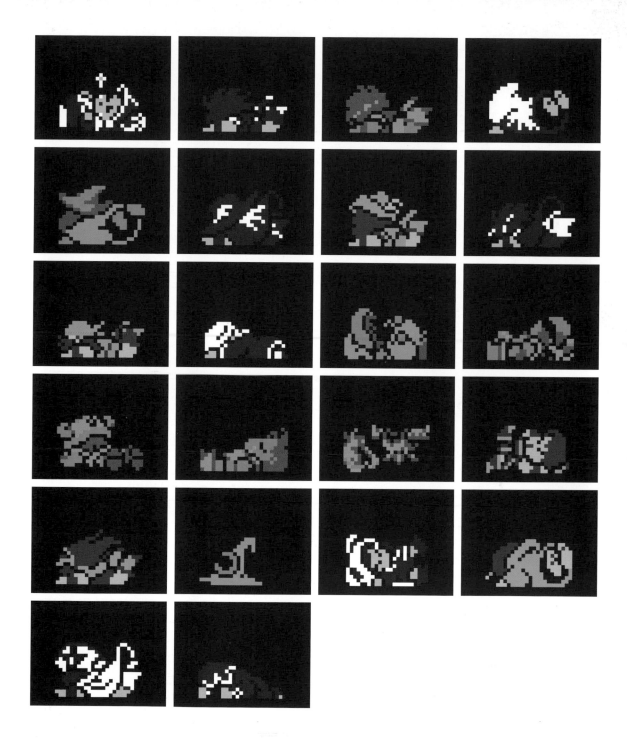

121

24 pixels

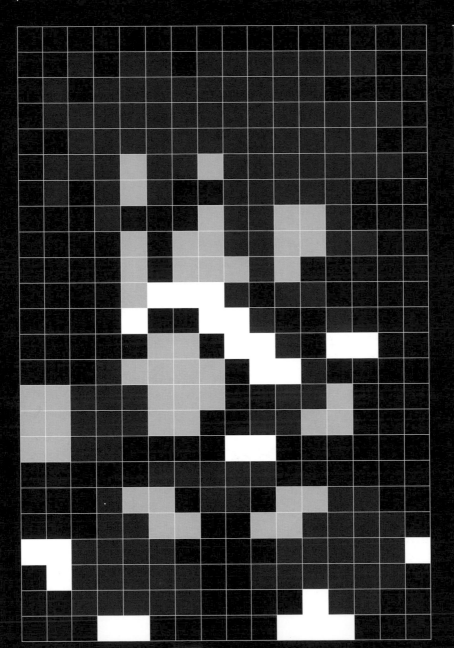

Color Palette

FINAL FANTASY III: Battle Character Sprite `Original` [Attack]
16 pixels × 24 pixels

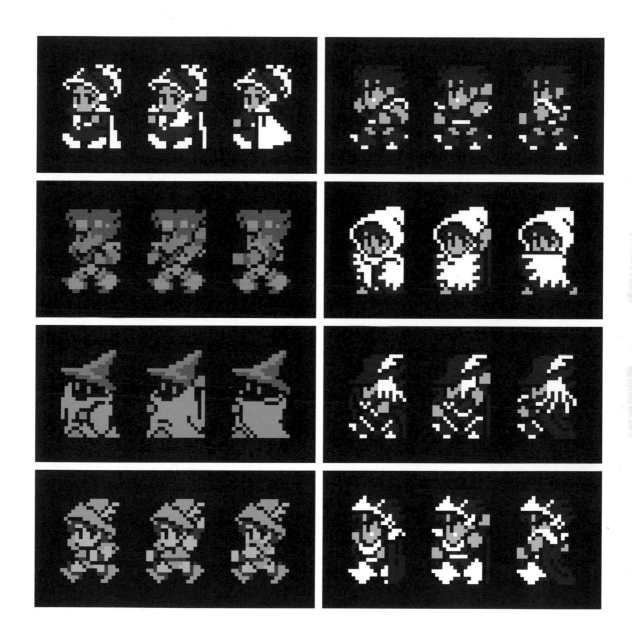

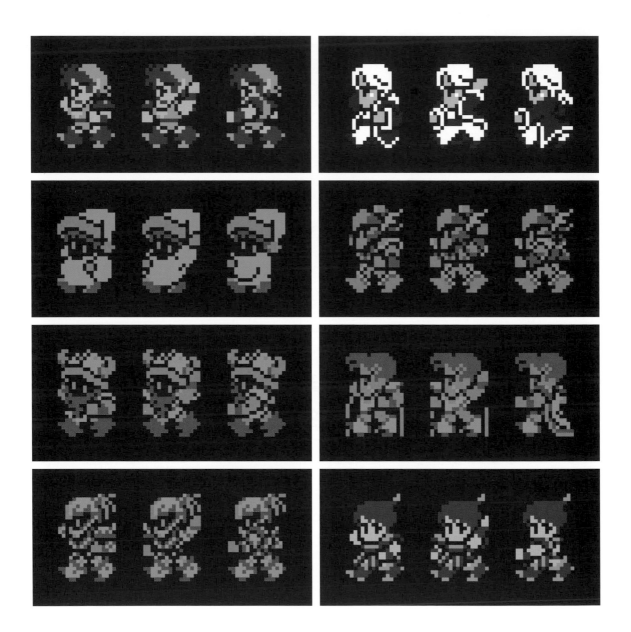

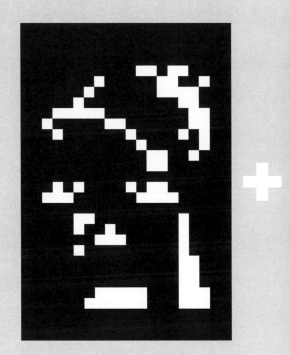 + 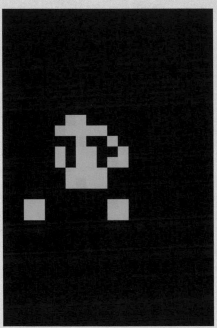 +

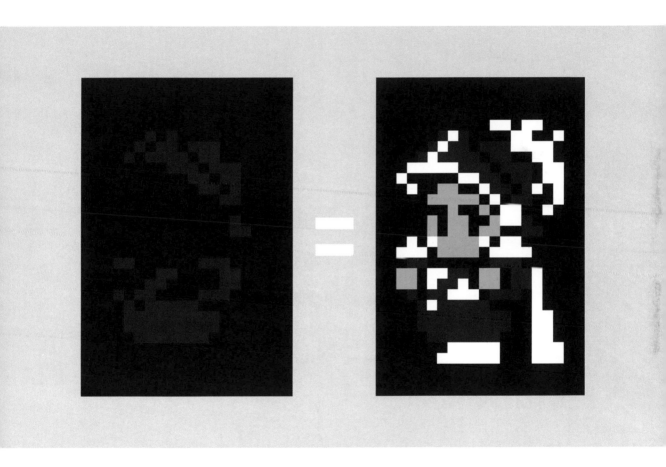

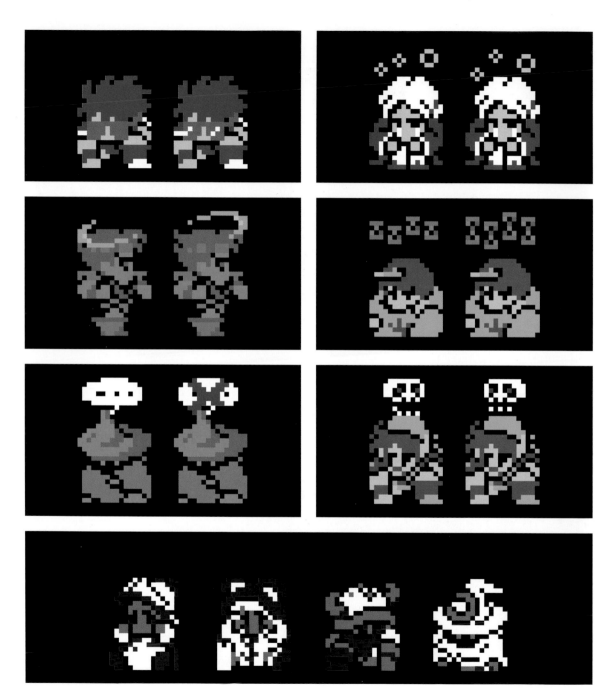

FINAL FANTASY III: Status Ailments

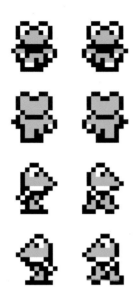

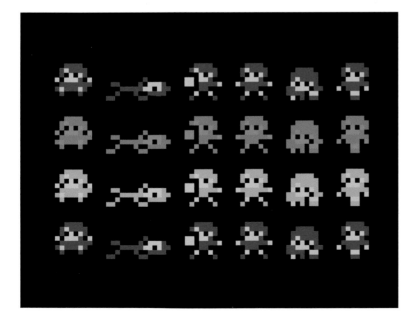

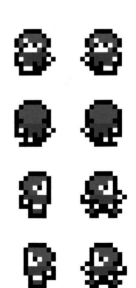

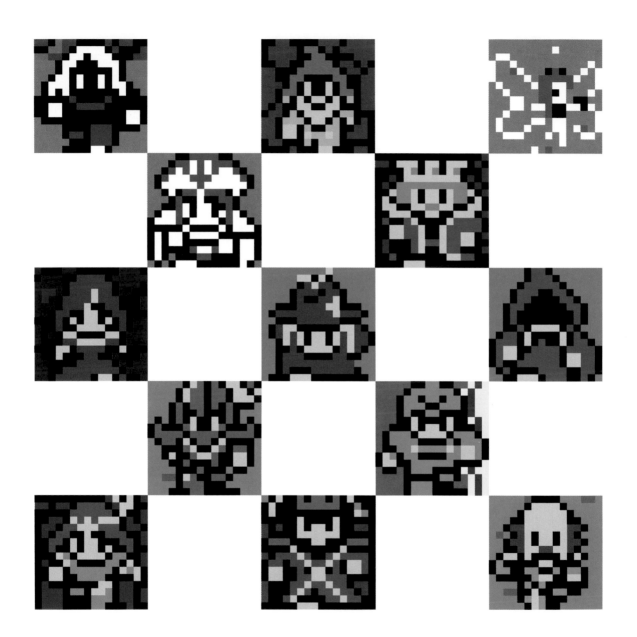

FINAL FANTASY III: World Character Sprites

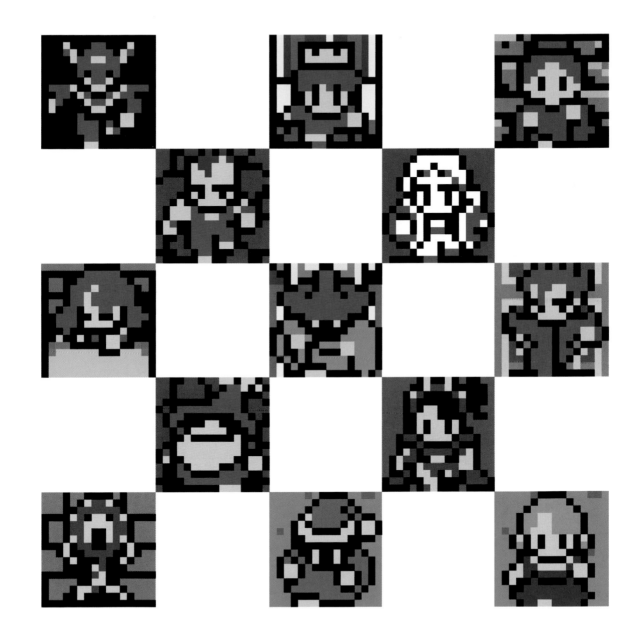

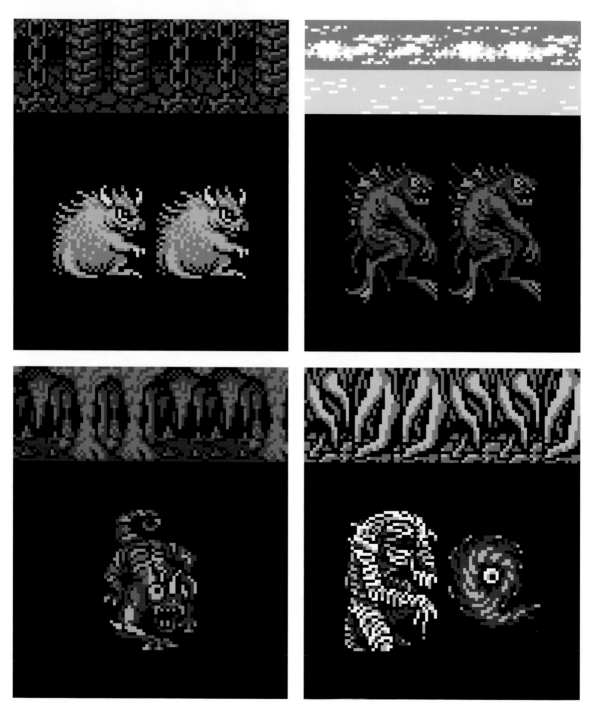

FINAL FANTASY III: Enemies #001

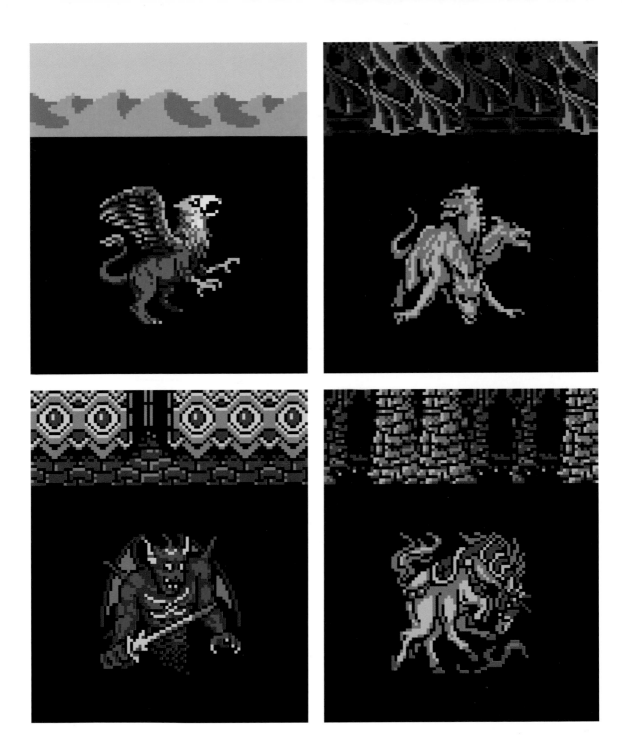

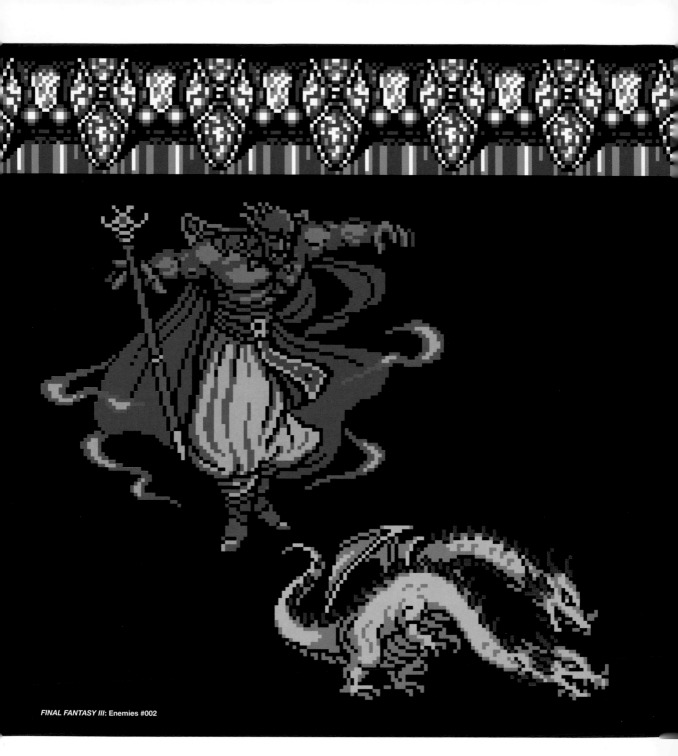

FINAL FANTASY III: Enemies #002

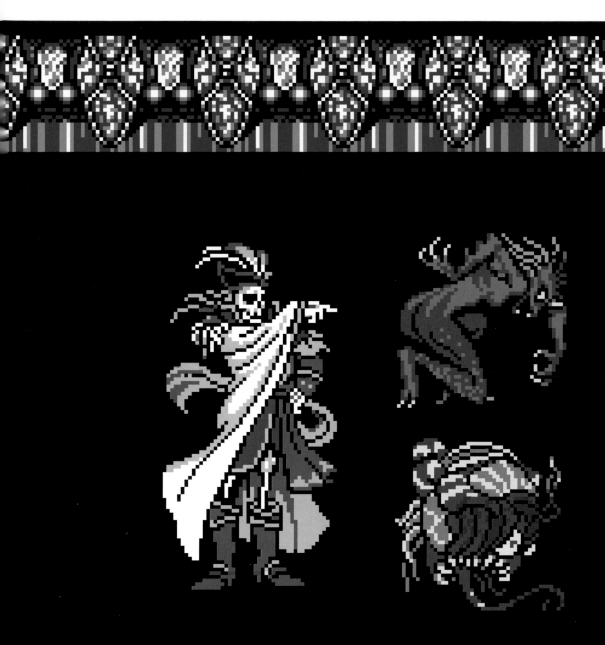

FINAL FANTASY III: Cloud of Darkness

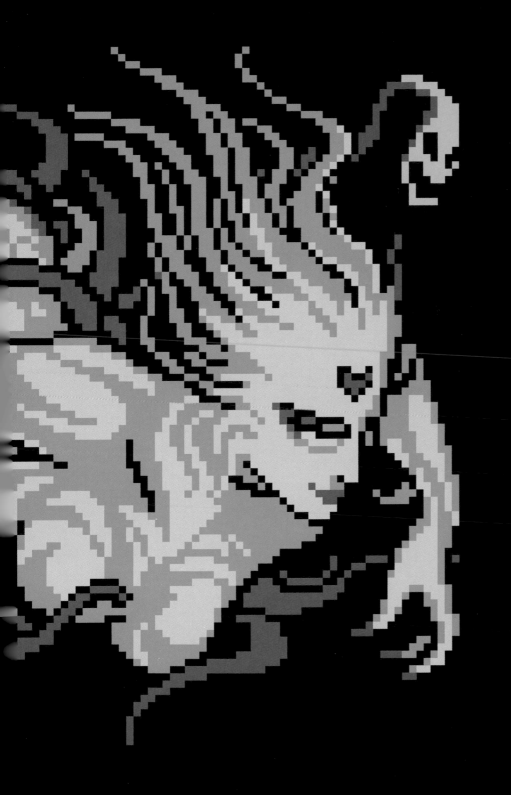

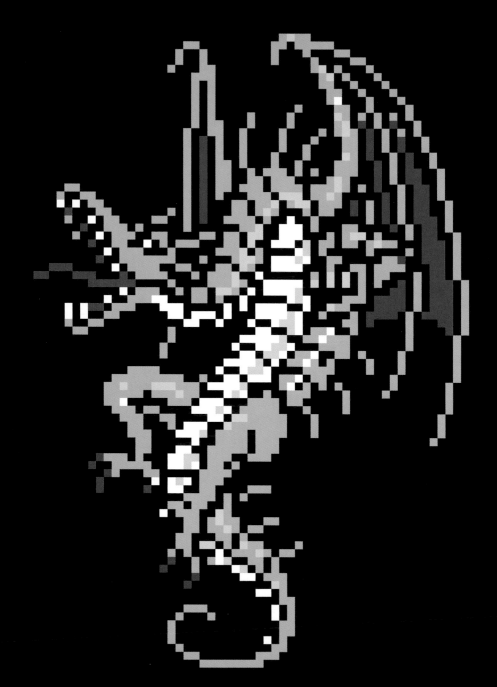

FINAL FANTASY III: Bahamut

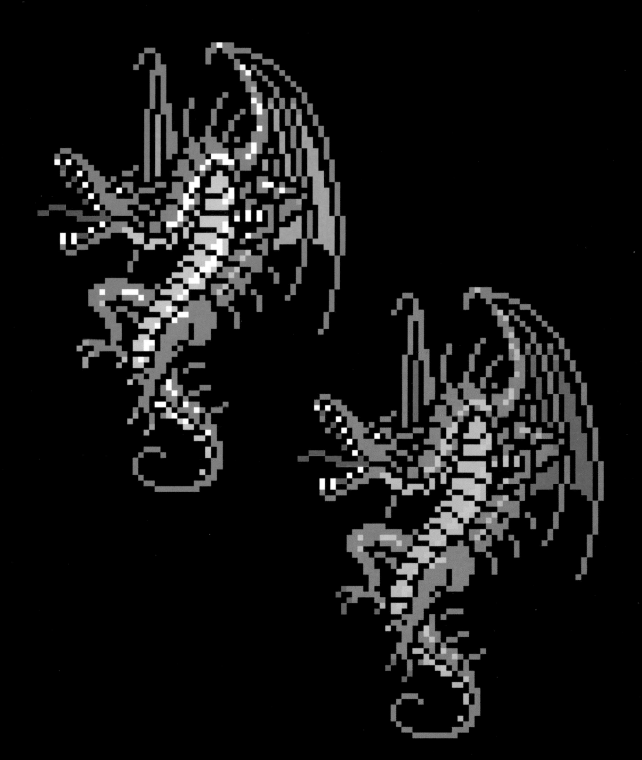

139

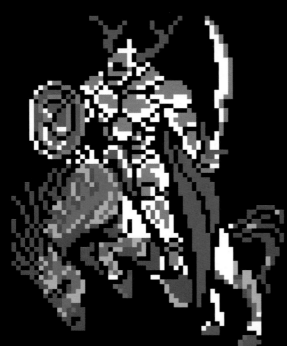

FINAL FANTASY III: Odin

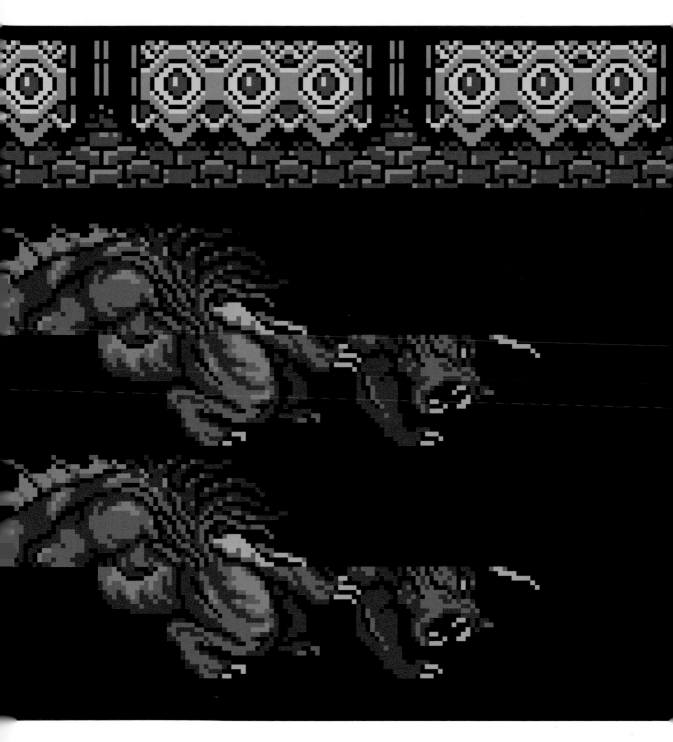

あ い う え お　か き く け こ
さ し す せ そ　た ち つ て と
な に ぬ ね の　は ひ ふ へ ほ
ま み む め も　や ゆ よ わ ん
ら り る れ ろ　が ぎ ぐ げ ご
ざ じ ず ぜ ぞ　だ ぢ づ で ど

あ　い　う　え　お　　か　き　く　け　こ
さ　し　す　せ　そ　　た　ち　つ　て　と
な　に　ぬ　ね　の　　は　ひ　ふ　へ　ほ
ま　み　む　め　も　　や　ゆ　よ　わ　ん
ら　り　る　れ　ろ　　が　ぎ　ぐ　げ　ご
ざ　じ　ず　ぜ　ぞ　　だ　ぢ　づ　で　ど
ば　び　ぶ　べ　ぼ　　ぱ　ぴ　ぷ　ぺ　ぽ
を　っ　ゃ　ゅ　ょ　　ア　イ　ウ　エ　オ
カ　キ　ク　ケ　コ　　サ　シ　ス　セ　ソ
タ　チ　ツ　テ　ト　　ナ　ニ　ヌ　ネ　ノ
ハ　ヒ　フ　ヘ　ホ　　マ　ミ　ム　メ　モ
ヤ　ユ　ヨ　ワ　ン　　ラ　リ　ル　レ　ロ
ガ　ギ　グ　ゲ　ゴ　　ザ　ジ　ズ　ゼ　ヅ
ダ　ヂ　ヅ　デ　ド　　バ　ビ　ブ　ベ　ボ
パ　ピ　プ　ペ　ポ　　ッ　ャ　ュ　ョ　ー
ァ　ィ　ゥ　ェ　ォ　　●　◖　◗　！
0　1　2　3　4　　5　6　7　8　9

チョコボみーっけっ！

Gotcha, chocobo!

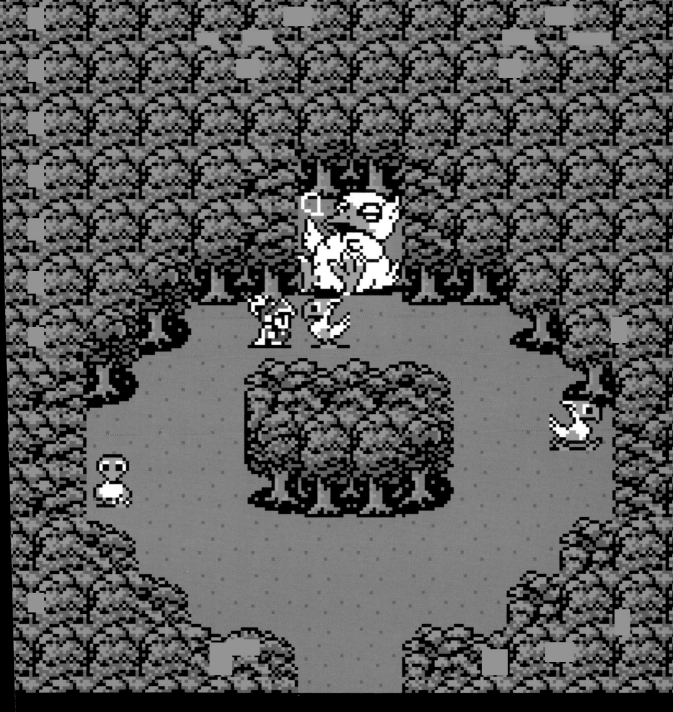

Map Tile Palette (16 pixels × 16 pixels)

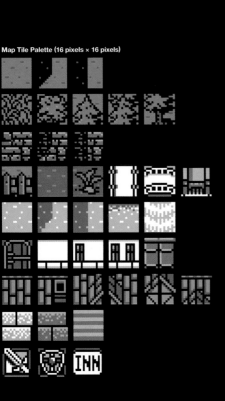

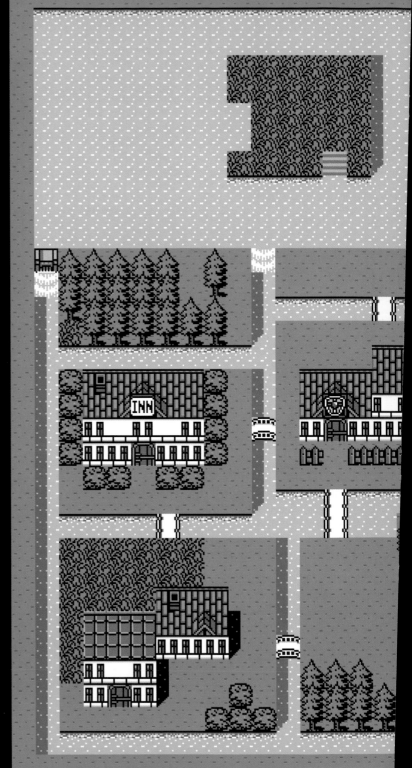

FINAL FANTASY III: Town [Amur]
34 tiles × 33 tiles

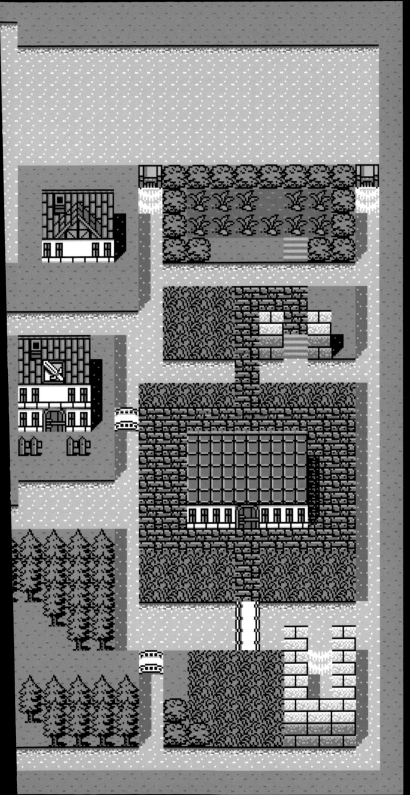

Color Palette

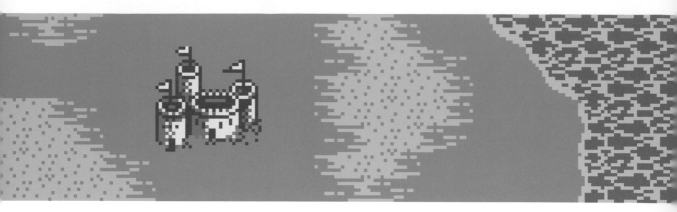

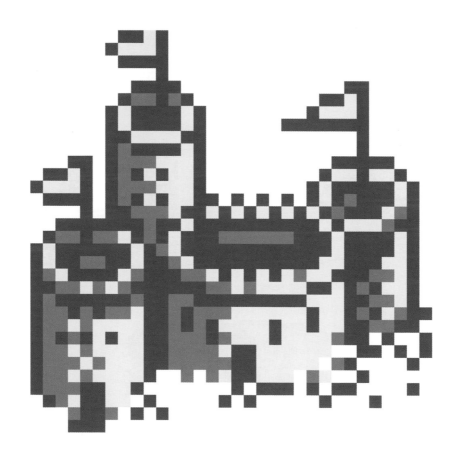

FINAL FANTASY III: World Locations [Castle Argus／Doga's Manor]

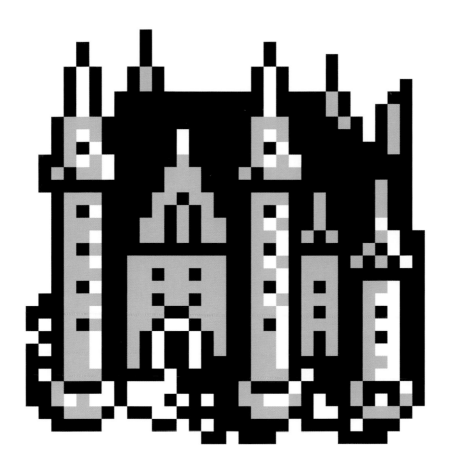

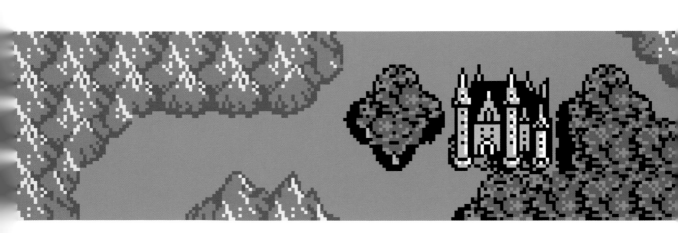

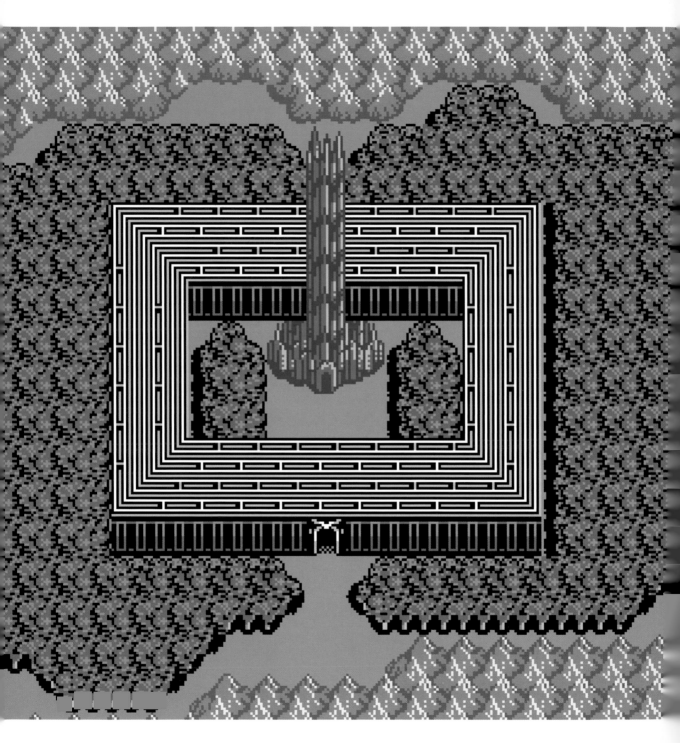

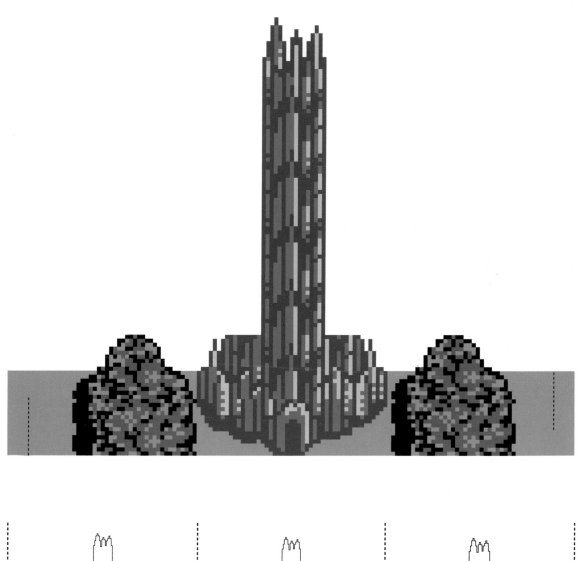

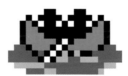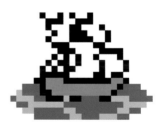

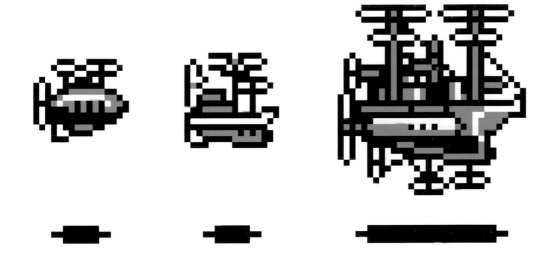

FINAL FANTASY III: Battle Character Sprites `2018 Ver.`

Left Page ──────────────────────────

		[Onion Knight]	[Warrior]
[Monk]	[White Mage]	[Black Mage]	[Red Mage]
[Ranger]	[Knight]	[Thief]	[Scholar]

Right Page ──────────────────────────

[Geomancer]	[Dragoon]	[Viking]	[Black Belt]
[Dark Knight]	[Evoker]	[Bard]	[Magus]
[Devout]	[Summoner]	[Sage]	[Ninja]

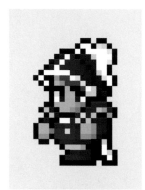
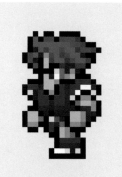

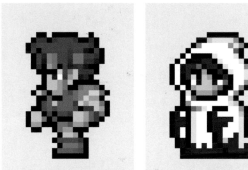
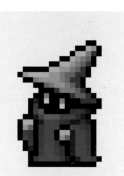
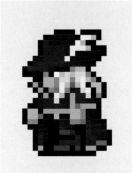

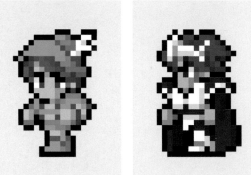
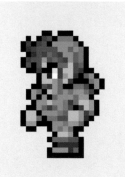
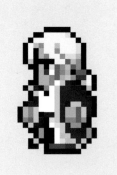

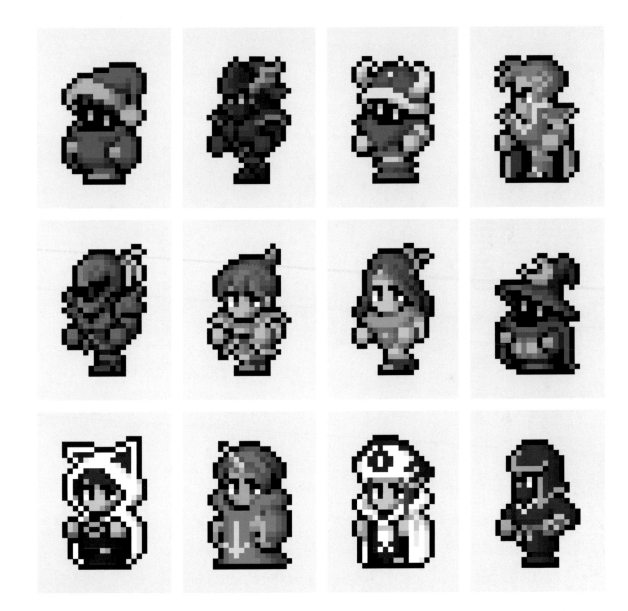

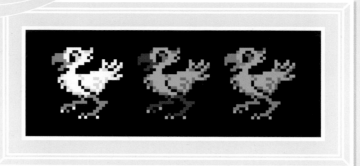

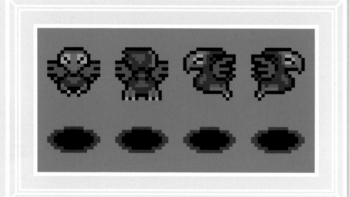

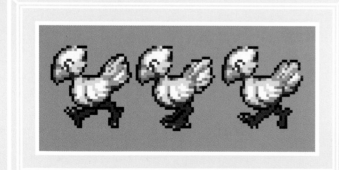

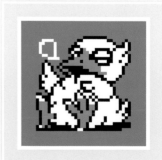

Chocobo Gallery

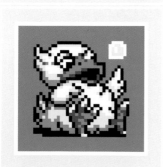

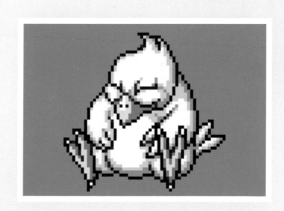

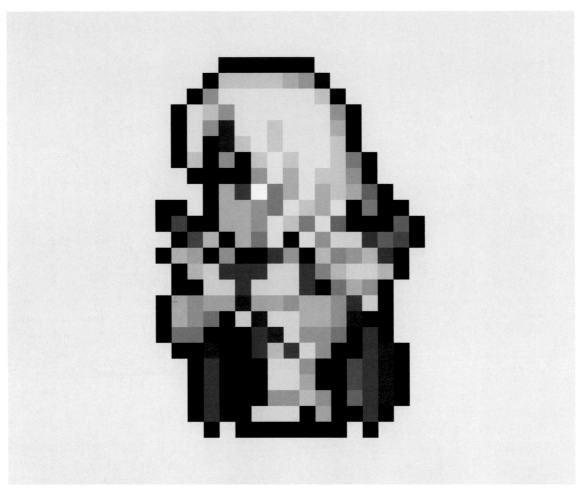

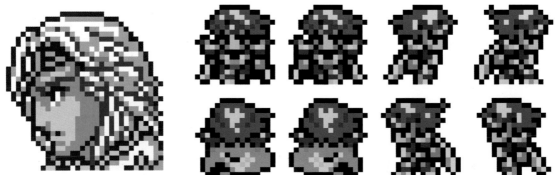

FINAL FANTASY IV: Cecil [Paladin] (Battle 2018 Ver. / Portrait Original / World Original)

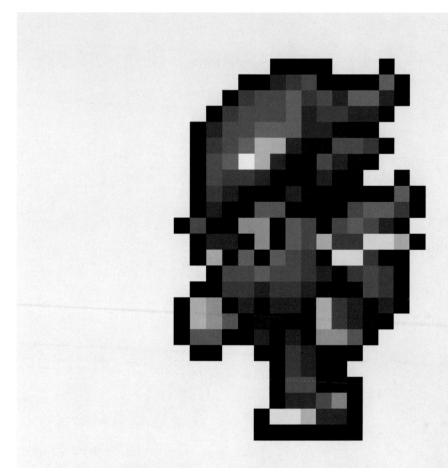

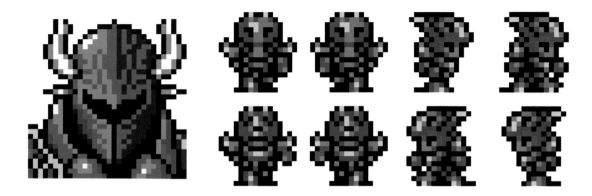

FINAL FANTASY IV: Cecil [Dark Knight] (Battle `2018 Ver.` /Portrait `Original` /World `Original`)

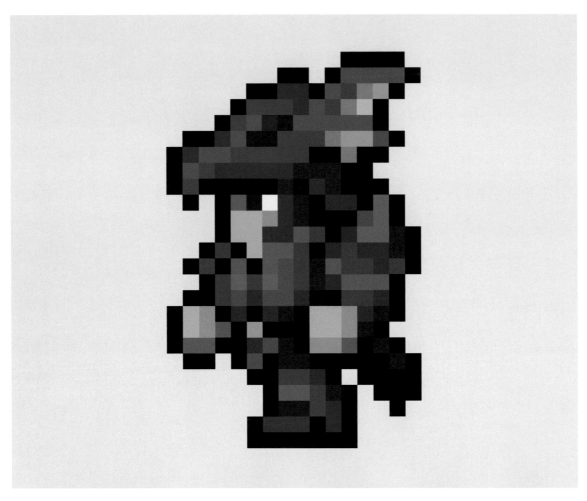

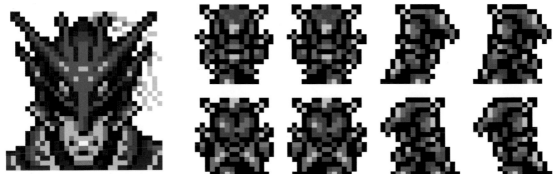

FINAL FANTASY IV: Kain (Battle `2018 Ver.` / Portrait `Original` / World `Original`)

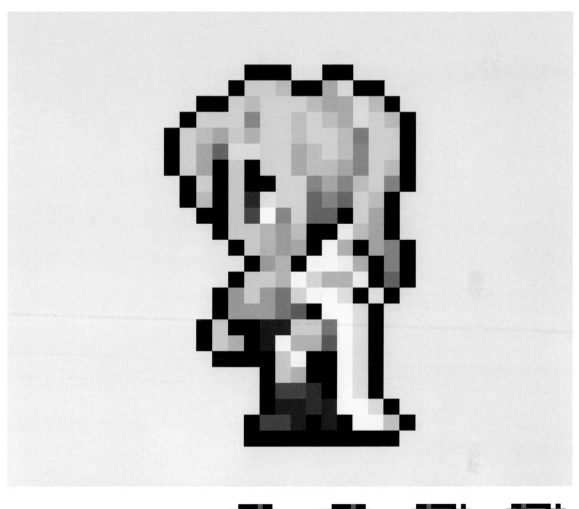

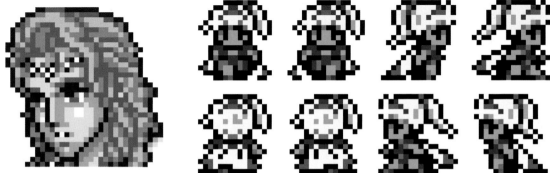

FINAL FANTASY IV: Rosa (Battle 2018 Ver. / Portrait Original / World Original)

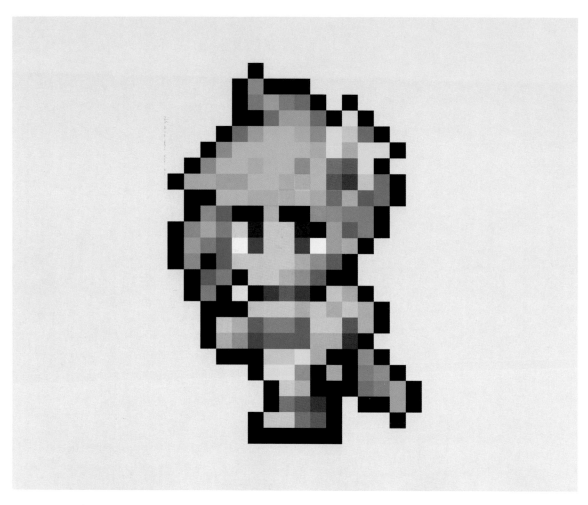

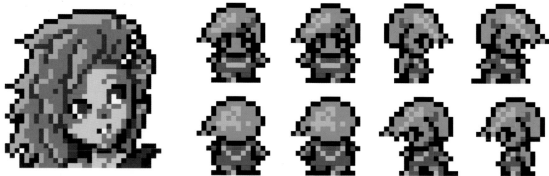

FINAL FANTASY IV: Rydia [Child] (Battle **2018 Ver.** / Portrait **Original** / World **Original**)

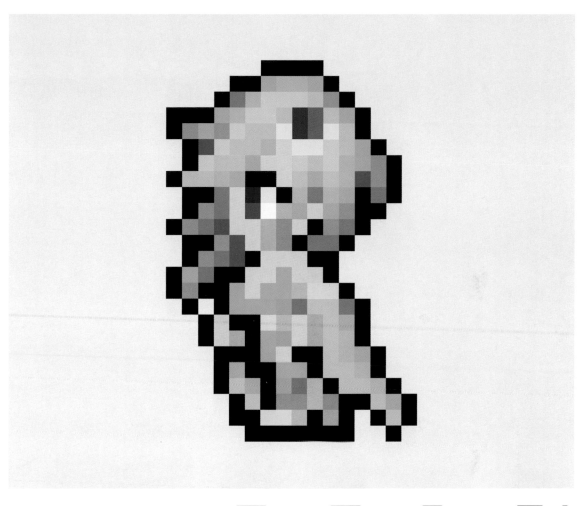

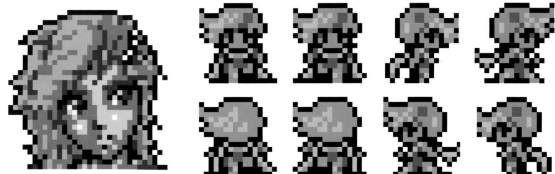

FINAL FANTASY IV: Rydia (Battle `2018 Ver.` / Portrait `Original` / World `Original`)

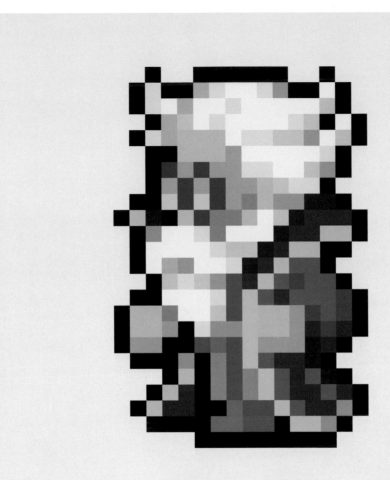

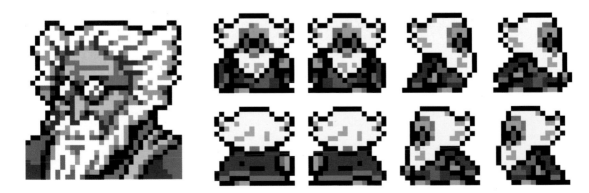

FINAL FANTASY IV: Tellah (Battle 2018 Ver. / Portrait Original / World Original)

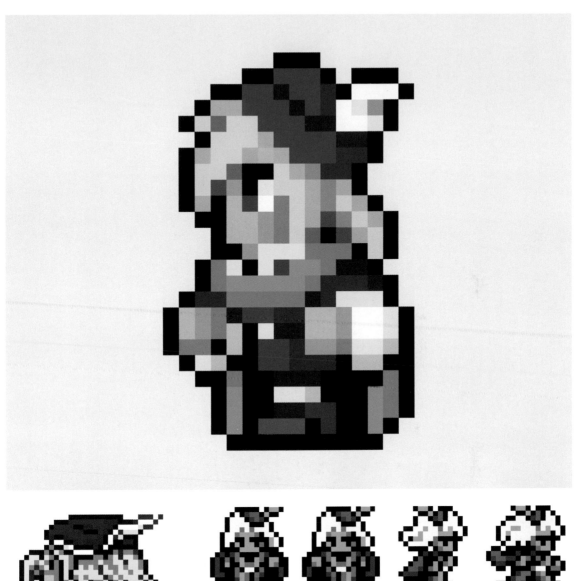

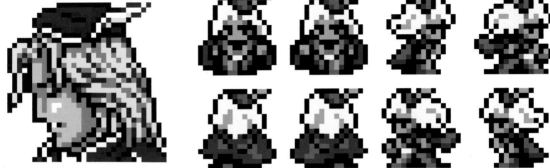

FINAL FANTASY IV: Gilbert (Edward) (Battle 2018 Ver. /Portrait Original /World Original)

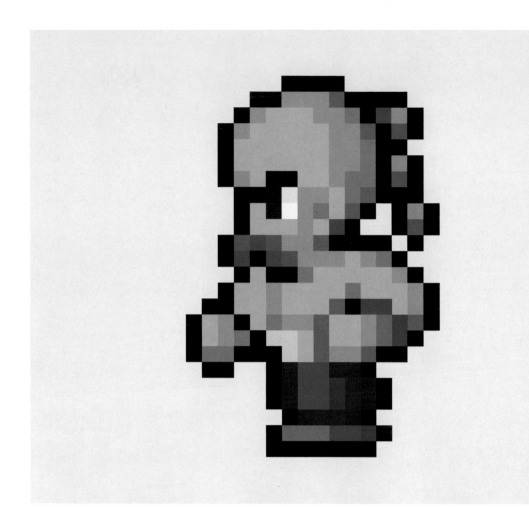

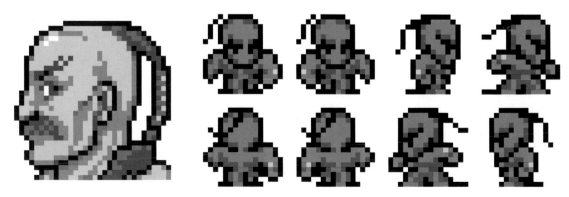

FINAL FANTASY IV: Yang (Battle `2018 Ver.` / Portrait `Original` / World `Original`)

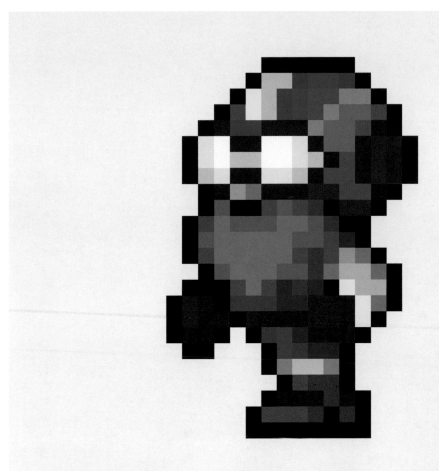

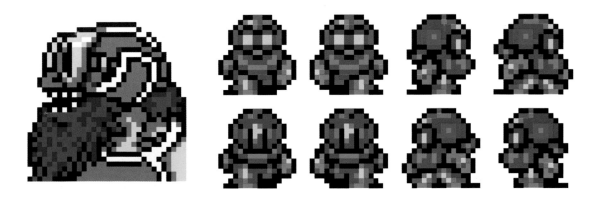

FINAL FANTASY IV: Cid (Battle `2018 Ver.` / Portrait `Original` / World `Original`)

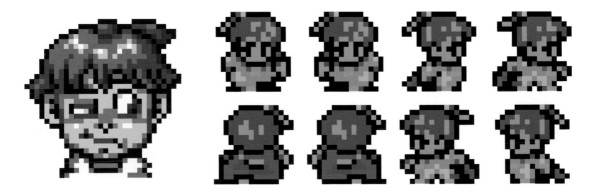

FINAL FANTASY IV: Palom (Battle 2018 Ver. / Portrait Original / World Original)

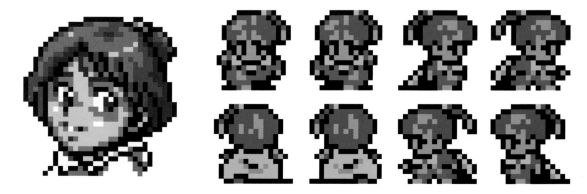

FINAL FANTASY IV: Porom (Battle `2018 Ver.` / Portrait `Original` / World `Original`)

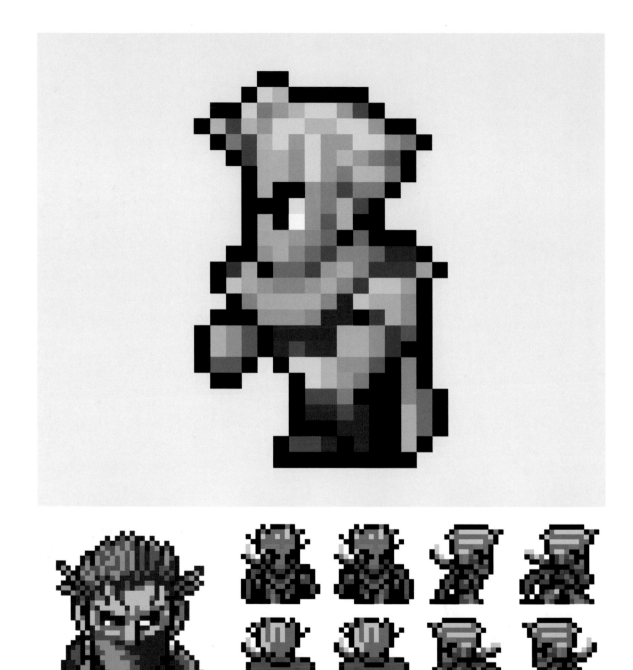

FINAL FANTASY IV: Edge (Battle 2018 Ver. / Portrait Original / World Original)

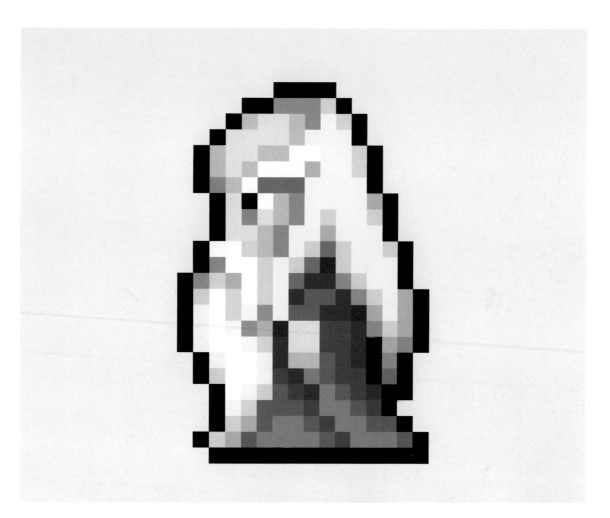

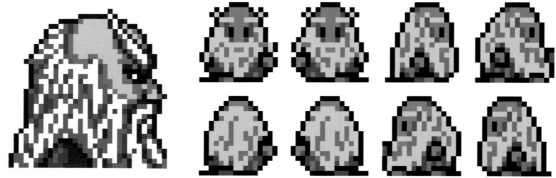

FINAL FANTASY IV: Fusoya (Battle 2018 Ver. / Portrait Original / World Original)

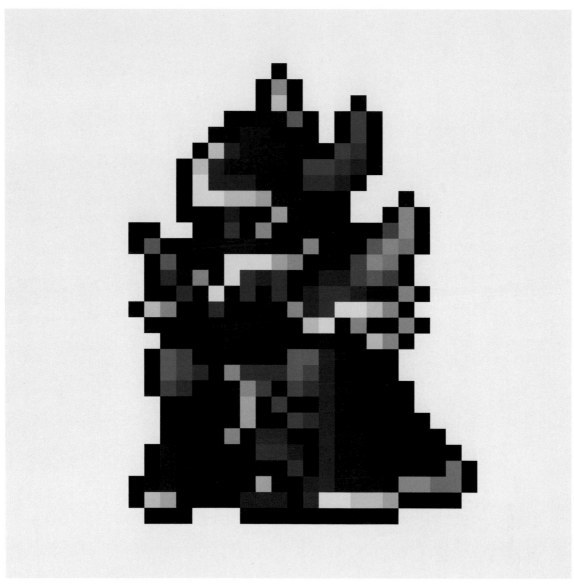

FINAL FANTASY IV: Golbez 2018 Ver.

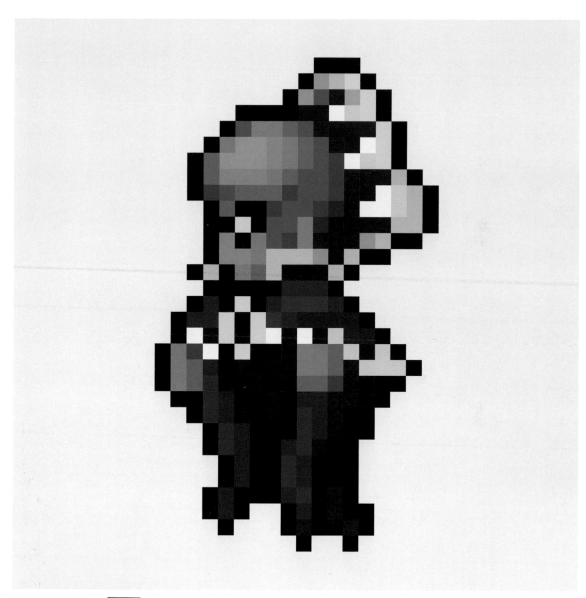

FINAL FANTASY IV: Zemus 2018 Ver.

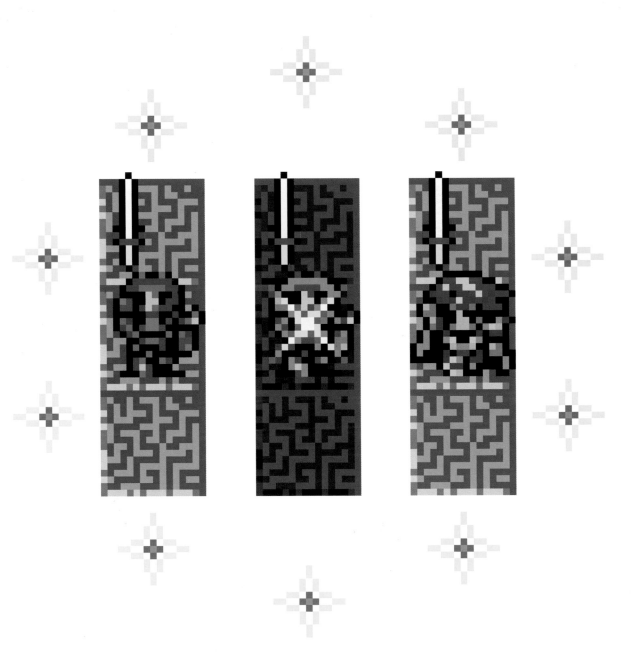

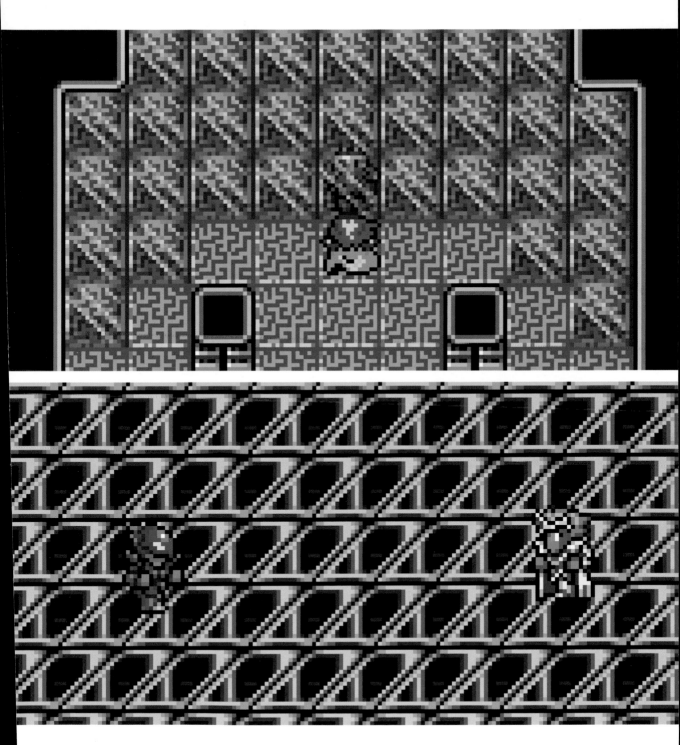

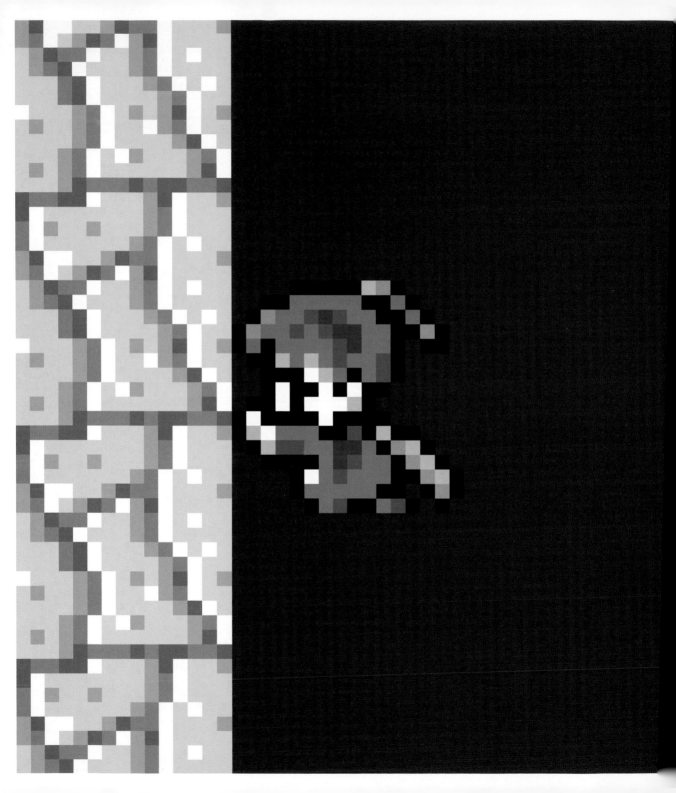

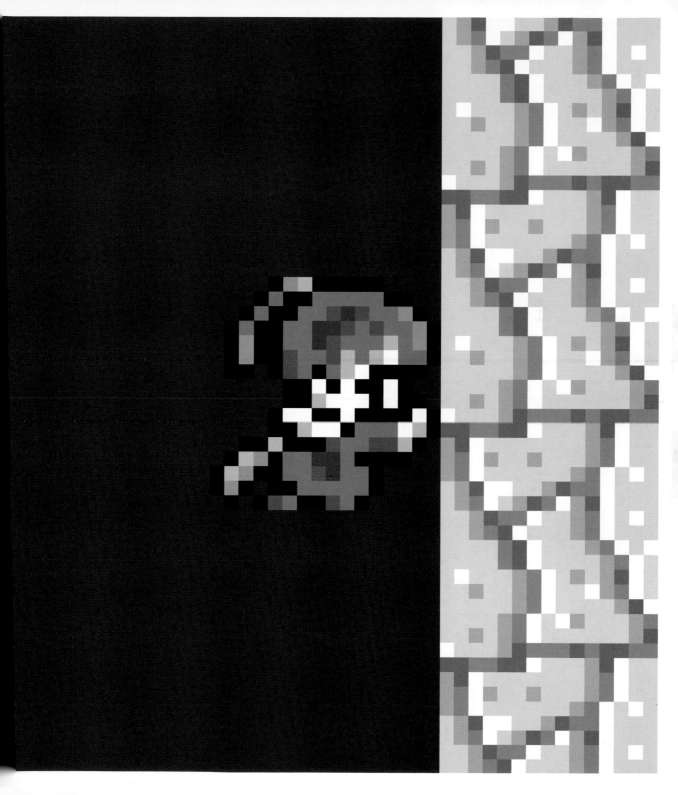

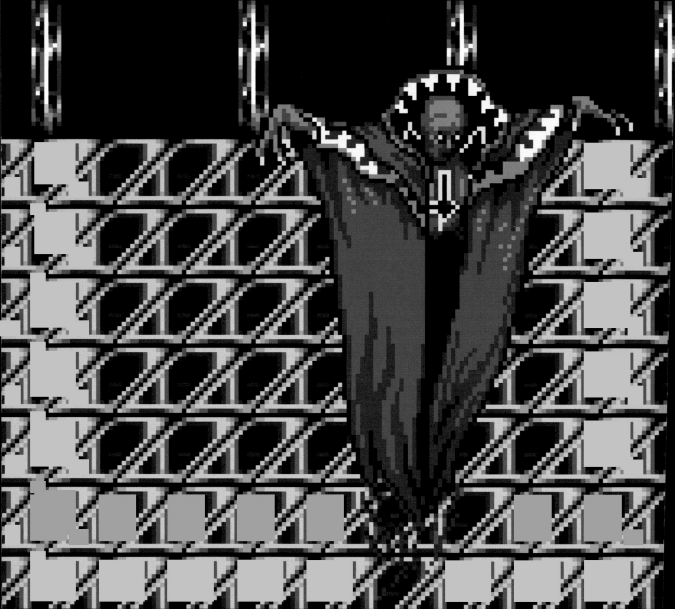

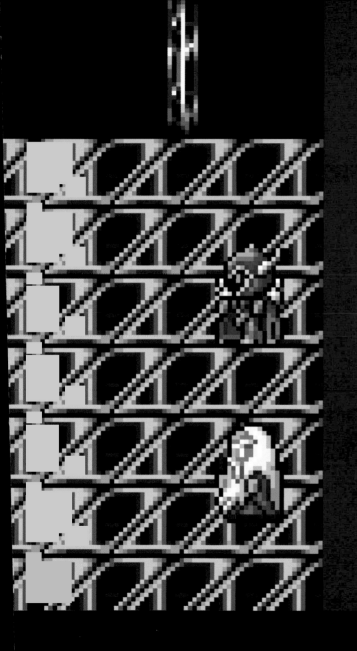

ゴルベーザ
「いいですとも！

Golbez:
Very well.

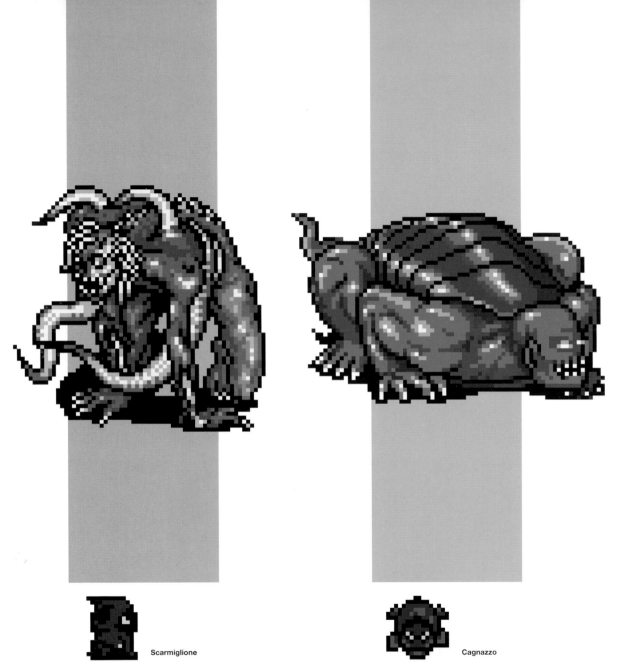

Scarmiglione

Cagnazzo

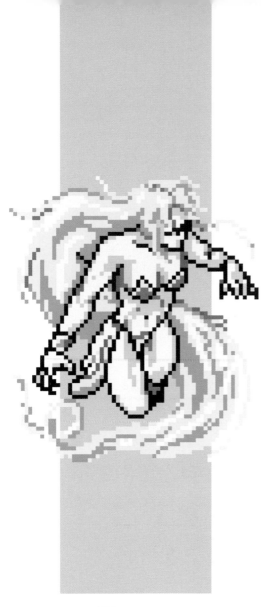

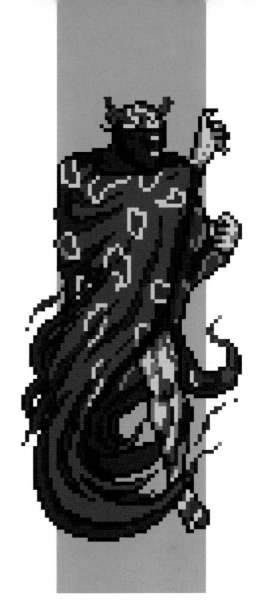

Barbariccia

Rubicante

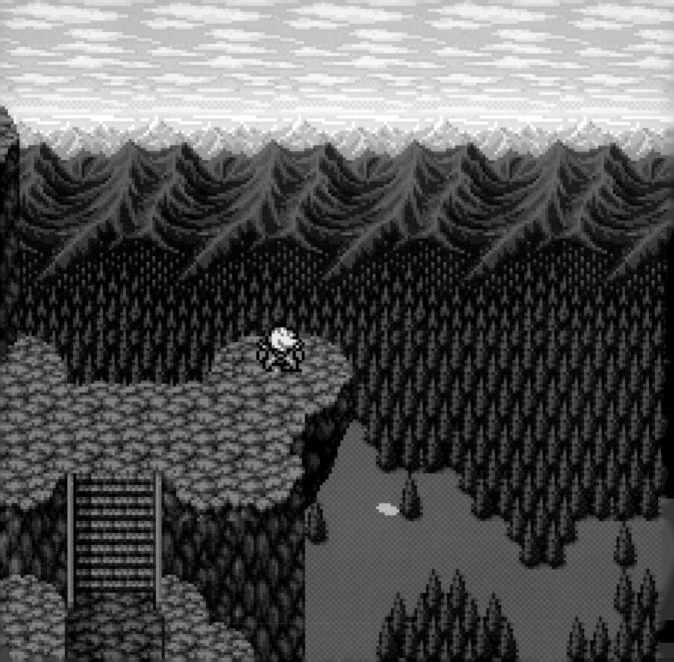

いまのおれには　おまえたちを　しゅくふく
することは　できん‥‥

この　しれんのやまで　わざをみがき‥‥
ちちをこえる　りゅうきしと　なったときには
バロンに‥‥もどれそうな　きがする‥‥
それまでは‥‥

I have no right to bear witness to your joy—not like this.

I will temper myself here, on Mount Ordeals.
And then, when I've become an even finer Dragoon than
my father—perhaps then I can return.
Until that day comes, I can but wish you well.

I

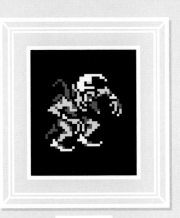

II

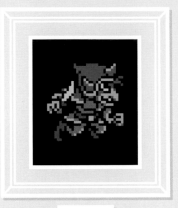

III

Goblin

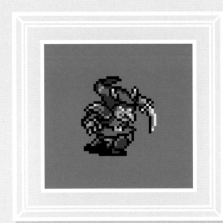

IV

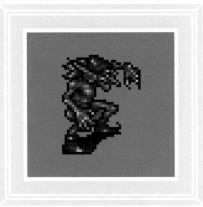

V

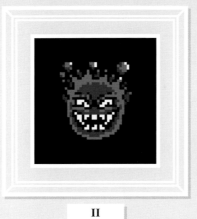

II

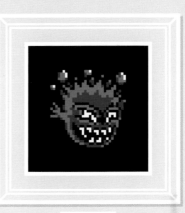

III

Bomb

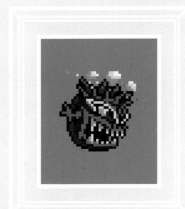

IV

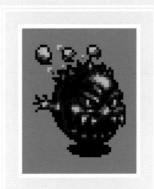

V

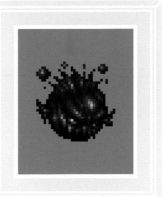

VI

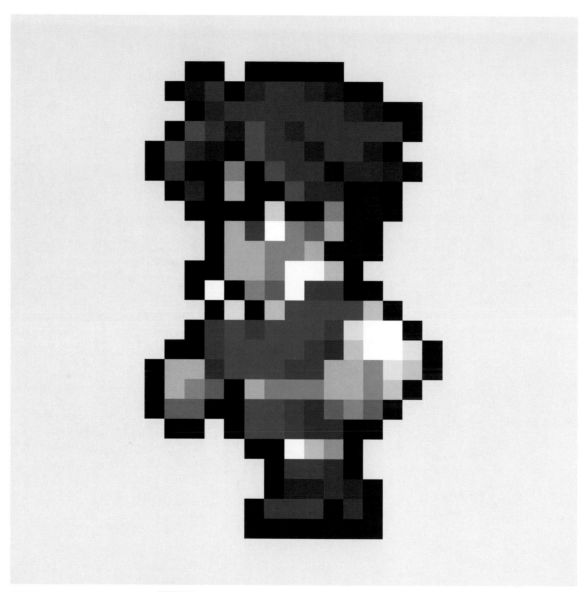

FINAL FANTASY V: Battle Character Sprite 2018 Ver. [Bartz (Freelancer)]

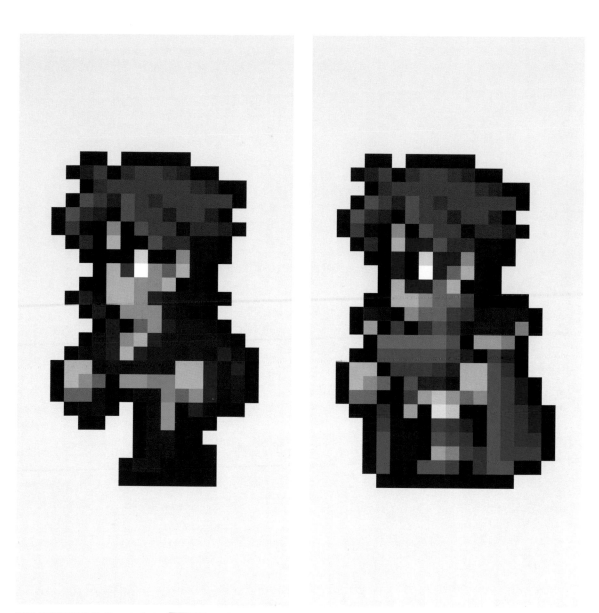

FINAL FANTASY V: Battle Character Sprites 2018 Ver. [Bartz (Dancer/Blue Mage)]

***FINAL FANTASY V*: Battle Character Sprites Original [Bartz (All Jobs)]**

Left Page
		[Knight]	[Monk]
[Thief]	[Dragoon]	[Ninja]	[Samurai]
[Berserker]	[Ranger]	[Mystic Knight]	[White Mage]

Right Page
[Black Mage]	[Time Mage]	[Summoner]	[Blue Mage]
[Red Mage]	[Beastmaster]	[Chemist]	[Geomancer]
[Bard]	[Dancer]	[Mime]	[Freelancer]

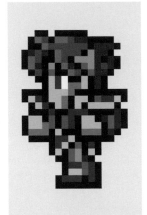
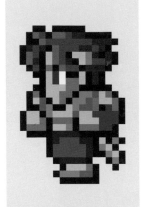

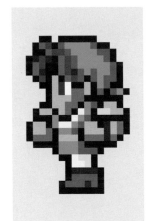
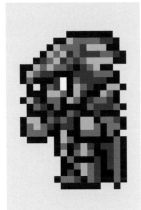
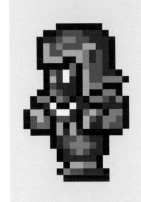
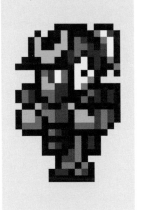

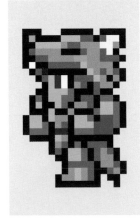
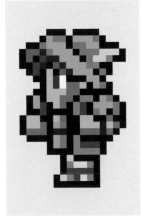
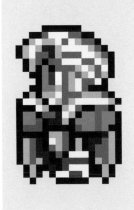
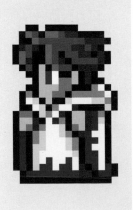

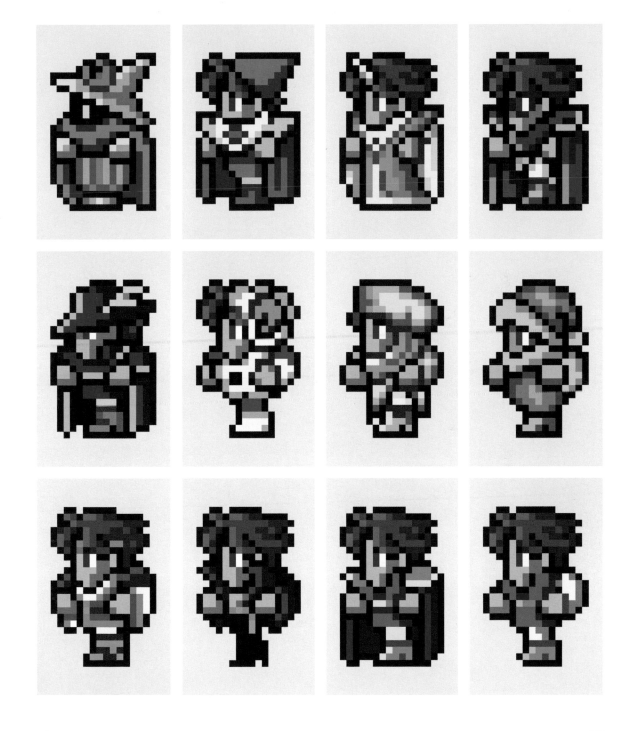

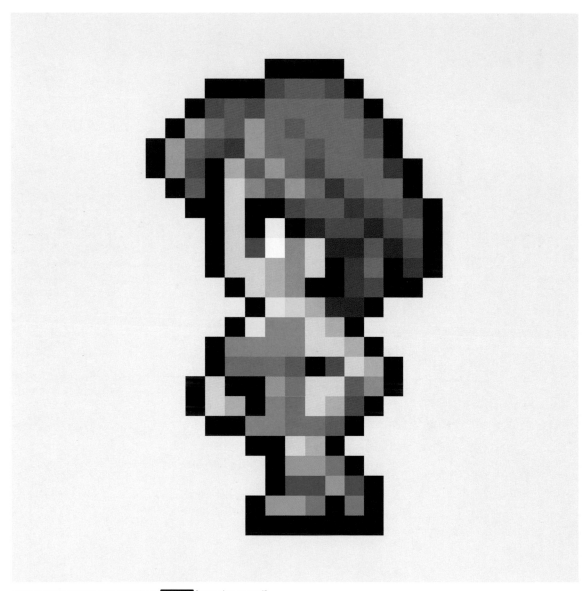

FINAL FANTASY V: Battle Character Sprite 2018 Ver. [Lenna (Freelancer)]

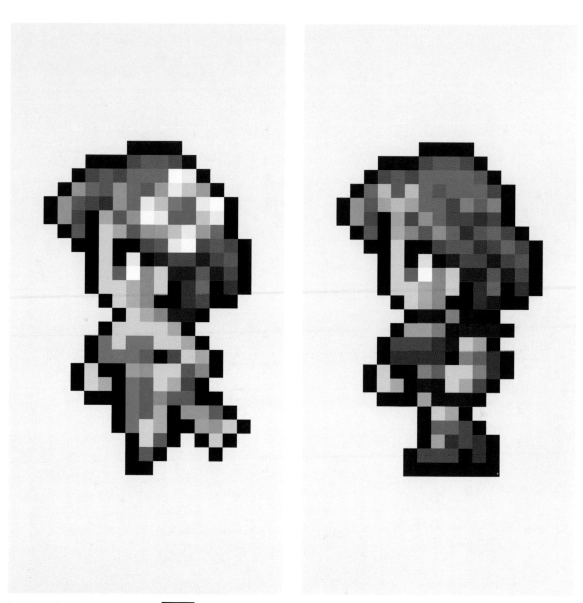

FINAL FANTASY V: Battle Character Sprites 2018 Ver. [Lenna (Dancer/Samurai)]

FINAL FANTASY V: Battle Character Sprites Original [Lenna (All Jobs)]

Left Page ─────────────────────

					[Knight]	[Monk]	
[Thief]	[Dragoon]	[Ninja]	[Samurai]
[Berserker]	[Ranger]	[Mystic Knight]	[White Mage]		

Right Page ─────────────────────

[Black Mage]	[Time Mage]	[Summoner]	[Blue Mage]
[Red Mage]	[Beastmaster]	[Chemist]	[Geomancer]
[Bard]	[Dancer]	[Mime]	[Freelancer]

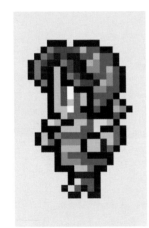
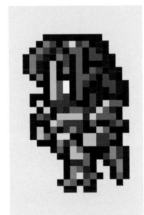
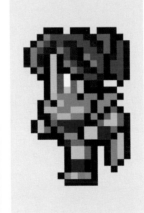
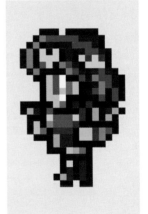

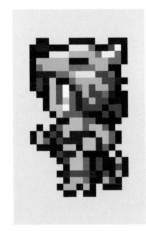
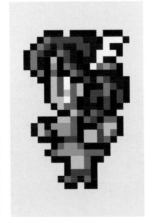
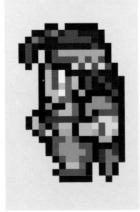
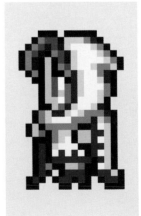

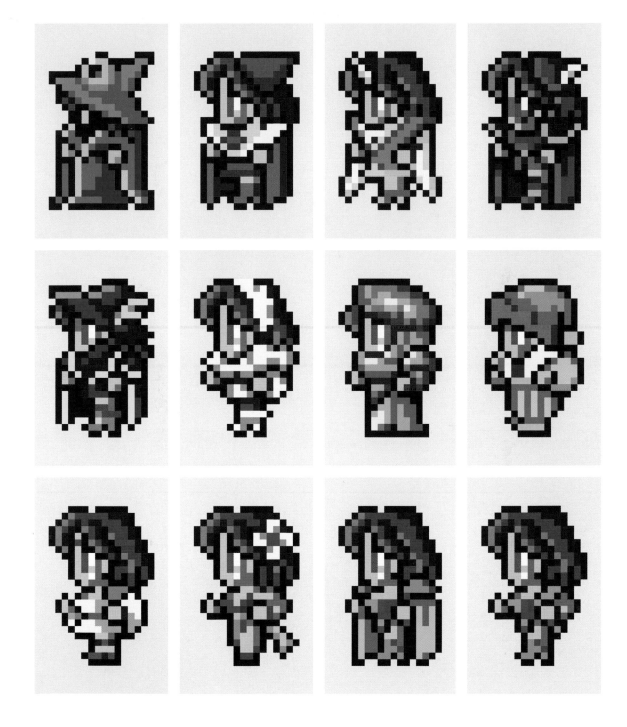

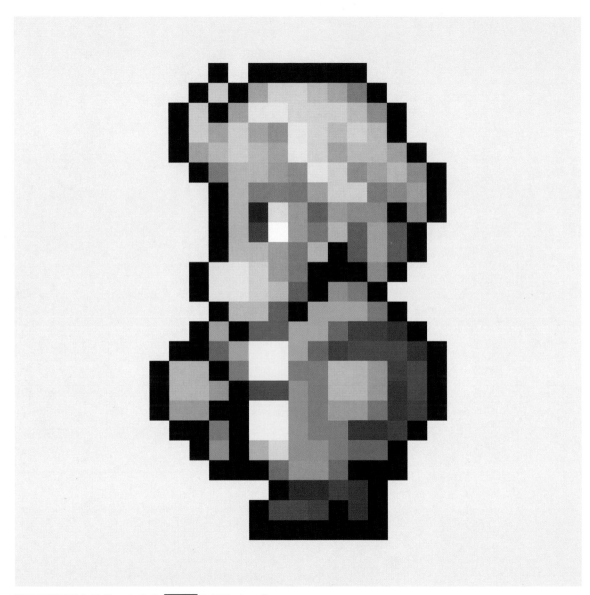

FINAL FANTASY V: Battle Character Sprite 2018 Ver. [Galuf (Freelancer)]

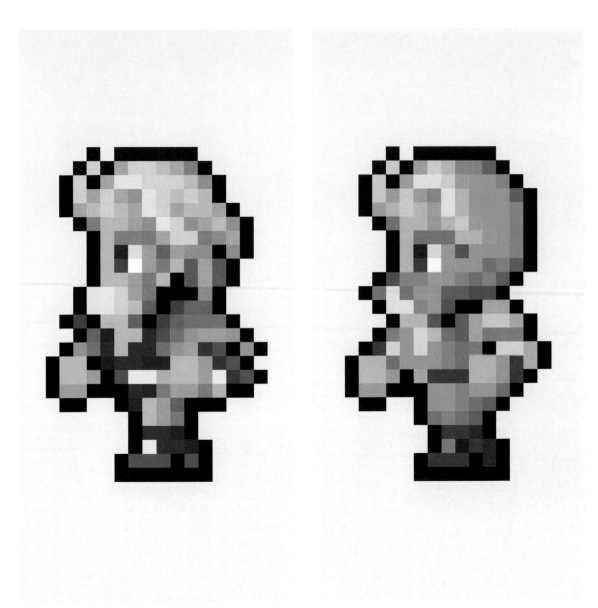

FINAL FANTASY V: Battle Character Sprites **2018 Ver.** [Galuf (Dancer/Thief)]

FINAL FANTASY V: Battle Character Sprites **Original** [Galuf (All Jobs)]

Left Page
[Knight] [Monk]
[Thief] [Dragoon] [Ninja] [Samurai]
[Berserker] [Ranger] [Mystic Knight] [White Mage]

Right Page
[Black Mage] [Time Mage] [Summoner] [Blue Mage]
[Red Mage] [Beastmaster] [Chemist] [Geomancer]
[Bard] [Dancer] [Freelancer]

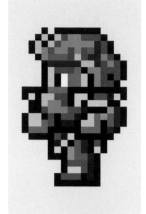
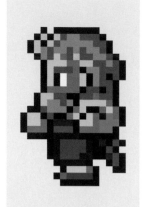

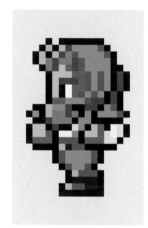
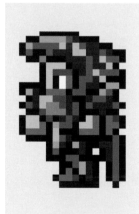
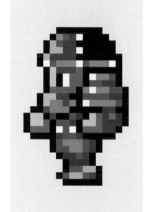
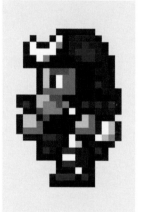

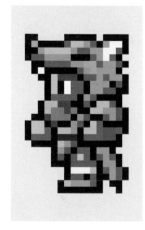
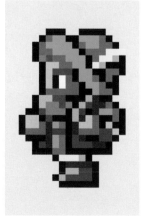
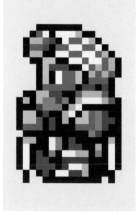
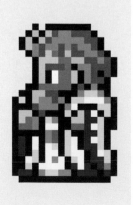

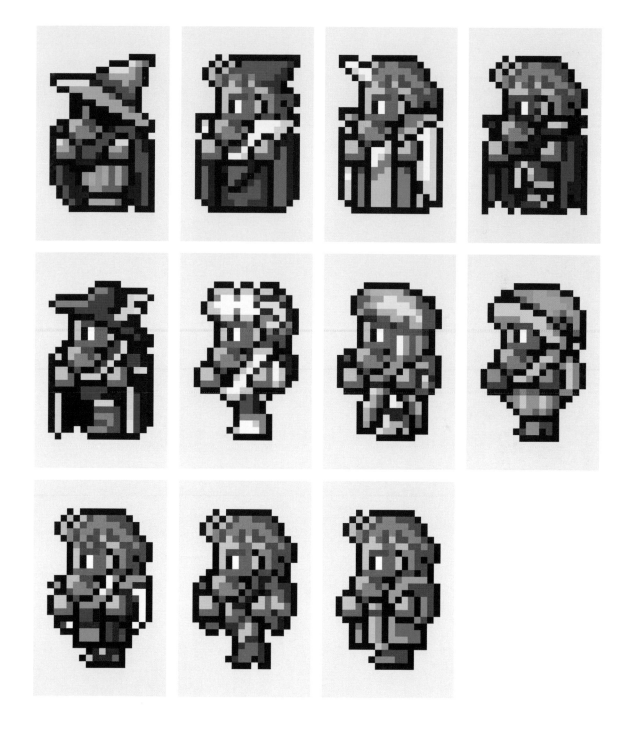

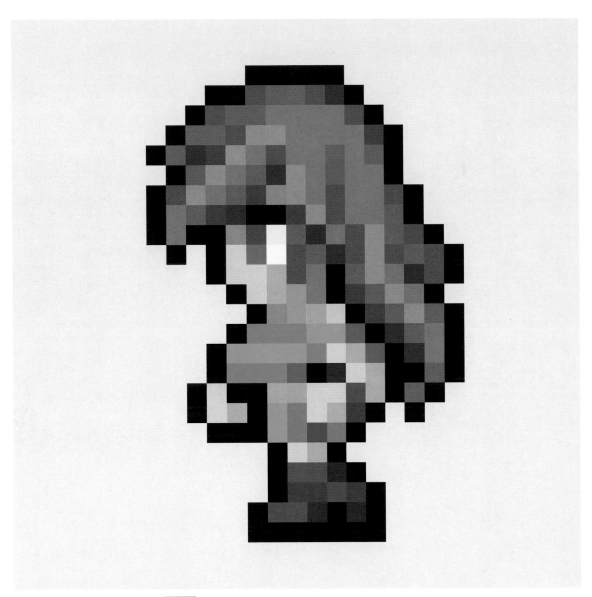

FINAL FANTASY V: Battle Character Sprite `2018 Ver.` [Faris (Freelancer)]

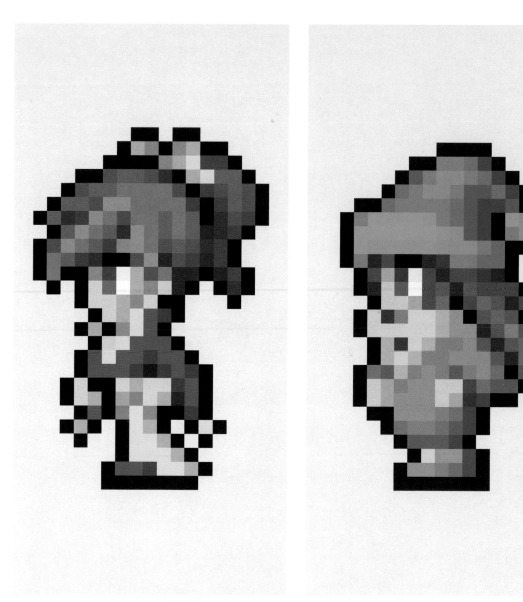

FINAL FANTASY V: Battle Character Sprites `2018 Ver.` [Faris (Dancer / Geomancer)]

FINAL FANTASY V: Battle Character Sprites Original [Faris (All Jobs)]

Left Page ───────────────

[] [] [Knight] [Monk]

[Thief] [Dragoon] [Ninja] [Samurai]

[Berserker] [Ranger] [Mystic Knight] [White Mage]

Right Page ───────────────

[Black Mage] [Time Mage] [Summoner] [Blue Mage]

[Red Mage] [Beastmaster] [Chemist] [Geomancer]

[Bard] [Dancer] [Mime] [Freelancer]

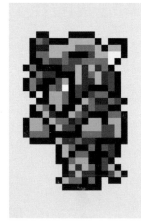 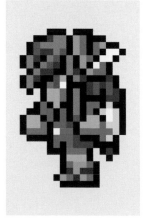 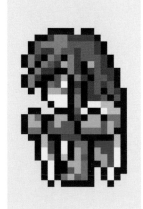 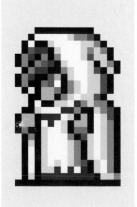

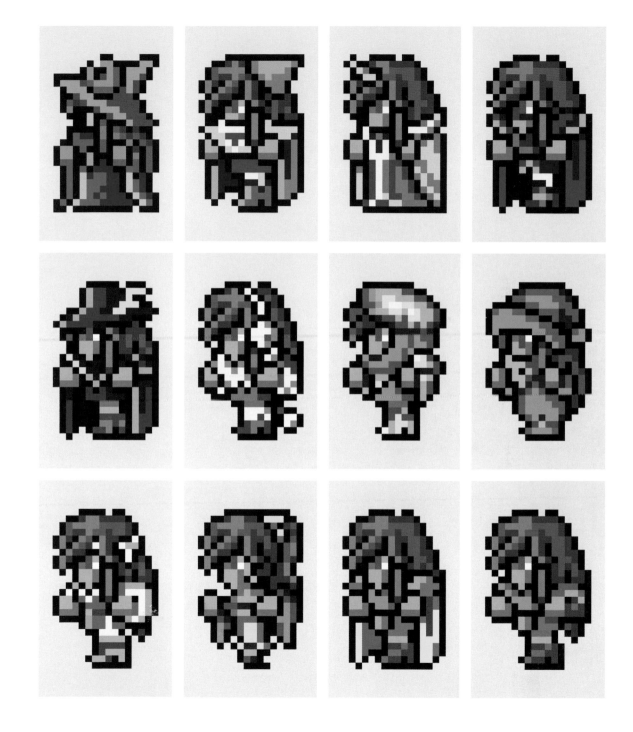

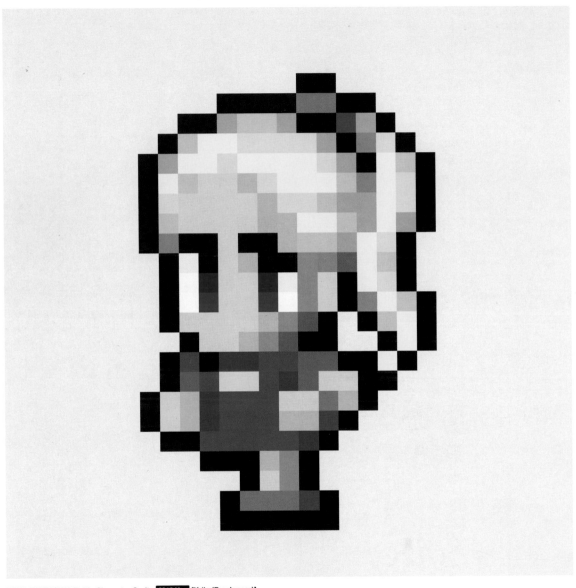

FINAL FANTASY V: Battle Character Sprite 2018 Ver. [Krile (Freelancer)]

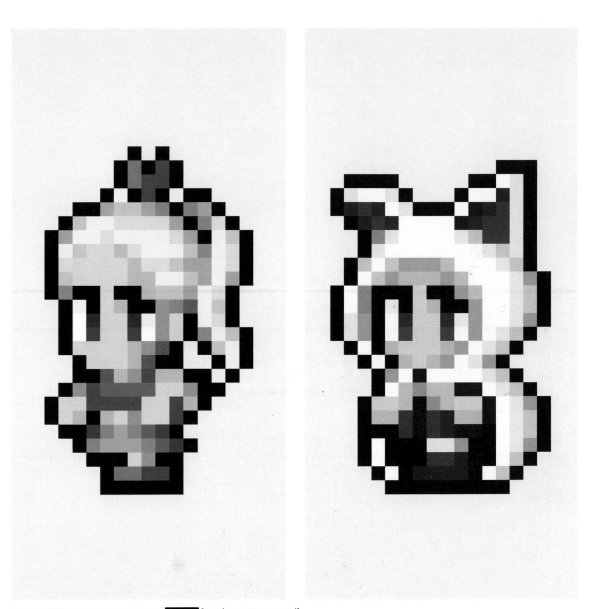

FINAL FANTASY V: Battle Character Sprites `2018 Ver.` [Krile (Dancer / White Mage)]

FINAL FANTASY V: Battle Character Sprites Original [Krile (All Jobs)]

Left Page ─────────────────────

		[Knight]	[Monk]
[Thief]	[Dragoon]	[Ninja]	[Samurai]
[Berserker]	[Ranger]	[Mystic Knight]	[White Mage]

Right Page ─────────────────────

[Black Mage]	[Time Mage]	[Summoner]	[Blue Mage]
[Red Mage]	[Beastmaster]	[Chemist]	[Geomancer]
[Bard]	[Dancer]	[Mime]	[Freelancer]

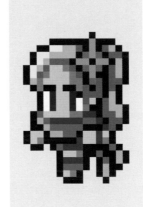
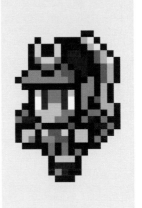

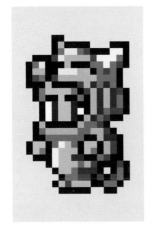
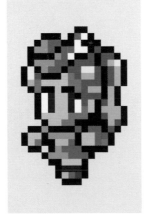
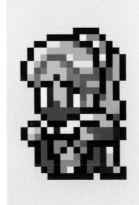
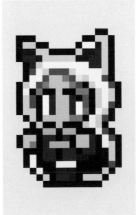

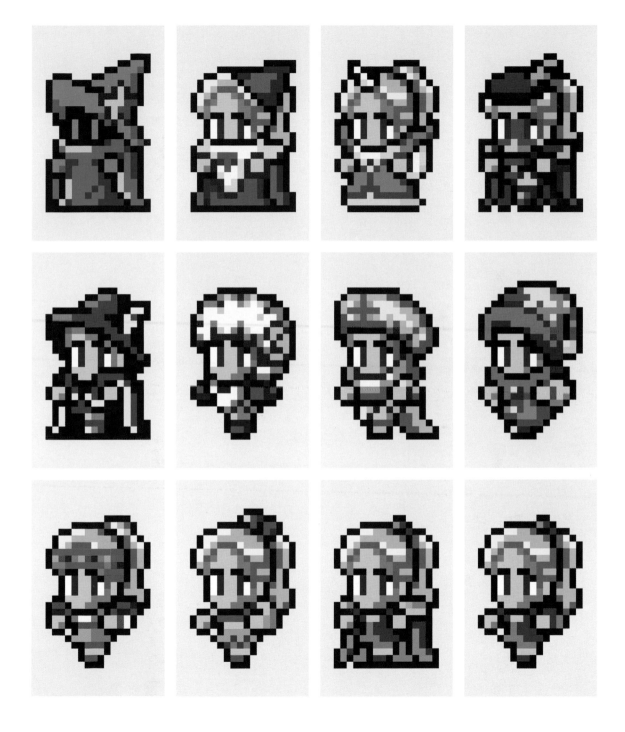

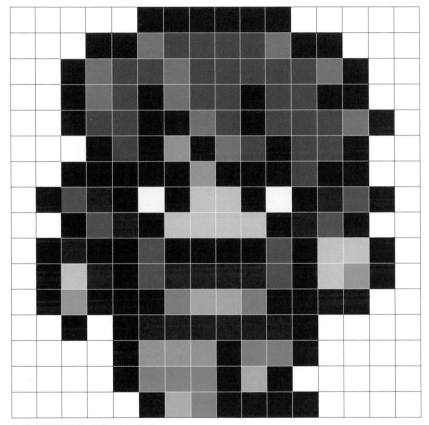

16 pixels

Color Palette

FINAL FANTASY V: World Character Sprite
16 pixels × 16 pixels

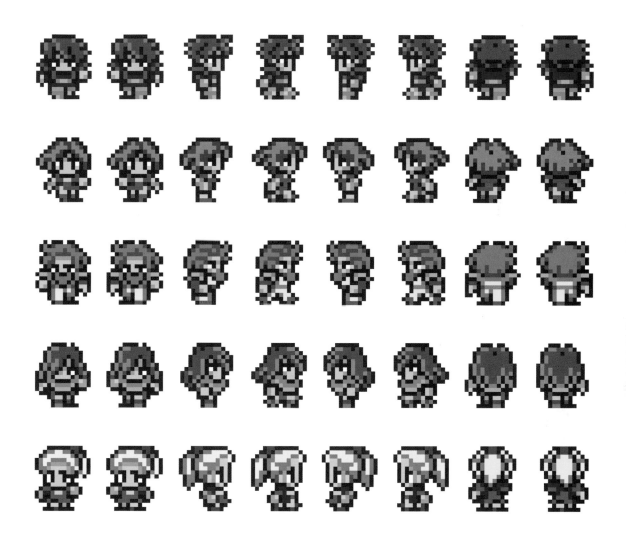

FINAL FANTASY V: World Character Sprites [Bartz/Lenna/Galuf/Faris/Krile]

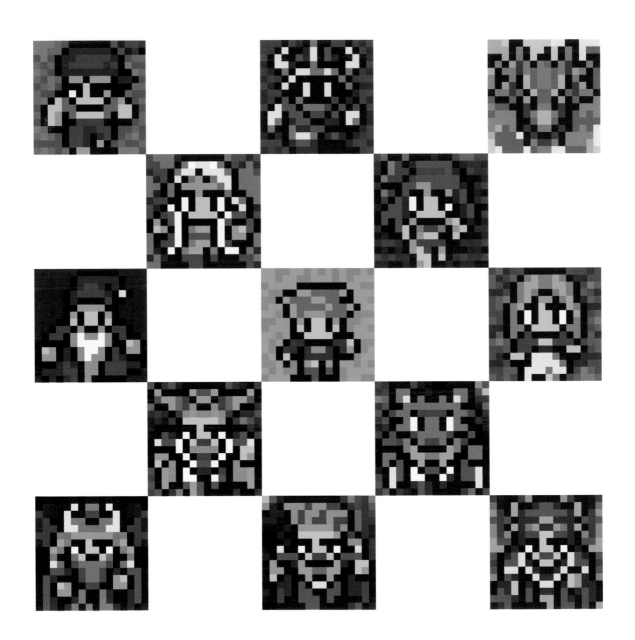

FINAL FANTASY V: World Character Sprites

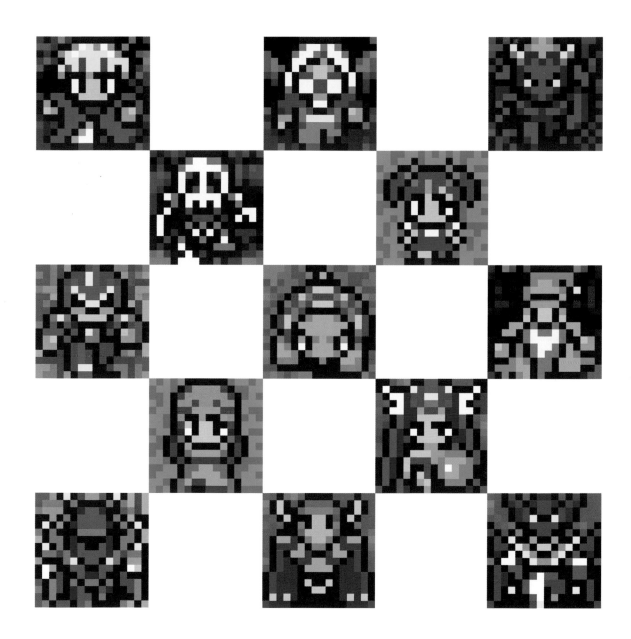

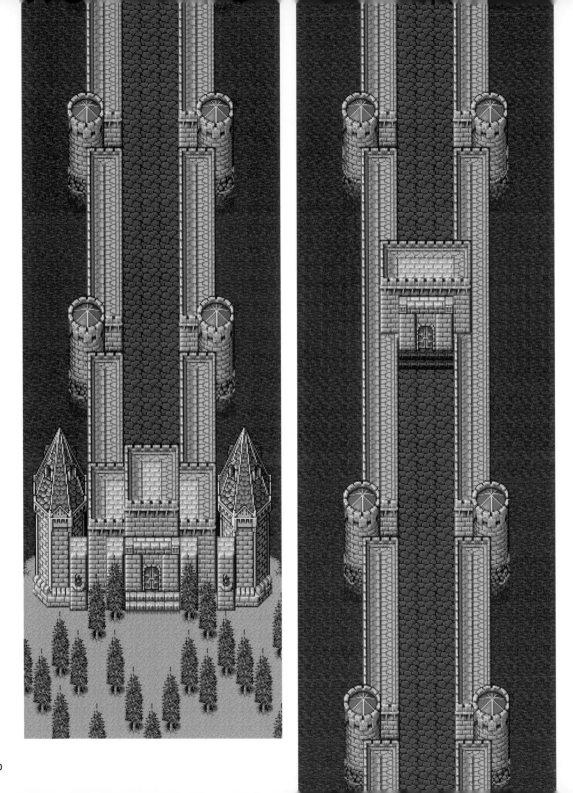

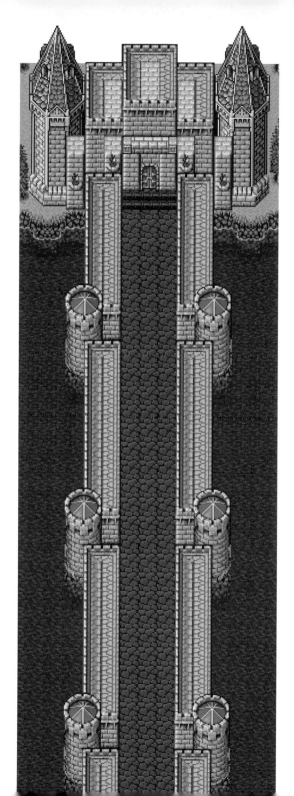

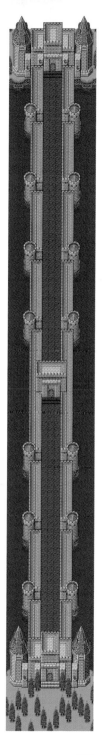

FINAL FANTASY V: Big Bridge

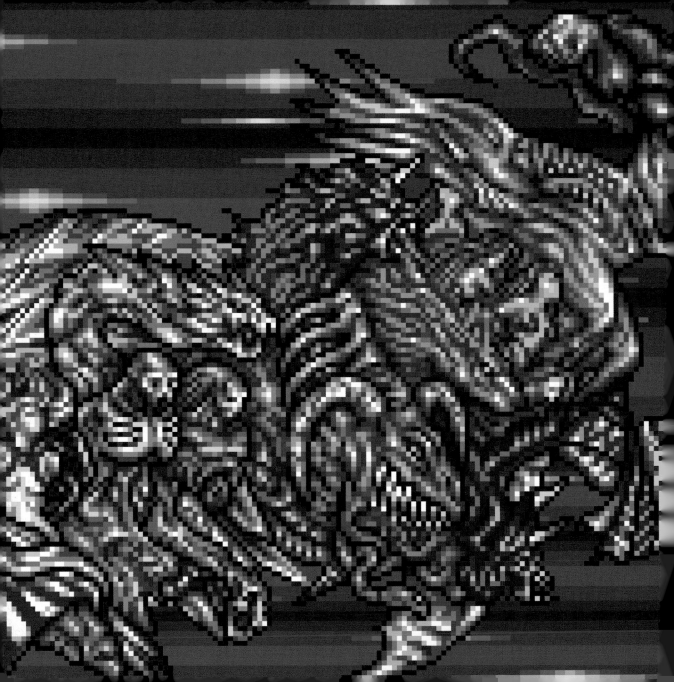

宇宙の
法則が
乱れる！

The laws of the universe mean nothing!

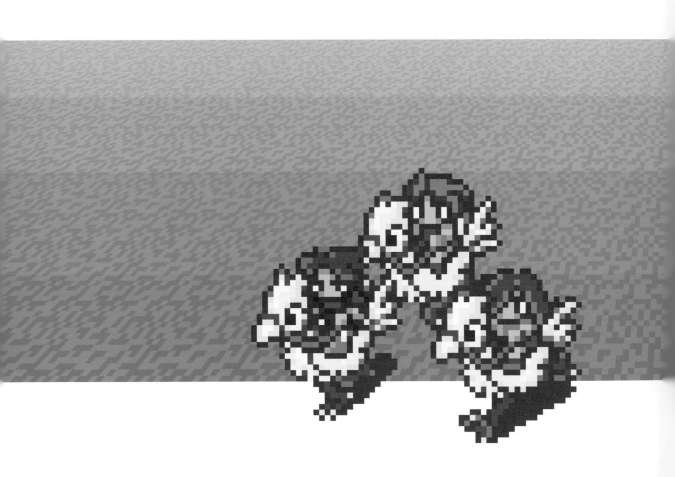

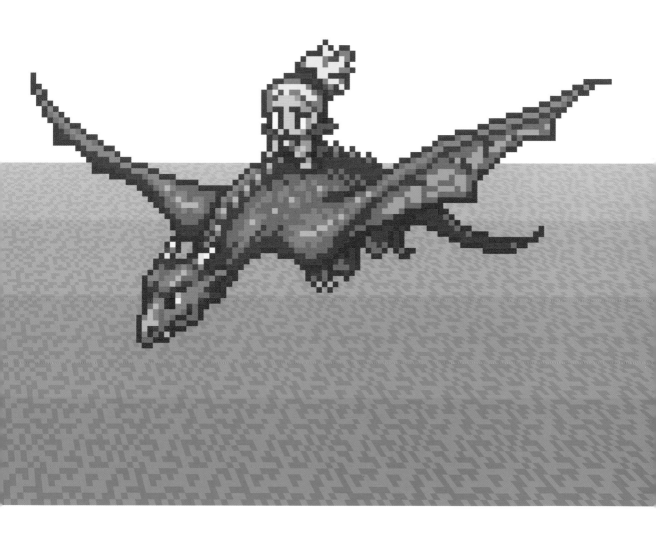

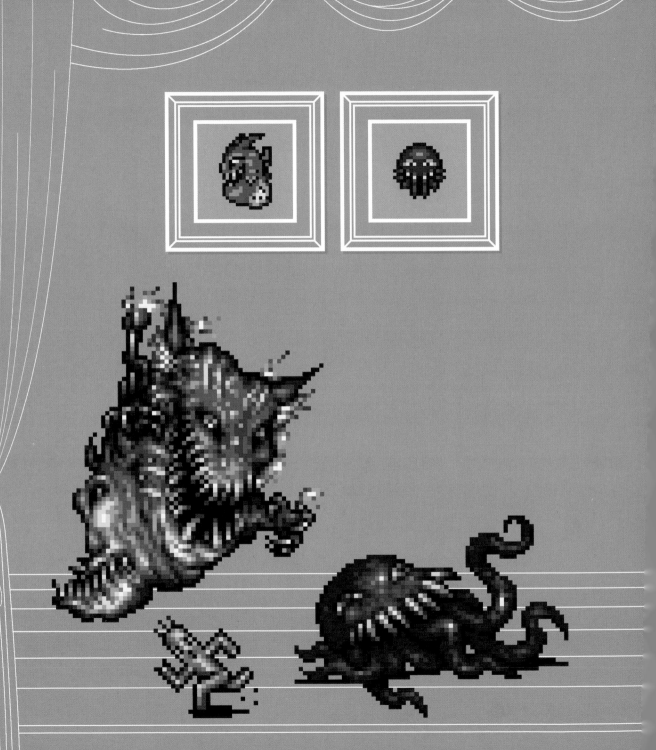

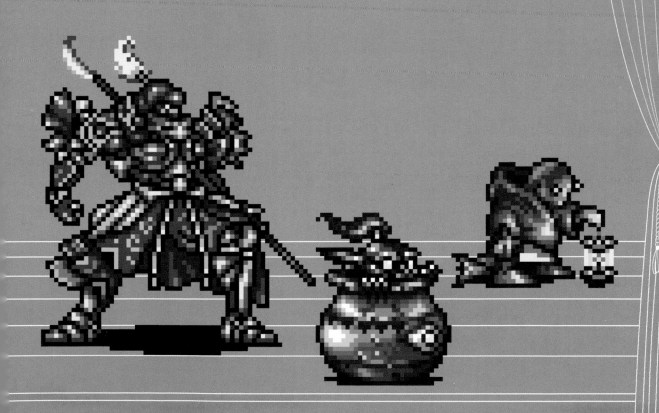

FINAL FANTASY VI: Character Sprite 2018 Ver. [Tina (Terra)]

 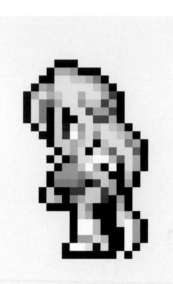

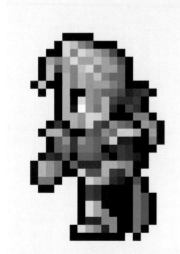 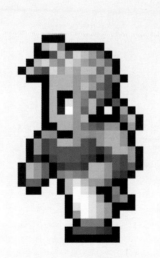 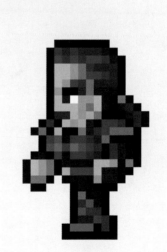

FINAL FANTASY VI: Character Sprites `2018 Ver.` [Locke/Celes/Edgar/Mash (Sabin)/Cayenne (Cyan)]

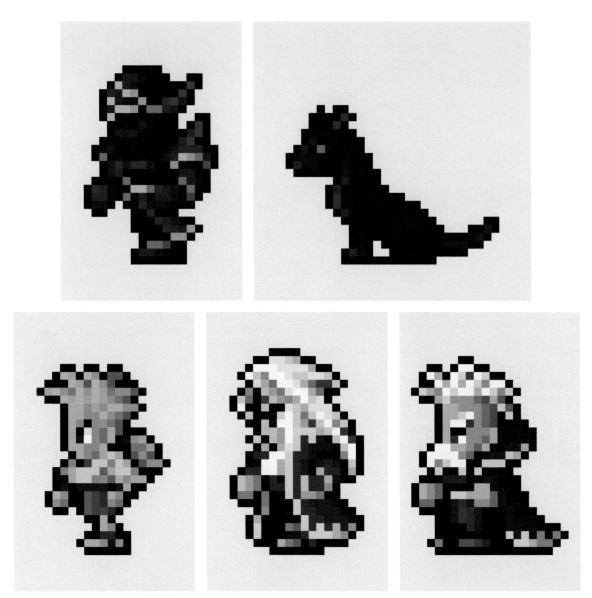

FINAL FANTASY VI: Character Sprites **2018 Ver.** [Shadow/Interceptor/Gau/Setzer/Strago]

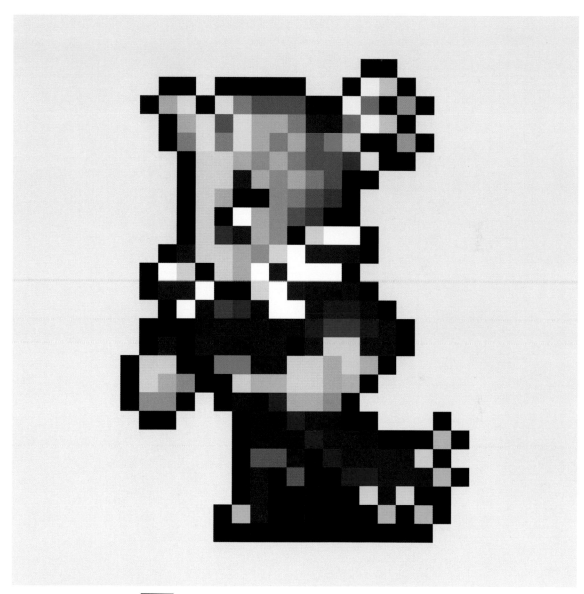

FINAL FANTASY VI: Character Sprite **2018 Ver.** [Kefka]

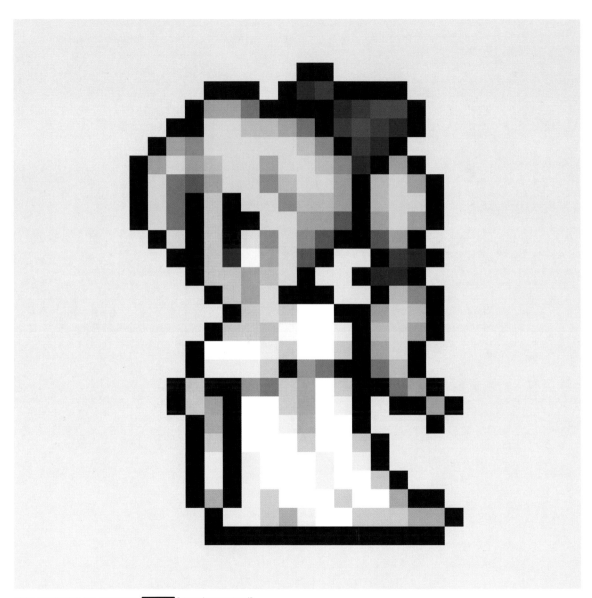

FINAL FANTASY VI: Character Sprite **2018 Ver.** [Celes (Opera Dress)]

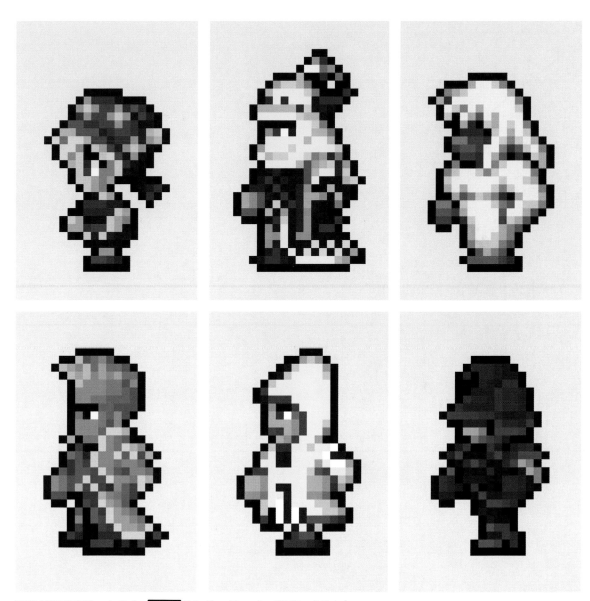

FINAL FANTASY VI: Character Sprites 2018 Ver. [Relm / Gogo / Umaro / Leo / Cid / Biggs & Wedge]

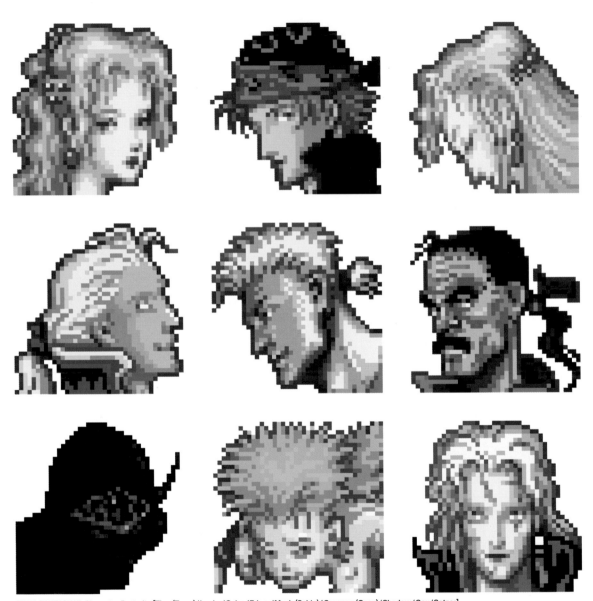

FINAL FANTASY VI: Character Portraits [Tina (Terra)/Locke/Celes/Edgar/Mash (Sabin)/Cayenne (Cyan)/Shadow/Gau/Setzer]

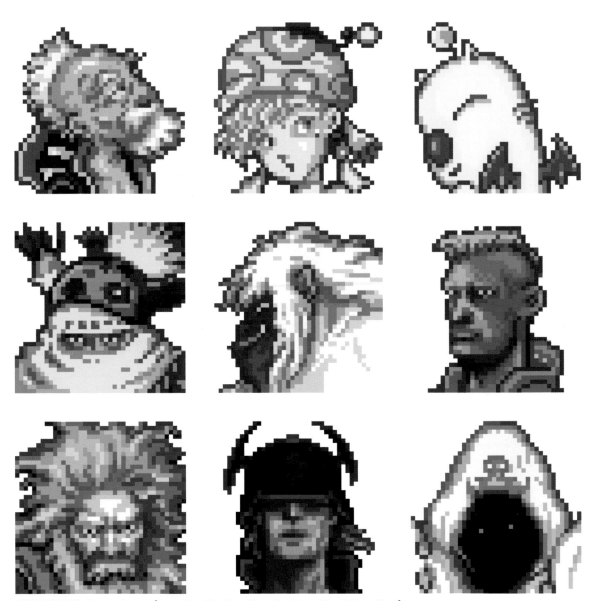

FINAL FANTASY VI: Character Portraits [Strago / Relm / Mog / Gogo / Umaro / Leo / Banon / Biggs & Wedge / Ghost]

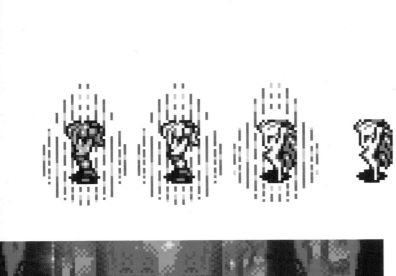

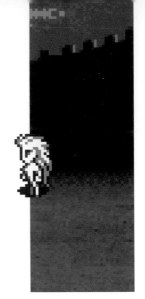

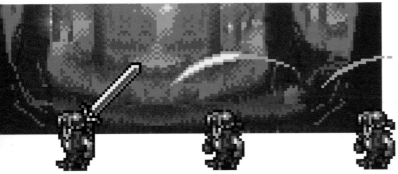

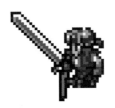

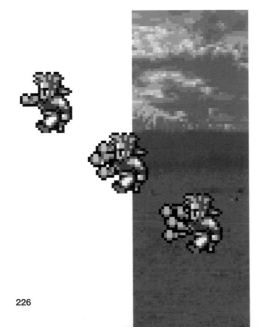

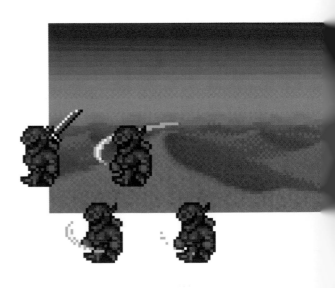

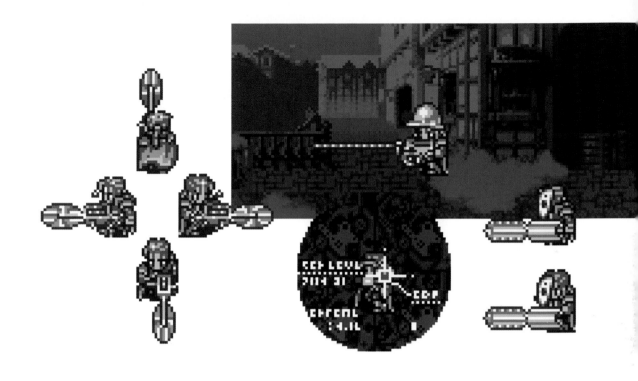

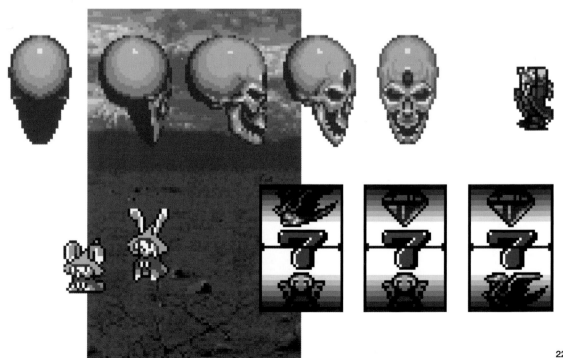

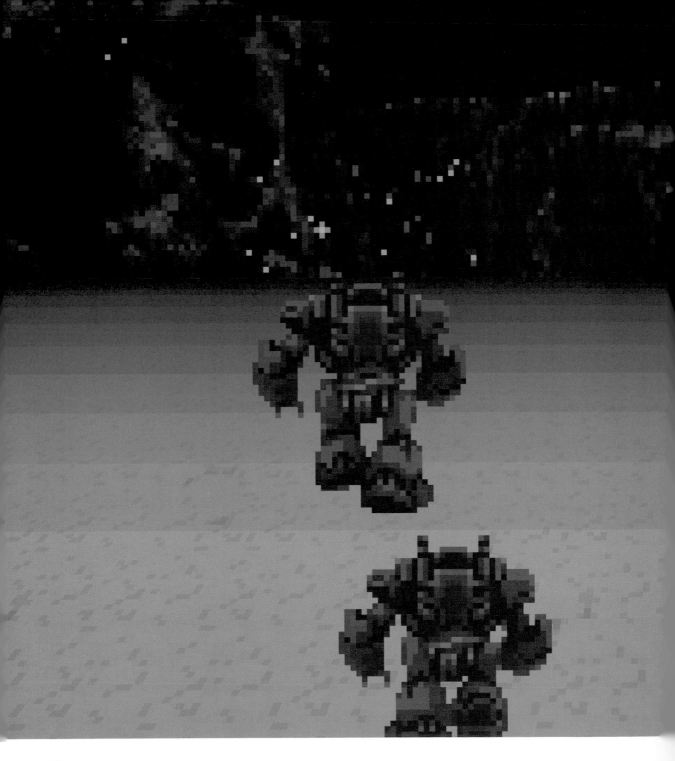

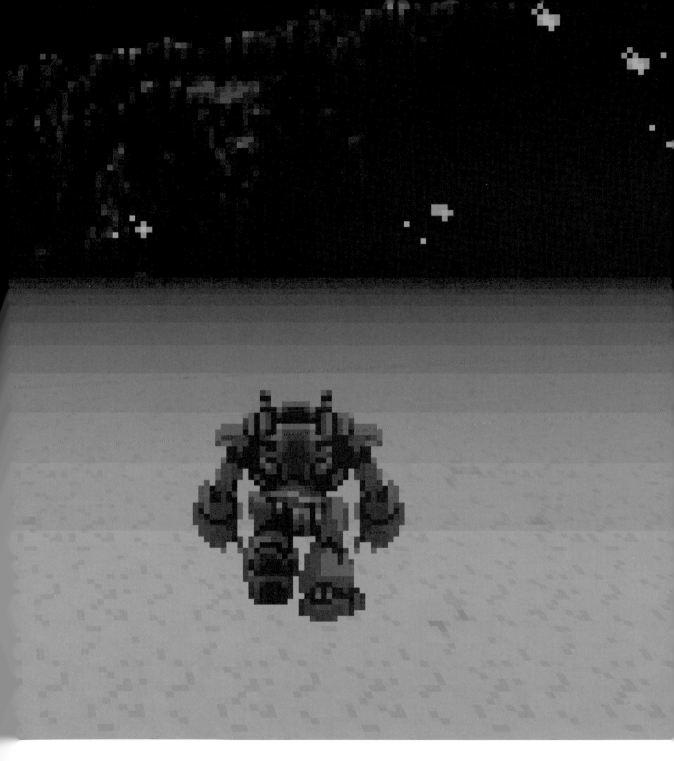

229

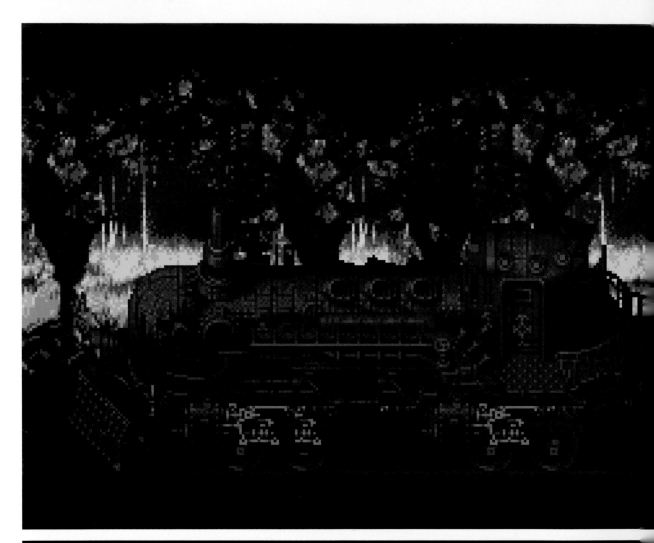

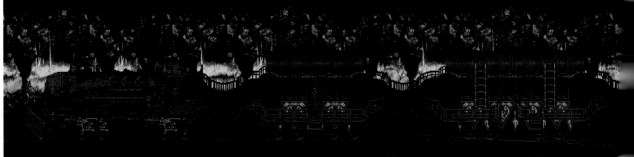

FINAL FANTASY VI: Phantom Train

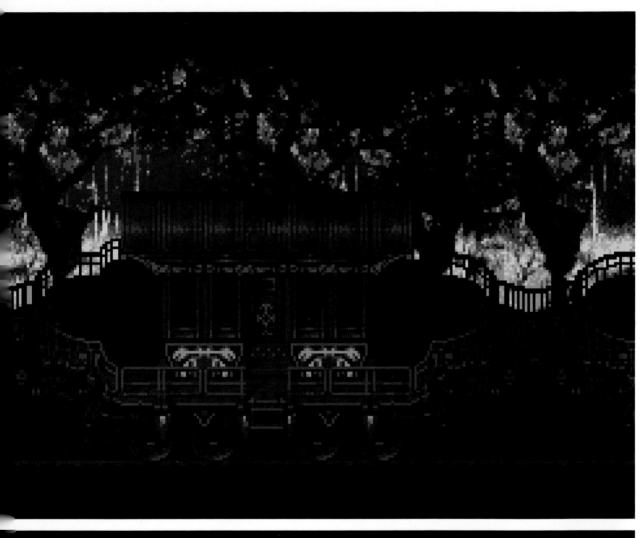

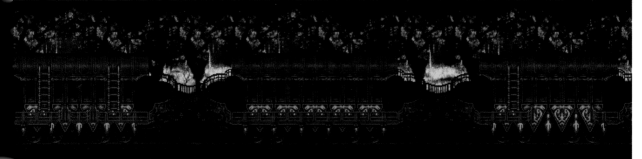

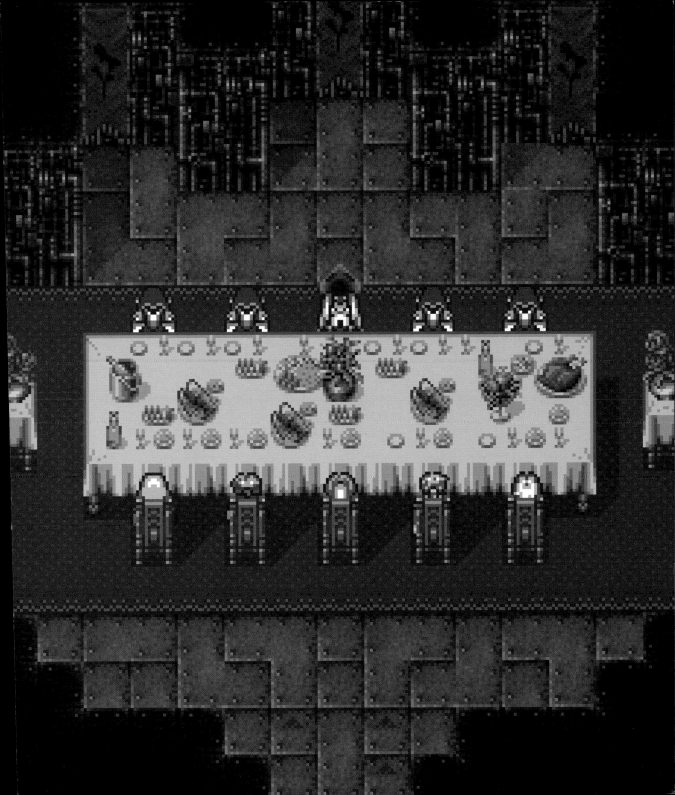

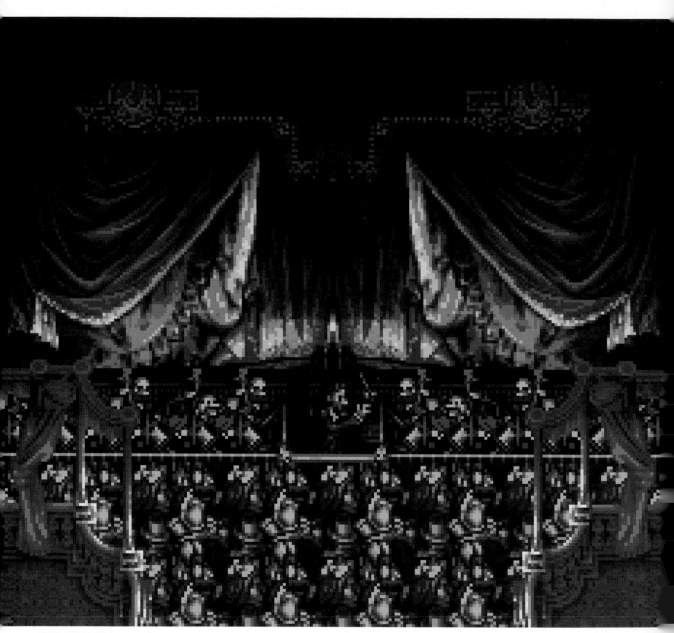

FINAL FANTASY VI: Opera House

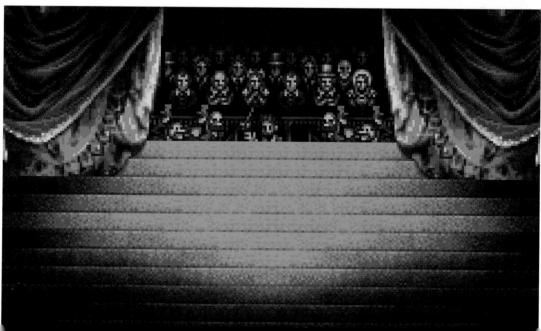

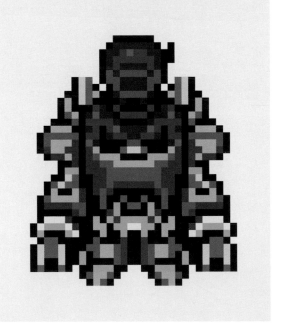

FINAL FANTASY VI: Magitek Armor

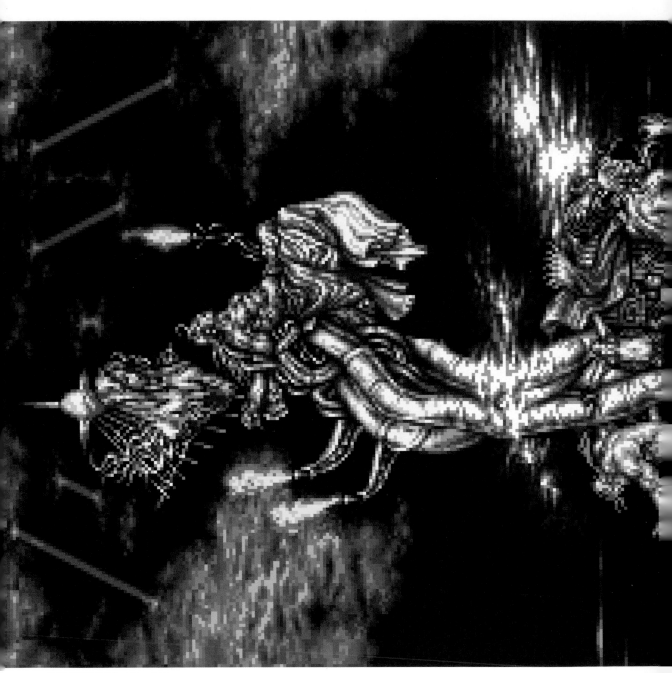

FINAL FANTASY VI: Last Boss Battle

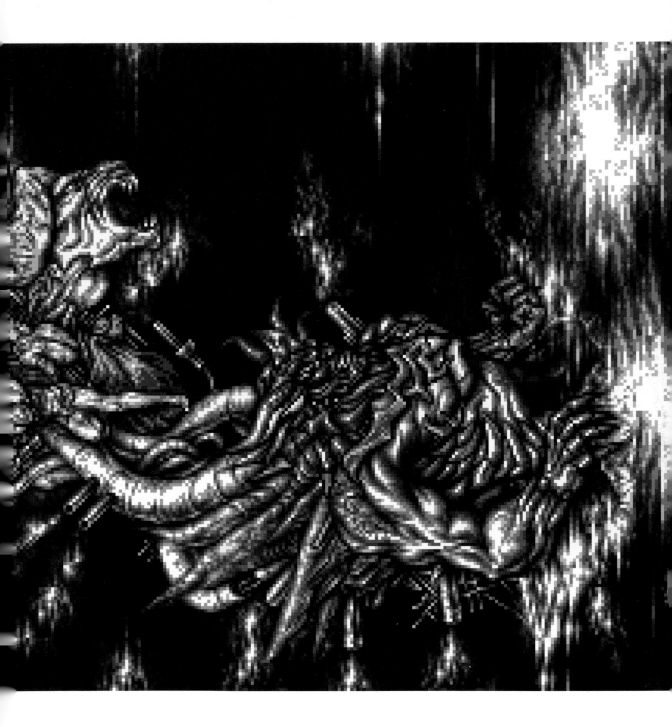

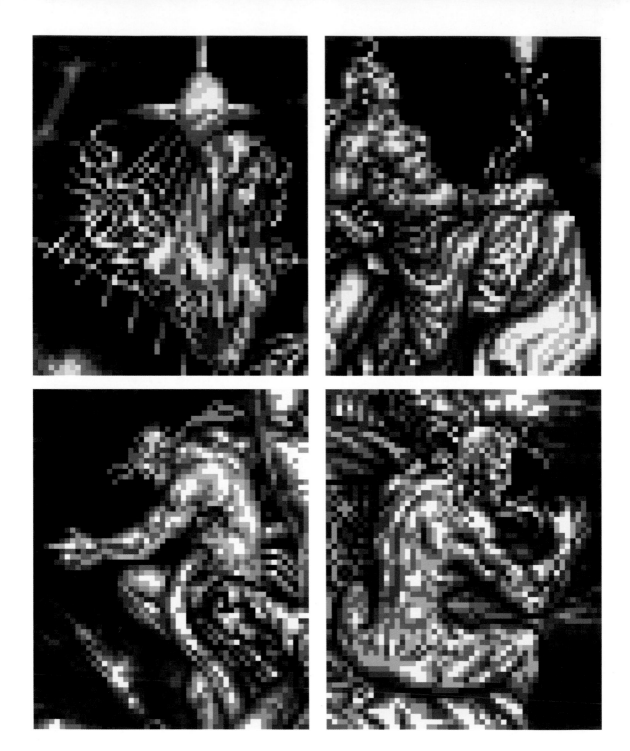

243

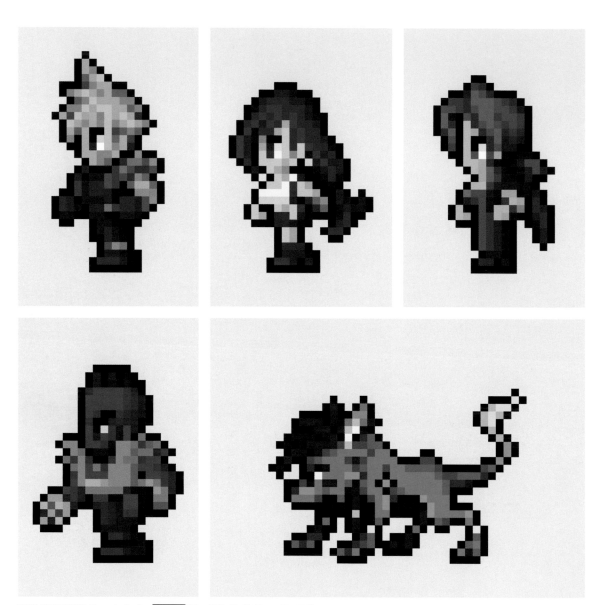

FINAL FANTASY VII: Character Sprites 2018 Ver. [Cloud / Tifa / Aerith / Barret / Red XIII]

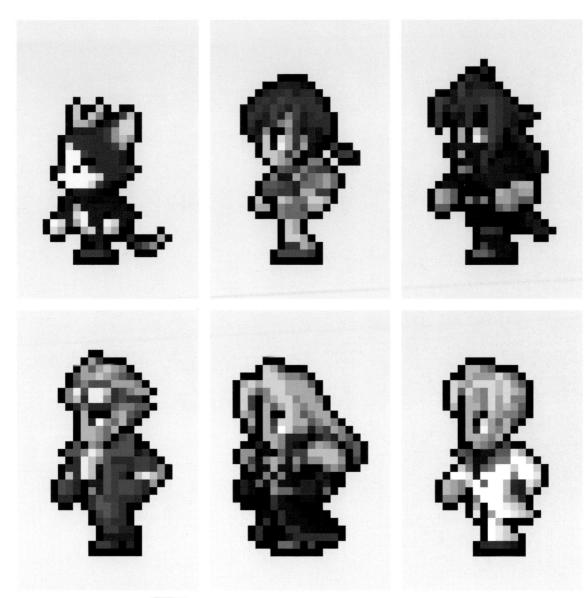

FINAL FANTASY VII: Character Sprites **2018 Ver.** [Cait Sith / Yuffie / Vincent / Cid / Sephiroth / Rufus Shinra]

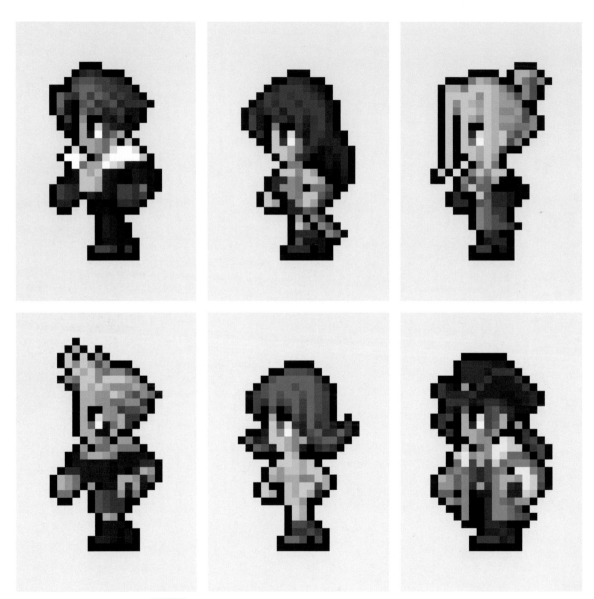

FINAL FANTASY VIII: Character Sprites **2018 Ver.** [Squall/Rinoa/Quistis/Zell/Selphie/Irvine]

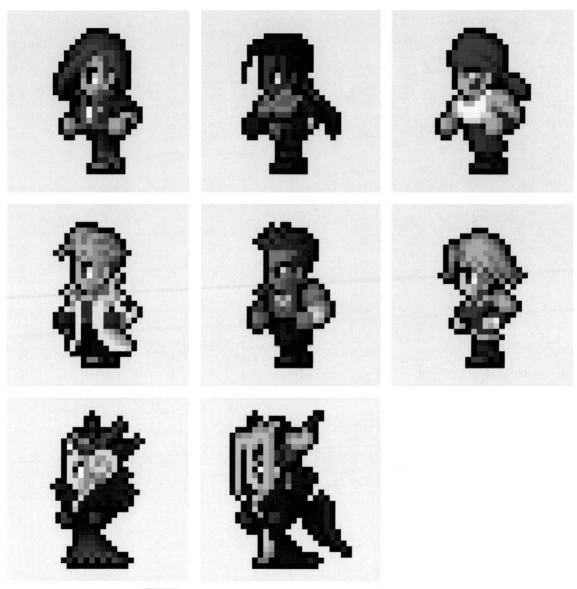

FINAL FANTASY VIII: Character Sprites `2018 Ver.` [Laguna / Kiros / Ward / Seifer / Raijin / Fujin / Edea / Ultimecia]

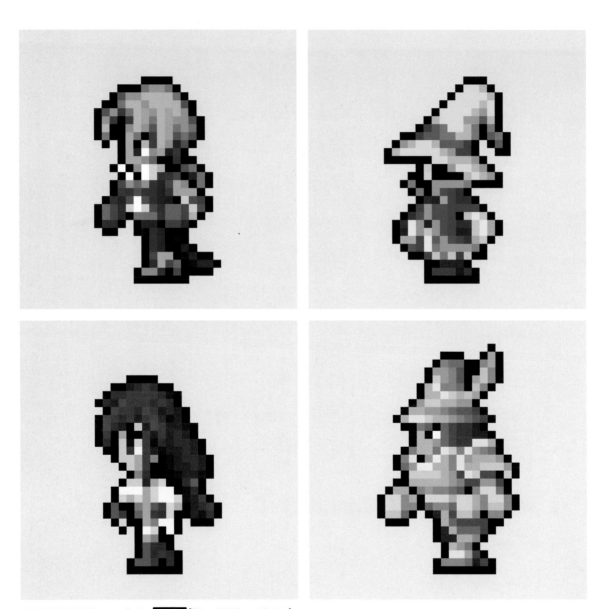

FINAL FANTASY IX: Character Sprites 2018 Ver. [Zidane/Vivi/Garnet/Steiner]

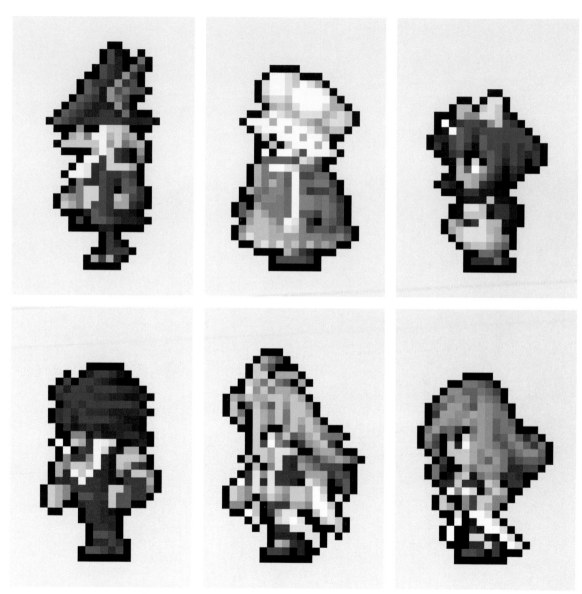

FINAL FANTASY IX: Character Sprites **2018 Ver.** [Freya / Quina / Eiko / Salamander (Amarant) / Kuja / Beatrix]

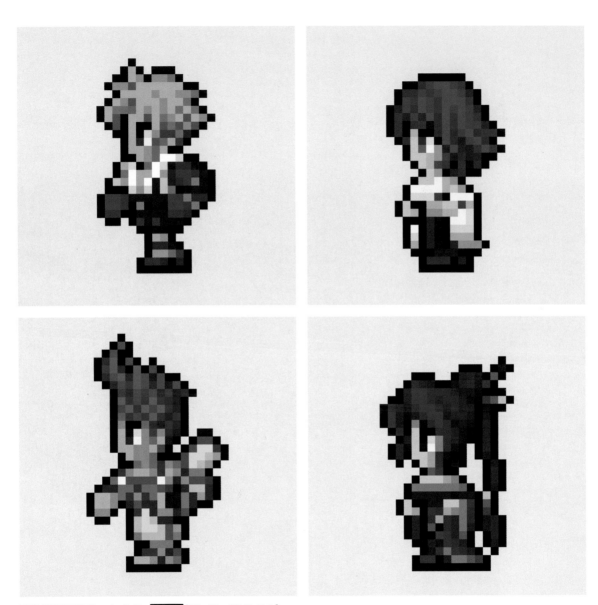

FINAL FANTASY X: Character Sprites 2018 Ver. [Tidus／Yuna／Wakka／Lulu]

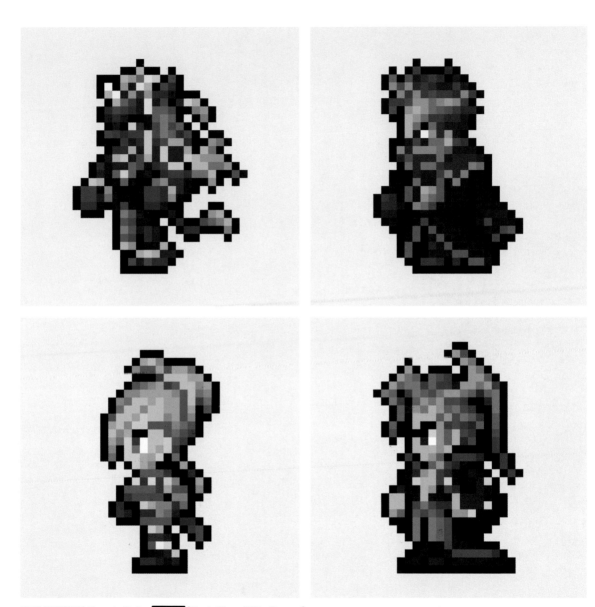

FINAL FANTASY X: Character Sprites **2018 Ver.** [Kimahri / Auron / Rikku / Seymour]

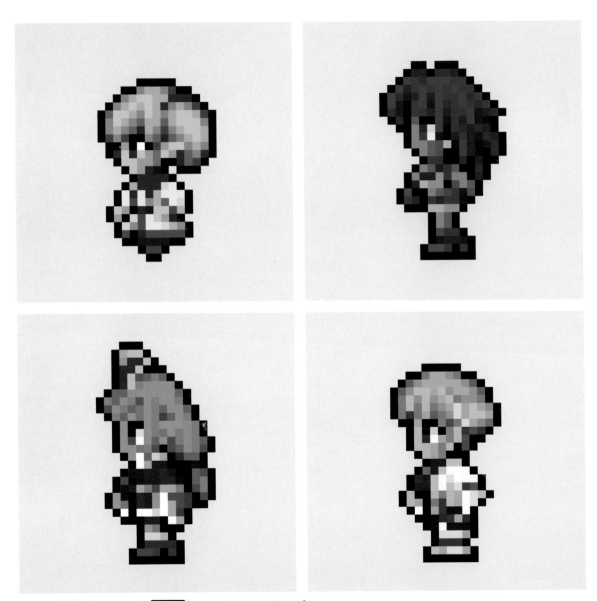

FINAL FANTASY XI: Character Sprites 2018 Ver. [Shantotto / Lion / Prishe / Aphmau]

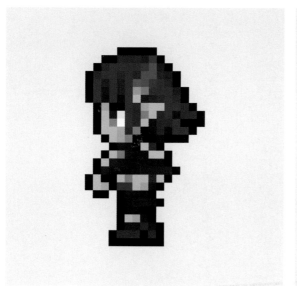

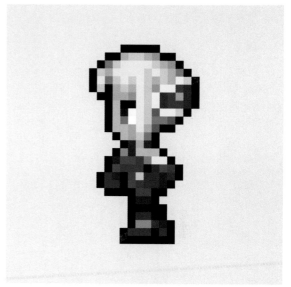

FINAL FANTASY XI: Character Sprites `2018 Ver.` [Lilisette / Arciela / Mandragora]

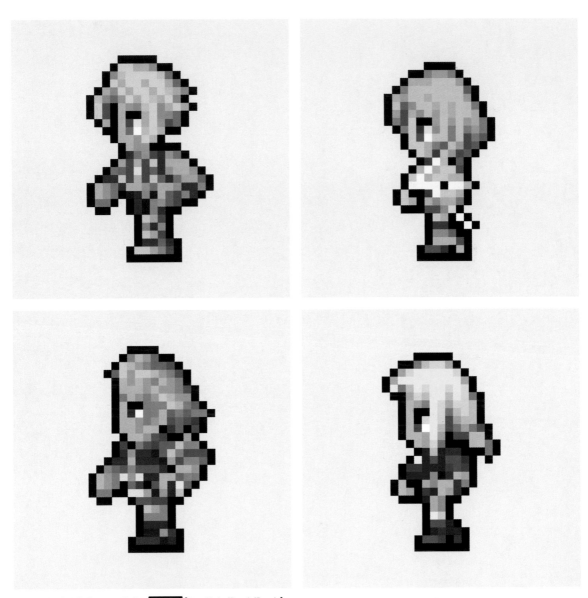

FINAL FANTASY XII: Character Sprites `2018 Ver.` [Vaan / Ashe / Basch / Penelo]

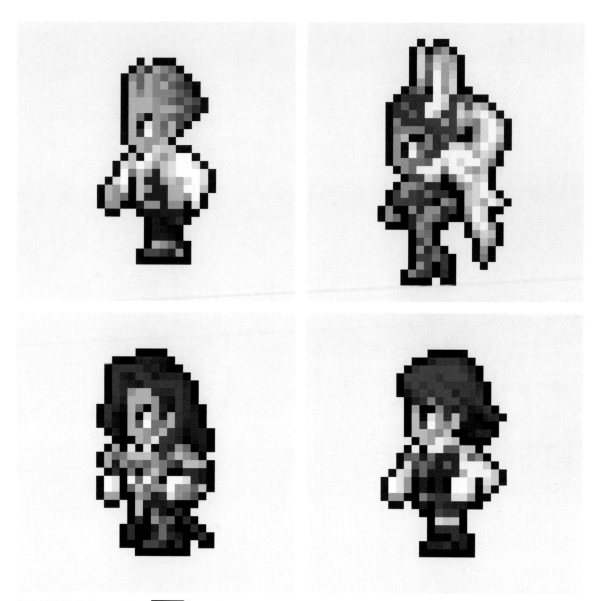

FINAL FANTASY XII: Character Sprites 2018 Ver. [Balflear (Balthier) / Fran / Vayne / Larsa]

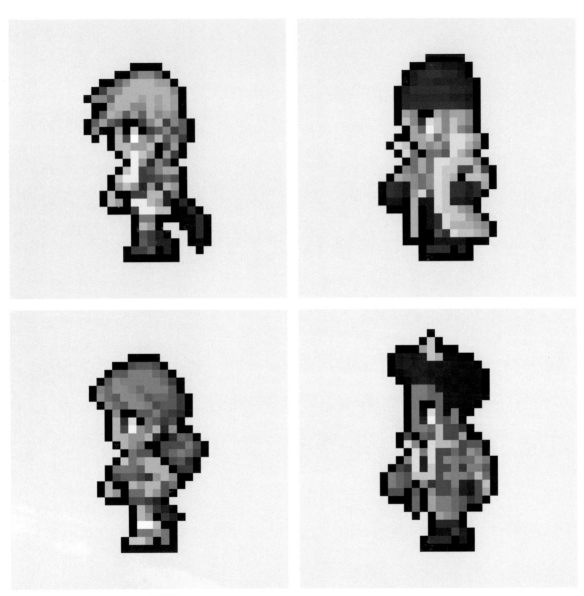

FINAL FANTASY XIII: Character Sprites 2018 Ver. [Lightning/Snow/Vanille/Sazh]

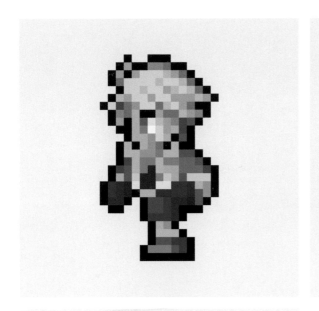
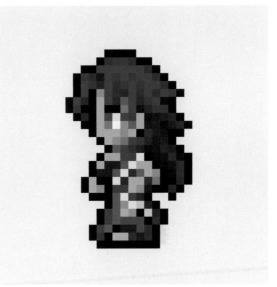
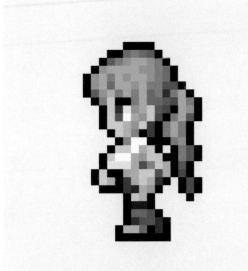

FINAL FANTASY XIII: Character Sprites `2018 Ver.` [Hope / Fang / Serah]

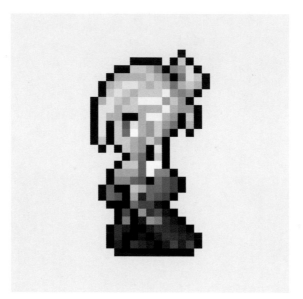

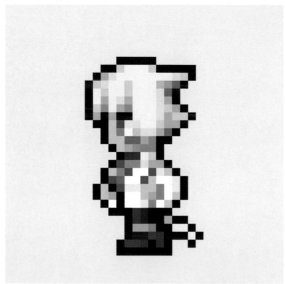

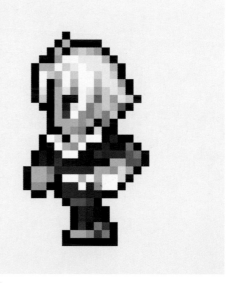

FINAL FANTASY XIV: A REALM REBORN: Character Sprites 2018 Ver. [Minfilia / Y'shtola / Thancred]

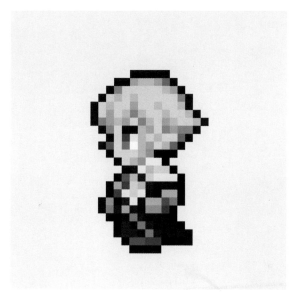

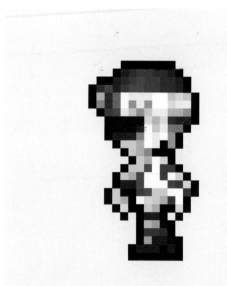

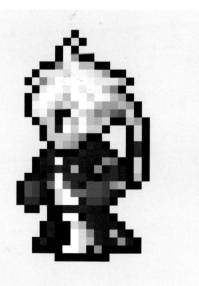

FINAL FANTASY XIV: A REALM REBORN: Character Sprites 2018 Ver. [Papalymo/Yda/Alphinaud]

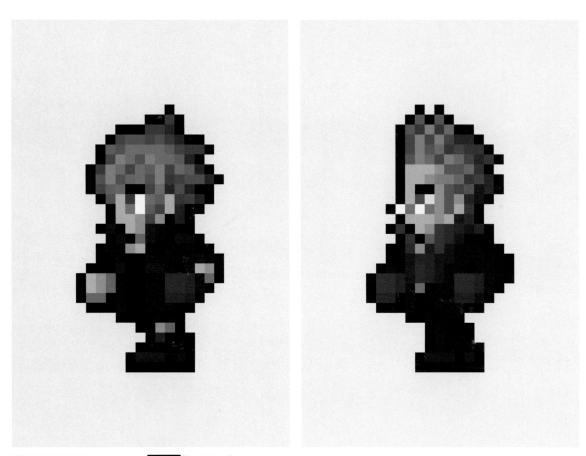

FINAL FANTASY XV: Character Sprites 2018 Ver. [Noctis／Ignis]

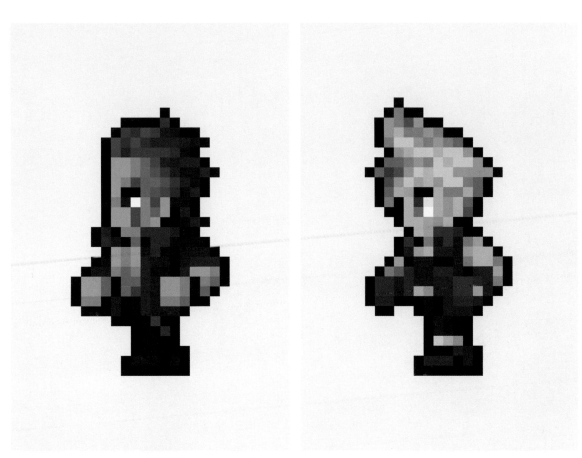

FINAL FANTASY XV: Character Sprites **2018 Ver.** [Gladiolus / Prompto]

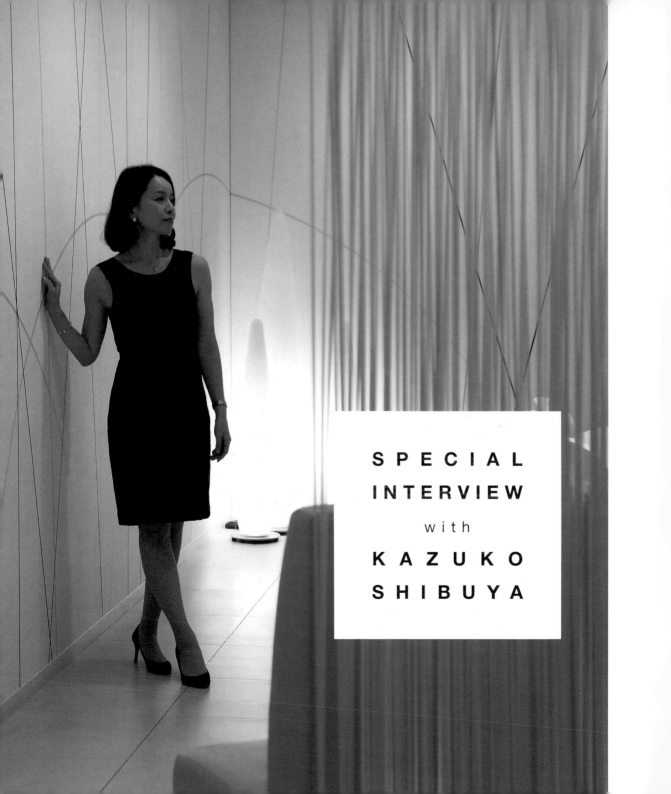

SPECIAL
INTERVIEW
with
KAZUKO
SHIBUYA

The Little Girl Who Loved to Draw

— **How did you get into pixel art?**

Well, this is going back a lot earlier than my first encounter with pixel art, but when I was of kindergarten age, I loved drawing and did it every day. Apparently, I would even take my art set with me when we went to visit relatives, and my parents said that I spent most of the time doodling. I started buying manga when I entered elementary school, and by the time I was in the fourth grade, I had picked up a pen and started doing something similar to [overlaying pencil sketches with] inks. That's because I loved to read *Shoujo manga nyuumon* [a series of how-to books for girls' manga].

— **Fourth grade is quite young to start inking, isn't it?**

Yes, it is. I have a niece who's about that age now, and when I see her, I realize how grown-up my art style was back then. I really liked imitating the art and layouts in *shoujo* manga. In those days, the characters had big, twinkling eyes. I would draw in that style every day.

— **Did you draw anything besides manga-style pictures?**

I used to draw the costumes worn by pop idols on television. It was the same in those days as it is now—they all have such cute outfits. VCRs were still not that common, so I'd draw while watching the music programs on TV. I really struggled with the New Year's music show *Kouhaku uta gassen* (Red and white year-end song festival) because there were so many performers, and each act only sang for a short time! [*laughs*] I would be sketching like crazy while they were singing, and I would have to imagine the parts of their costumes that I couldn't see.

— **That's an impressive level of concentration.**

I think I can be a bit obsessive. If I saw something that I wanted to draw, I'd start copying it, and I would cut out my favorite scenes from manga and stick them into a scrapbook. Around sixth grade, I had a vague notion of wanting a job related to art. I started off thinking I wanted to draw manga, since I was so familiar with it. My classmates were impressed with my pictures and told me I could become a manga artist, and I appreciated the encouragement, so I would give them things I'd drawn. And that's how I spent my elementary school years.

Middle-School Mentor

— **How about middle school?**

After entering a local middle school, I joined the art club. It was there that I met someone of particular importance to me. Our art teacher taught us a great deal—not just the basics like how to use oils and watercolors, but she also took the art club to exhibitions. I received in-depth tuition in drawing from observation, which included being told to fill an entire sketchbook with pictures of a single plaster statue. I'd start at the end of the school day at three o'clock and, since it was a middle school, I think the latest I could stay was about six o'clock, so I would spend that entire time sketching. I'll never forget that plaster-cast head of Venus. After each of those three-hour sessions, I'd show my teacher, who'd make corrections to my work, and we'd repeat this on a daily basis. It was worth the effort, though, because when I got to the end of that sketchbook and looked back at the first few pages, there was a drastic improvement. I even surprised myself, and I think the purpose of it was to learn how important it is to keep drawing.

— **So that's how you learned the fundamental skills needed to become a designer?**

Our teacher also taught us how to sculpt reliefs and three-dimensional pieces, and we had the opportunity to do this ourselves with a type of papier-mâché. We put torn-up newspaper into a bucket and mixed it with glue and sawdust, which forms a substance that hardens when dry. The senior members of the art club made a life-sized statue of [the bodhisattva] Kannon,

which I think still stands somewhere in the school. Some of the other younger members and I tried our hand at making a two-to-three-meter-square relief. I was in a team of three or four girls, and we stuck bits of papier-mâché onto a board which eventually became four goddesses in various poses. I remember thinking that it's actually harder to make only half of something, as in a relief, than it is to make a fully three-dimensional sculpture. It was entered into a local art event in Sagamihara called the Sagami Kazekko-ten, which is still held to this day. If that relief is still around, it's probably decorating the school's staff entrance.

My teacher, who taught me about sculpture, oil painting, and sketching—everything related to art—was the first person I met to have a major impact on my life.

—— **Other than your experiences with art, were there any other changes at this point in your life?**

Anime suddenly became very popular while I was in the first and second years of middle school, and shows such as *Space Battleship Yamato*, *Galaxy Express 999*, *Mobile Suit Gundam*, and *Space Runaway Ideon* all appeared around this time. I was really into *Gundam*, and since I had gotten good at mimicking styles, I tried to color in the style of cel animation. It was also the golden age for anime magazines and related media, and

there was a vast amount of information available, so I learned a lot about the various aspects of anime beyond drawing techniques. While my studies were giving me a deeper understanding of art, I was also immersing myself in the world of animation and continued to emulate the style of shoujo manga.

—— **Did you try re-creating any cel animation?**

The anime magazines included images of actual cels, which I copied and tried animating. I'd keep myself amused by re-creating various scenes or making things for my friends. I would even draw my New Year's cards one by one by hand. I'd be really grateful if anyone still had those cards!

High School and Another Impactful Meeting

—— **What was high school like for you?**

While I was in middle school, I would spend time with one of the older members of the art club, creating anime-style images, making little animations, and so on, but when I started high school, my interests leaned back toward shoujo manga, and my art style became a bit more grown-up, too. In the first year,

I became friends with the girl sitting next to me who shared my interest in art. We would buy manga and read them together, go to the bookstore on the way home, and draw. We would pass a sketchbook between us every day, like how some people do with a diary, but with pictures instead, and this continued throughout the three years of high school. It was thanks to her that I fell in love with shoujo manga all over again.

At that time, I had another friend who was into anime and novels, and it was because of her that I started reading the *Crusher Joe* books by Haruka Takachiho. It was actually Yoshikazu Yasuhiko, the character designer and animation director for *Mobile Suit Gundam*, who did the illustrations for the books and directed the animated movie, so I became reacquainted with his work for the first time since middle school. I loved *Gundam* when I was in middle school and could draw the characters from memory. My copies of his artwork went a step further in that I went through a phase where even if I tried to do my own original artwork, it would be based on Yoshikazu Yasuhiko's style. I would often go through phases like this, and the basis for my art would change depending on what I was watching or reading at the time, like I was gravitating toward those styles. This is why my style contains a mixture of the essences of all these great artists, but I've internalized them pretty well by now, so no particular style stands out.

— **Did the exposure to all these different forms of media change your thoughts on your direction in life?**

In elementary school, I really liked manga and wanted to become a manga artist, but I considered anime as well after being introduced to it in middle school. I started making *doujinshi* [fan-made works] with the girl who sat next to me in high school, which showed me the rich and expansive world of fandom. I started having my work published in magazines and attending Comiket [the doujinshi fair], and I suppose I was becoming what would be called an *otaku* by today's standards. Even so, I joined the art club in high school, just like before.

There was actually a manga appreciation club as well, but I was already making my own doujinshi, so I didn't feel the need to join it. With the art club, I would make sketches, do oil paintings, and draw from observation. For those three years, I really focused on improving my technique through the art club. Since I was also drawing manga and illustrations for doujinshi at the same time, this was the point where the volume of my artistic output was at its highest.

When the time came to choose a career path, becoming an animator was one of the things I felt ready to do. Whatever field I worked in, I just wanted to draw, and I joined an atelier in the third year of high school to work on my skills. My aim was to relearn the basics of fine art before thinking about the next step, and I attended the atelier for about a year with a friend who was applying to enter an art school. I went back to spending each day working with plaster busts and still lifes, but because I seemed to have an eye for accuracy, I progressed in leaps and bounds. The instructor praised my work and said that I would definitely be able to get into art school if I applied. But back in those days, it was hard to imagine a job waiting for me after

The Path to the Games Industry, and a Great Turning Point

—— So you didn't go straight into a job in animation?

It's probably the same these days, but you have to draw an unbelievable number of cels to make a decent wage, so I didn't feel that it was going to work out in the long run. I wasn't really suited to drawing between the lines of two other cels like that, and it seemed to me that it's not much fun being an animator unless you're doing the key frames. The vocational school found me part-time work on proper anime shows like the *Obake no Q-tarou* remake and *Transformers*, but it just wasn't for me. I was worried about finding a job at the end of the two-year course, so I asked my tutor about working in other fields, which led to video game companies, and the only one hiring at the time was Square. I didn't play games at all and knew absolutely nothing about them, but it was a chance to draw for a living, so I decided to give it a try and went for an interview.

It was held in a rented office space on the second floor of a small building in Hiyoshi on the Touyoko Line. The interviewers were Hironobu Sakaguchi[1] and Hisashi Suzuki.[2] It was more like a casual chat than an interview, and they asked me to make pictures using a 16 × 16 grid. That was pretty much all it was, and they contacted me two days later to offer me a job.

—— So in other words, they asked you to create pixel art. Did they hire you based on what you drew at the interview?

I think I drew something simple like a flower. I didn't play games, the only oil paintings and illustrations I'd done were all quite realistic, and I'd never even heard of pixel art and had obviously never tried it before, but I gave it a shot anyway. I have no idea if my pictures were what they were after, though! [*laughs*]

That interview was my first encounter with pixel art, and I'd never really considered a video game company as a place where I could work as an artist. All I could think about was how happy

graduating from art school. We didn't have the internet, so it was hard to get any information. On the other hand, I thought that if I studied animation at a vocational school, I'd be able to get a job making anime. If I'd wanted to become a manga artist, I would have had to prepare drafts of manga pages and take them to publishers, and I wasn't passionate enough about manga to go through all that, so I opted to study animation at a vocational school.

I was to be offered a job drawing pictures. Looking back on it now, I was rather carefree about the whole thing, but when I think about all the people I'd meet from that point on, I get the feeling that it was a case of amazing foresight on my part. Life can be strange like that. [*laughs*]

— **What was it like when you started working there?**

Mr. Sakaguchi was there on my first day, and I was introduced to Hiromichi Tanaka[3] and Nobuo Uematsu.[4] I've met several people who've had a major impact on me; the first was my middle-school art teacher, and the next was the girl who sat next to me in high school. Joining this company, the next three were Messrs. Sakaguchi, Tanaka, and Uematsu. Now that I think about it, I feel like that was the point that decided the rest of my life. I never imagined this is where I'd be thirty years later! [*laughs*]

Creating Art for Games

— **Pixel art is very different from traditional styles of art. Was it easy to adapt?**

Whenever I visualize an image, it's always completely realistic. I approach sketching and still life with the mindset of making it true to life, and there are no grids or limits on the number of colors, so it's fair to say I was a little lost at first. Having said that, I kept in mind that the finished piece would be different from the realistic image I had visualized, and considering the hardware limitations of the time, I think I was able to produce the best possible results.

My first assignment was creating pixel art for the MSX[5] version of *King's Knight*. The game had four protagonists, all rendered in tiny 16 × 16 pixel art, with a walk animation made by flipping the same sprite horizontally with each step. I also drew the scenery, like the trees and the ground. The PC game *Alpha* was being developed in-house, and I was asked to produce illustrations for the manual, as well as in-game artwork for the PC version of *King's Knight*.

Back then, the pixel art for PC games wasn't drawn using a mouse or stylus; the graphics software had each color assigned to a key on the numeric keypad, and we had to draw one pixel at a time. The 1 key would be red, for example, while 2 would be yellow, and we could make other colors by arranging the pixels in a checkered pattern, like alternating red and yellow to make a skin tone, or yellow and blue to make green, making the image pixel by pixel. It was really painstaking work. *Alpha*'s main character had a blinking animation, and in those days, it was considered groundbreaking and one of the selling points of the game.

— **Then you worked on *WorldRunner* and *Rad Racer*?**

After the programmer Nasir Gebelli[6] arrived at Square, we made *WorldRunner* and *Rad Racer*. He did all the programming, and I made most of the graphics, while some of the other designers took care of the backgrounds and so on. I wasn't directly involved, but there were several other titles that Square released, like *Suishou no dragon* and *Apple Town Story*. It was around this time that *Dragon Quest* made its debut, and it caused quite a stir within our company.

Mr. Sakaguchi was really into *Wizardry* on the Apple II[7] and I think he felt like he'd been outdone when something similar was created for the Famicom. He didn't think it was possible to make a role-playing game on that console. That's when he said, "We're going to make one too!"

I actually can't remember how I came to join the *Final Fantasy* team, but Mr. Sakaguchi told me recently what had happened. There was a meeting held in the company where a few members, including him and Mr. Tanaka, pitched their ideas for a new game to the rest of us, and Mr. Sakaguchi announced he was going to make a role-playing game called *Final Fantasy*, but it seems nobody volunteered to join his team. Apparently, I raised my hand and said, "I'll make the graphics."

— **So if someone wanted to join a certain team, all they had to do was raise their hand?**

Yes, that's right. I think it's in the credits for the original *Final Fantasy*, but something called "Square A-Team" is listed, which was originally just me and one guy, a game designer. We were hopelessly understaffed, so Koichi Ishii[8] and Akitoshi Kawazu[9] were hired to join our team.

— **This was your first time working on a role-playing game. Where did you start?**

I thought I should start by making the towns. I'd mainly worked on action games and adventure games up until that point, so I hadn't created maps of a full town or city before. Anyway, I thought that we should be fine as long as we had the scenery, towns, and battle scenes, so I began with the towns. I also looked at other games, and when I found things that I would've done differently, I tried experimenting with my own style. For example, buildings such as houses were often depicted without a roof, just exterior walls, so I decided to add roofs to make them more realistic. Even though I was working at a video game company, I didn't actually play any games, so I hardly knew anything about them. I drew on my experience of what I'd seen and the things I'd drawn myself, which culminated in the image

of the town [*page 046*]. It has a European feel to it. For a Famicom game, this was quite a detailed depiction, and it used up a lot of the available data, but if there was something I really wanted to do, they generally let me do it, and I compensated by using more economical techniques in other areas.

You know, whenever I do something new, I try not to take it too seriously. That's why when it comes to pixel art, I don't let anything faze me because I know that once I start, it should turn out fine. That's my approach when I try new things, even now. You never know until you try.

Monsters Formed of Shadow

— **You are well known for your work on the character sprites in the *Final Fantasy* series, but what else have you worked on?**

There were only two designers, myself included, working on *Final Fantasy* and *Final Fantasy II*, so the two of us basically did everything. We split the work between us, whether it was the backgrounds, enemies, scenery, towns, or even the fonts used in the menus, depending on which of us was available. The first time I worked exclusively on character graphics was *Final Fantasy V*. By then, the workload had increased to the point that I didn't have time to work on anything else. By comparison, when I was assigned to *Final Fantasy III*, I only worked a little on the character sprites and mainly focused on the enemies, battle backgrounds, and dungeons. Around the time of *Final Fantasy IV*, we were also developing the Game Boy title *Final Fantasy Adventure*, which I was assigned to. I hardly did any of the pixel art, but I painted the watercolor image used in the box art for *Final Fantasy IV*.[10] I was asked to do that because I had previously done little illustrations for the *Final Fantasy Adventure* strategy guide, and when Hironobu

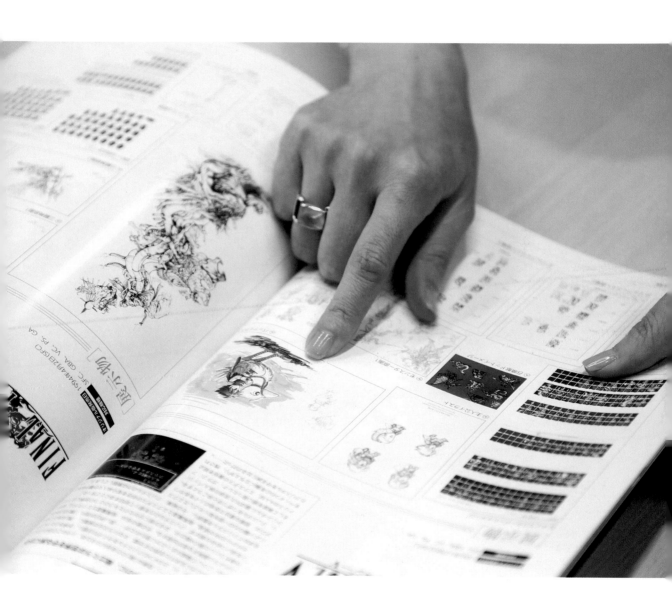

Sakaguchi saw them, he said, "These are really cute. You should do some of those for *FF*."

— **The early *Final Fantasy* games featured enemies designed by Yoshitaka Amano converted into pixel art. Were there any aspects to which you paid particular attention?**

Yoshitaka Amano's artwork forms the most beautiful silhouettes, so even if the details aren't clearly depicted, as long as the sprite retains a similar outline, it should still convey the essence of the design. Another thing is, the first three *FF* titles all have black backgrounds during battle. I only realized this recently, but I think we did a great job of utilizing that black. The parts of the sprites that appear black are actually transparent, with the black background showing through, which we put to good effect. There was no need to try to make muscles appear to bulge out by using colors; we can use black lines, like a Japanese-style ink painting. It's a perfect fit for Mr. Amano's art style.

Lines and silhouettes are very important in expressing the sense of movement in his designs, and we applied similar thinking when working on the enemies created by the team as well. I did the concept designs used as a basis for the helldiver, mermaid, cockatrice [*page 132, bottom left*], and Charybdis in *Final Fantasy III*. I think we've still got those illustrations somewhere.

Pixel Art in Motion

— **In the original *Final Fantasy*, the characters' proportions change after they upgrade their job, but this was abandoned in later titles. What's the story behind this?**

I quite liked it, but some people have said they were kind of shocked that the characters start off cute and suddenly become scary looking after upgrading. I suppose that the more lifelike proportions make them look quite imposing. Koichi Ishii drew the designs for the characters as they appear in battle, and I

converted them to pixel art. In *Final Fantasy V*, I designed all of the character sprites from scratch so that they were recognizable as who they were while still retaining the visual traits of each job.

— **One of the fun things about *Final Fantasy V* is seeing how the characters change appearance for each job. Do you have any favorites?**

Galuf as a dancer. I like to draw things that can make people laugh. With a good-looking character, they'll end up looking good however you draw them. But a bearded old guy in a leotard is pretty adorable, don't you think? All of the jobs have separate poses for attacking too, and I really enjoyed thinking up poses for the more comical jobs.

I'm often asked who my favorite *Final Fantasy* character is, and although there are a lot of wonderful and visually appealing characters, my favorite is Kefka from *Final Fantasy VI*. It's a real challenge to express a completely insane character like Kefka with such a small sprite, but I loved thinking about how he would behave while I designed his poses, drew his eyes, and made his animations. I still like him, even now.

— **How about the sprites used when the characters are walking around?**

For the first two *Final Fantasy* games, these sprites were only 16 × 16, so there wasn't enough room to even think about designs. As long as you could tell which character was which, that was enough, and they were closer to being symbols than anything else.

— **The character animations used in the overworlds, towns, and dungeons became a lot more advanced from *Final Fantasy V* onward, didn't they?**

They were difficult to make, though. If we added an extra movement, we'd have to add that to every character, from every angle. Even if we wanted to make them move their hands, we still only had a width of sixteen pixels to work with, so there wasn't much wiggle room! [*laughs*] The battle sprites were hard

work too, because regardless of the pose we wanted to make, we still only had 16 × 24 pixels.

When remaking the sprites up to *Final Fantasy VI* for this book, I noticed that the characters in *Final Fantasy VI* have slightly smaller heads, and that they still look fine even when their faces are obscured a little by their hands. I can't remember how they ended up with smaller heads, but it might have been done out of desperation to make animating the characters easier. Then again, it's more likely that there was no reason in particular, and I just did it without realizing.

— Which pieces of pixel art were the most enjoyable to make, and which were the most difficult?

The *Final Fantasy* series wasn't especially difficult. For better or worse, the sprites' clothing and hairstyles are all very archetypical in relationship to the character's role. Compared to that, Tomomi Kobayashi's designs for the *SaGa* series were extremely difficult to render as pixel art. The designs for the hair and clothing are incredibly elaborate. I recently did some work for *SaGa: Scarlet Grace* and on the one hand, I felt that it was very tricky, but at the same time I thought to myself, "I'm one of the few left who could turn these designs into pixel art." I hope people liked them.

As for *Final Fantasy*, I found it hard to express the individuality of the 3D-rendered characters from *Final Fantasy VII* onward when making their sprites. It's important for pixel art games to have character sprites that look good onscreen despite being very small. I ran into all sorts of problems, like some characters might be dressed all in black, or they might look good in 3D, but their personality doesn't really come across when they are reimagined in pixel art. This type of pixel art relies on deformation

of proportions and so on, and it's not easy to judge how much of the original design should be retained.

Thorough Observation and Seeing from the Player's Perspective

— **When making the jump from Famicom to Super Famicom, the number of colors available increased to sixteen per sprite. What kind of changes did this bring about?**
The overall quality improved dramatically. I wasn't really involved with *Final Fantasy IV*, so my first experience with designing for this hardware was on *Final Fantasy V*. I'd worked with the previous generation of hardware, so I felt like, "Is it really okay for me to be using all these colors?" That's still the case now, and even the redrawn sprites that appear in this book use a limited palette. However, sixteen colors still isn't that many, so the color limit for these sprites has been increased to suit the modern LCD format.

— **So the way colors are used varies according to the type of display used?**
If we were still in the CRT era, three gradations of each color would generally be enough for things to look good. A lot of things go through my mind when choosing a palette. For example, red is a strange one. Maybe because it's such a loud color. Three or four shades is normally enough to create a nice gradient, but having only four shades of purple or green is not quite enough . . .

I try to consider the various traits of each color and keep the palette within thirty colors per sprite. The size is still 16 × 24 pixels, the same as it was back then, so even increasing the number of colors won't make that big a difference.

— **Could you explain the process you use when making pixel art sprites?**

I just look at the concept image and go straight into placing the pixels. I'll also look through reference materials and search on the internet to find images from various angles. Things I'll consider might include "I wonder what this hairstyle looks like from the other side" and so on. If the base art only has a character in profile, for example, it doesn't tell you what the character's bangs would look like from the front, or where the tufts of hair that stick out come from. This process allows me to visualize the character from all angles. When I'm working on a sprite, I'm only thinking about that character. But once I've finished, I completely forget everything. I've drawn hundreds of these sprites, so it's better for me to remain detached and mentally return to a blank slate after each one. At the beginning of a new project, I won't look back at any of my previous work and will reset my brain and start from zero. Often, I'll only realize I'm doing this when my assistant, who's been with me through thick and thin, asks me, "Is the style supposed to be different from before?"

— **Is there a knack to capturing the essence of a character?**
With the proportions used in this kind of pixel art, the head and the hairstyle are the most important parts. If the hair looks

okay, everything else should be fine. This is why I spend a lot of time trying to get the hairstyle just right. Other than that, I have to choose which parts of the character design to keep. When it comes to the clothing, I just make sure to leave the most iconic parts, so it's relatively easy. If we use *Final Fantasy VIII*'s Squall as an example, his hair doesn't really have any standout features, but his jacket has a fur collar, so as long as he has that, you can tell it's Squall. There's no need to draw everything. The key is to be able to judge which parts are the most important.

— You mentioned earlier that the graphics look different depending on whether a CRT or LCD screen is used.

Yes, that's why I can never go back to working like I did back in the days of CRT. Those games were designed to be displayed on CRT screens, so even if I tried to re-create that style with LCD, I wouldn't be able to. These days, we only have LCD, don't we? On a CRT screen, things get a little squashed vertically, which we had to take into consideration when creating the sprites. We just don't have the same equipment nowadays, so it's not even possible to work the same way we did back then. I'm glad to hear that a lot of people like the style of pixel art from that era, though.

— How do you decide which colors to use and where?

These days, the type of display we work on is the same as the screens the players themselves use, so there's no need to account for the blurring that occurs on CRT screens, and we can choose color schemes according to what looks best. Before the introduction of LCD screens, we would work while checking the image on a CRT display. Our work computers were connected to tube televisions, so with a simple input we could see how it would look on a TV, and we were able to select colors according to how they would actually appear, rather than how they looked on our PCs. That's why looking back at the older sprites, I'm often surprised by the color schemes.

If the Pixel Art Era Had Never Ended

— How did it feel to go back and redraw these characters?

It was like saying "Nice to meet you" to someone whom I'd actually met a long time ago but had totally forgotten about. Everything was completely fresh, and I was eager to draw with all the extra colors and possibilities for gradation, but it didn't go as well as I'd hoped. They ended up being nothing like the old sprites. I decided to preserve the essence of the originals, while keeping the style consistent and not going too overboard. For the characters from *Final Fantasy IV*, I started adding more color here and there, and I thought I was pretty lucky to be able to use six colors just for the hair. *Final Fantasy VII* was the first set where I converted the 3D characters into pixel art sprites, so it was quite tough at first, but they served as a basic template for the characters from *Final Fantasy VIII* onward.

On this occasion, I had a little more freedom than usual. Originally the character sprites were designed to be used in-game, under a strict size limit of 16 × 24, whereas these were made simply as pieces of artwork, so some of the characters are a little bigger than that. Cloud's hair is one example. Other sprites might be slightly wider. If I were to get too carried away with this, it would ruin the balance with the other characters, so I tried to limit it to just one or two pixels. Even one pixel can make a huge difference, though. I wish I could've had an extra pixel back in those days. If the sprites were just one pixel wider, the animations where they swing their arms would've been easier to make out.

— Was there an overall concept?

I imagined what might have happened if there was no 3D era and we continued to use pixel art. If that were the case, they probably would've allowed us to use thirty-two colors, and maybe increased the size to 24 × 24 pixels. Actually, *Romancing SaGa 3* had 24 × 32—pixel sprites. That was a lot of fun. There were capes that flapped in the breeze, and their arms not only moved upward, but horizontally, too. Having an extra eight

vertical pixels meant we could make a variety of poses. However, if the sprites become too large, they lose a lot of what makes pixel art special in the first place. I think 16 × 24 is about the perfect size, and if we were allowed to stick out by an extra pixel or two, it would be even more perfect!

—— **If the pixel art era had continued, the character designs themselves might have been different too.**

Yes, I think so too. Some illustrations or character designs lend themselves well to pixel art, and I can imagine what they will look like straightaway. With those sprites, there's no need to go through a process of trial and error, hoping for the right idea to just fall into my lap; I can visualize the finished piece right from the very beginning. Since I've already visualized it, all I have to do is think about how to reach that point. There's nothing particularly special about it—I've been doing this for thirty years, so it just comes naturally. Whatever you do, it's important to keep doing it. Now I'm back to talking about what I was taught in middle school. You know, I can't thank my teacher enough.

Every Pixel in Its Place

—— **How do you go about creating the backgrounds and so on?**

I haven't been working on many backgrounds recently, but when I do, I rely on all the knowledge and experience I've accumulated over the years. I've studied numerous methods of artistic expression, and my repertoire has continued to increase as I've grown older, and I think I'm now able to create more of a sense of place. My aim is to convey the atmosphere of that location: the air, the wind. In the Famicom days, it was very difficult to create the illusion of depth, which is something I always try to incorporate now. If I was asked to work on something other than pixel art, I might go back and study artistic techniques. I'd like to look into creating pieces in the style of watercolors or oils, so if I had an offer like that, I'd relish the opportunity.

—— **Besides the sprites featured in this book, have you done any other pixel art lately?**

These days, my job mainly involves checking other people's work, so I don't get many requests to produce artwork. Recently, I've had offers from other companies to draw pixel art sprites. The requests ranged from 64 × 64 to 72 × 72 pixels, but at that size, there's a little too much freedom for expression. In the game, they just look like regular illustrations. When the next request came, I started working in 48 × 48 pixels, and I would say that this size is much better suited to pixel art sprites. Then it struck me that they'd still look nice even if enlarged or shrunk. I'd still like to have a few more colors at my disposal though.

— **How exactly do you draw your pixel art?**

I don't use any lines, just shading. I simply place one pixel at a time and build the image using different shades. I enjoy the feeling of searching for the right place to put a pixel. There is always a perfect spot for each one. The smaller the sprite, the more fun it is to search.

But sometimes, it takes ages to decide where the pixels should go. I'll stare at the screen, place a pixel, erase it, place a pixel, erase it, over and over. In my head, I know what I want to do, and I'll be trying to figure out how to bring it to fruition while placing those pixels. Then suddenly, something just clicks into place. I'll be absent-mindedly trying to find the right spot, and then with the placement of one pixel, I'll have a moment of revelation. I'll find myself sitting there with a grin on my face. I try not to let anyone see me doing that! [*laughs*]

Into the Future

— **Do you think there's been an increase in demand for pixel art since the rise of mobile and smartphone games?**

After *SaGa Frontier*, which was in 1997, I didn't create any pixel art at all for over ten years. I don't play mobile games, but one day, out of the blue, Takashi Tokita[11] asked me if I could draw character sprites for a sequel to *Final Fantasy IV.* I was completely taken aback. "What kind of era is this? I thought this is the age where 3D graphics are at the cutting edge. People want to go back to the past?" I honestly thought that the days of pixel art were over, but here we were with this weird time-lag situation. That's why I think it's so strange that younger developers who don't remember the Famicom or Super Famicom days enjoy copying the art style of *Final Fantasy V* and *Final Fantasy VI*. Still, I'm quite happy to hear that.

However, I'm a pixel artist by profession, and I know we can't go back in time. Whether the demand for pixel art continues, or it ends up being forgotten, we have no choice but to keep pushing forward. Maybe fifteen years from now, people will start reminiscing about the pixel art of the LCD era! [*laughs*]

— **If the display type moves on to something other than LCD, right?**

Yes, exactly. Perhaps that will happen when I'm an old lady. It's funny how, like fashion, trends in gaming have a habit of repeating themselves. Pixel art is on the opposite end of the spectrum to what's considered the cutting edge of technology, but I think there's something comforting and nostalgic about it. When my coworkers saw the 3D characters redrawn as pixel art sprites for this book, they smiled and told me how much they like them. It seems like it's a nice balance between the old and the new. In this age of such a vast range of art styles, I'm really glad that pixel art has been accepted as part of modern culture, and it makes creating sprites really worthwhile. But I will continue to look to the future. Each pixel I place is just another point in my journey. The sprites I drew for this book might look completely different if I were to draw them a year from now. [*laughs*]

— **Finally, do you have any words for all the pixel art lovers out there?**

It's best not to take pixel art too seriously. You know, I often see my sprites re-created in embroidery, crochet, and fusible beads. There are all sorts of ways to enjoy it. It doesn't matter how skilled you are; anyone can have fun with pixel art. You don't need expensive graphics software. I made sprites to be used in games, and there were always strict size and palette restrictions, but there's no need for you to follow these rules, so you can draw away to your heart's content. Pixel art is a fascinating style where a single pixel can make all the difference, and it has the power to bring smiles to people's faces. I hope you all continue to show your love for pixel art, in whatever form it may take.

Profile
Kazuko Shibuya

CG artist and art director for Square Enix. Pixel artist for the *Final Fantasy* series, with a focus on character sprites. Known as the "Pixel Master," she has an extensive portfolio of works that has charmed fans the world over.

Endnotes

※1: Creator of *Final Fantasy*. Played an integral part in numerous titles including the *Final Fantasy* series until his departure from Square in 2001.

※2: One of the founders of Square. Became CEO in 2000.

※3: Worked on the game system and user interface for the first three *Final Fantasy* titles. Producer of online titles such as *Final Fantasy XI*.

※4: Composer for early Square titles and the *Final Fantasy* series. Continues to compose for a wide range of Square Enix titles.

※5: Standardized home computer format, introduced as a joint venture between Microsoft and ASCII in 1983.

※6: Programmer of *WorldRunner*, *Rad Racer*, and the first three *Final Fantasy* titles. Internationally renowned programming genius.

※7: Personal computer announced by Apple in 1977.

※8: Game designer on numerous titles, beginning with *Final Fantasy*. Known as creator of the *Mana* series, the chocobo, and moogles.

※9: Battle and scenario designer for *Final Fantasy* and *Final Fantasy II*. Director of the *SaGa* series.

※10: *Final Fantasy IV* box art featuring small character illustrations on a white background.

※11: Worked on graphics for *Final Fantasy*, sound effects for *Final Fantasy III*, and game design for *Final Fantasy IV*.

FF DOT. -The Pixel Art of FINAL FANTASY-

ENGLISH LANGUAGE EDITION

Publisher
Mike Richardson

Editor
Ian Tucker

Assistant Editor
Brett Israel

Designer
Cindy Cacerez-Sprague

Digital Art Technician
Chris Horn

Special Thanks to Tina Alessi and Michael Gombos
at Dark Horse Comics.

JAPANESE LANGUAGE EDITION

Planning & Production
SQUARE ENIX CO., LTD. [http://www.jp.square-enix.com/]
Editor in Chief: Kazuhiro Oya
Editors: Tomoko Hatakeyama, Takuji Tada
Production: Kenichi Abe, Toshihiro Ohoka, Youhei Arima

Layout Editing
QBIST Inc. [https://www.qbist.co.jp/]
 Toru Wakabayashi, Kyohei Hashimoto, Akihiro Ushioda

Cover Design, Book Design & DTP
QBIST Inc.
 Keiko Kawaguchi, Moe Muraki, Kaori Tanimoto

Photos
Hiroshi Shibaizumi

Supervision
Business Division VIII
 Kazuko Shibuya
Creative Promotion Division
 Takeshi Kashio, Mariko Nishizawa
Final Fantasy 30th Anniversary Committee

Published by Dark Horse Books
A division of Dark Horse Comics LLC
10956 SE Main Street
Milwaukie, OR 97222

DarkHorse.com
Square-Enix.com

 Facebook.com/DarkHorseComics
 Twitter.com/DarkHorseComics

Advertising Sales: (503) 905-2315
To find a comics shop in your area, visit comicshoplocator.com

First edition: January 2020
ISBN 978-1-50671-352-6

10 9 8 7 6 5 4 3 2 1
Printed in China

Library of Congress Cataloging-in-Publication Data

Names: Square Enix (Firm) | Dark Horse Books, Publisher.
Title: FF DOT : the pixel art of Final Fantasy.
Description: Milwaukie, Or. : Dark Horse Books, 2020. | Summary:
 "Experience the intriguing evolution of pixel art from the Final
 Fantasy's series! Containing detailed sprite sheets that showcase the
 pixel composition of Final Fantasy's beloved characters, maps of Final
 Fantasy's most popular highlighting tools used by the developers, and a
 special interview with Kazuko Shibuya, the character pixel artist for
 the Final Fantasy series, FF Dot is a one of a kind product that
 immerses readers into an iconic aspect of the Final Fantasy
 experience"-- Provided by publisher.
Identifiers: LCCN 2019027714 | ISBN 9781506713526 (hardcover)
Subjects: LCSH: Final fantasy--Pictorial works. | Video games--Pictorial
 works. | Video games in art.
Classification: LCC GV1469.25.F54 F4 2020 | DDC 793.93--dc23
LC record available at https://lccn.loc.gov/2019027714

A Big Thanks to All Pixel Art Fans!